D1630651

Paul Wells

scriptwriting

n. developing and creating
text for a play, film or broadcast

An AVA Book
Published by AVA Publishing SA

Rue des Fontenailles 16
Case Postale
1000 Lausanne 6
Switzerland
Tel: +41 786 005 109
Email: enquiries@avabooks.ch

Distributed by Thames & Hudson
(ex-North America)
181a High Holborn
London WC1V 7QX
United Kingdom
Tel: +44 20 7845 5000
Fax: +44 20 7845 5055
Email: sales@thameshudson.co.uk
www.thamesandhudson.com

Distributed in the USA & Canada by:
Watson-Guptill Publications
770 Broadway
New York, New York 10003
Fax: +1 646 654 5487
Email: info@watsonguptill.com
www.watsonguptill.com

English Language Support Office
AVA Publishing (UK) Ltd.
Tel: +44 1903 204 455
Email: enquiries@avabooks.co.uk

Copyright © AVA Publishing SA 2007

All rights reserved. No part of this publication
may be reproduced, stored in a retrieval system or
transmitted in any form or by any means, electronic,
mechanical, photocopying, recording or otherwise,
without permission of the copyright holder.

ISBN 2-940373-16-7
and 978-2-940373-16-1

10 9 8 7 6 5 4 3 2 1

Designed by Them

Production and separations
by AVA Book Production Pte. Ltd., Singapore
Tel: +65 6334 8173
Fax: +65 6259 9830
Email: production@avabooks.com.sg

BLACKBURN COLLEGE
LIBRARY

Acc No. BB16433
+BC 791.4302 WEL
Class No.
Date 9/4/8

Title: The Future of Gaming
Animator: Johnny Hardstaff

Contents

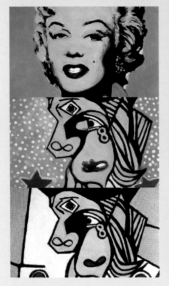

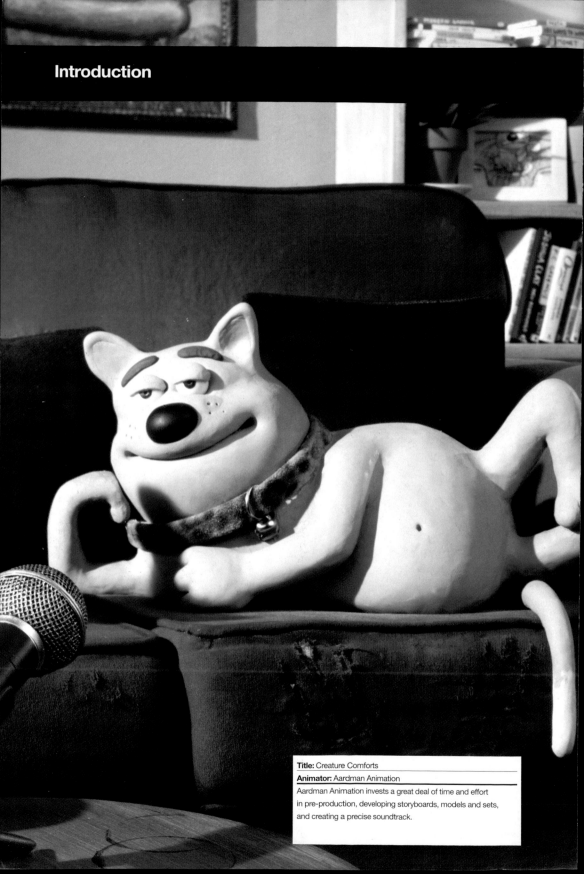

Introduction

Title: Creature Comforts

Animator: Aardman Animation

Aardman Animation invests a great deal of time and effort
in pre-production, developing storyboards, models and sets,
and creating a precise soundtrack.

IN RECENT YEARS ANIMATION HAS FOUND INCREASING RECOGNITION AND ACCLAIM AS AN ART FORM AND A SOURCE OF ENTERTAINMENT.

It is present in a plethora of children's films, programming and commercials; independent film-making; the expanding festival circuit; the web; mobile phones; gallery installations and public displays. Animation is everywhere – it is the omnipresent visual language of the 21st century.

Simultaneously, there has also been a growth in books about animation studies and practice, and indeed, other forms of writing for and about the contemporary media.This is largely a response to the expanding opportunities at various levels of media and cultural production. Crucially, it also signifies a recognition that there remains a need to embrace the core skills and knowledge still required to undertake creative work.

Basics Animation: Scriptwriting seeks to be a helpful addition to the literature on media writing for two key reasons. First, more and more people – from students to established practitioners – are increasingly engaged with the form in all its techniques and approaches. This may be a consequence of the form's higher profile in the contemporary era or merely because animation can now be done in the domestic as well as the academic and professional space. Secondly, greater attention is being paid to pre-production and the core skills in writing, which are viewed as instrumental in ensuring a high-quality outcome before any aspect of animation itself is undertaken. It has become an industry adage in an era that has sometimes complacently invested in 'fixing it in the post' that greater attention be given to creative problem-solving in pre-production, stressing both the creative and economic viability in such work. The better the writer, the better the story or visualisation, the more precise the construction of the piece, and hopefully, the more successful the outcome.

Animation has a unique production process that differs from other media. This book speaks to both the diversity of the potential readership and to the variety of approaches that can be undertaken. It looks at the specificity of animation as a language of expression in the ways that it differs from other media forms, and consequently, looks at how a writer can take into account this distinctiveness, and write for various forms and styles of animated film.

Definitions

Explores the meanings attached to becoming an animation scriptwriter and the contexts in which an animation writer might emerge. This section also touches on the 'language' of animation.

Initial Approaches

This section considers the animation writer's possible sources of inspiration and starting points for storytelling.

Genres in Animation

Looks at animation as a form and mode of expression drawing on the following genres: formal, deconstructive, political, abstract, re-narration, paradigmatic and primal.

Story Design

This chapter looks in depth at approaches to writing animated stories and covers production processes and storyboarding. Episodes from two children's series are used as case studies.

Writing Styles

Examines the works of various writers and animators using different approaches to writing for animation. It covers topics such as writing emotionally, conceptually and experimentally.

Animation in Alternative Contexts

This last chapter looks at how animation can be used in other non-traditional platforms – in theatre, advertising and in a planetarium.

THIS BOOK HAS BEEN WRITTEN WITH A VARIETY OF PURPOSES IN MIND. FIRST, TO HELP WRITERS WHO ARE THINKING ABOUT WRITING FOR THE ANIMATED FORM FOR THE FIRST TIME.

Second, to help established writers bring their traditional scriptwriting skills to animation. Third, to collapse the distinction and divide between theory and practice. This book deliberately 'theorises' animation so that its 'practice' idioms are delineated, and thus made available to the writer and critic.

Most of all, the book does not want to be a 'technical' textbook, but a point of stimulus, provocation and encouragement – a place of departure to create, devise and write for animation as a particular and progressive art form.

Clear navigation
Each chapter has a clear strapline to allow readers to quickly locate areas of interest.

Chapter openers
Special section introductions outline basic concepts that will be discussed.

Chapter 4: Story Design

96 | 97

THIS SECTION IS COMPOSED OF TWO DETAILED CASE STUDIES. ITS INTENTION IS TO SHOW HOW TRADITIONAL APPROACHES TO STORY DESIGN INFORM SOME APPROACHES TO WRITING ANIMATED STORIES. THE TERMS AND APPROACHES AVAILABLE TO CONVENTIONAL SCREENWRITERS ARE PRESENT HERE AND ARE DEFINED WITHIN THE PROCESS OF CREATING SERIES-BASED ANIMATION FOR CHILDREN. THE FIRST CASE STUDY – *CHARLIE AND LOLA* – EXPLORES THE WHOLE PRODUCTION PROCESS FROM INCITING IDEA TO COMPLETED SCRIPT, WHILE THE SECOND CASE STUDY – *WILLIAM'S WISH WELLINGTONS* – LOOKS AT THE CENTRAL ROLE OF STORYBOARDING AND A SIMPLE APPROACH TO NARRATIVE BUILDING THROUGH PROBLEM SOLVING. THESE TRADITIONAL APPROACHES CREATE APPEALING WORKS FOR CHILDREN THAT REMAIN DISTINCTIVE FROM OTHER FORMS OF CHILDREN'S ENTERTAINMENT.

Title: Johnny Bravo
Animation Van Partible

Section introductions
Lead in to the topic to be discussed.

Script extracts
Sections within the body text taken from actual animated scripts. These help to demonstrate main points covered in the body text.

Examples
Works of various animators bring to life principles discussed.

Tags and captions
Provide the title and animator/writer of the images used to support the main text. Also give insights to the people, practices and styles discussed.

Tables
Provide conceptual and theoretical principles in writing for animation, allowing for a particular understanding of core ideas, which help in the creation and development of material.

Box outs
Offer particular thoughts and ideas about approaches, techniques and outlooks. These help with the practical development of material.

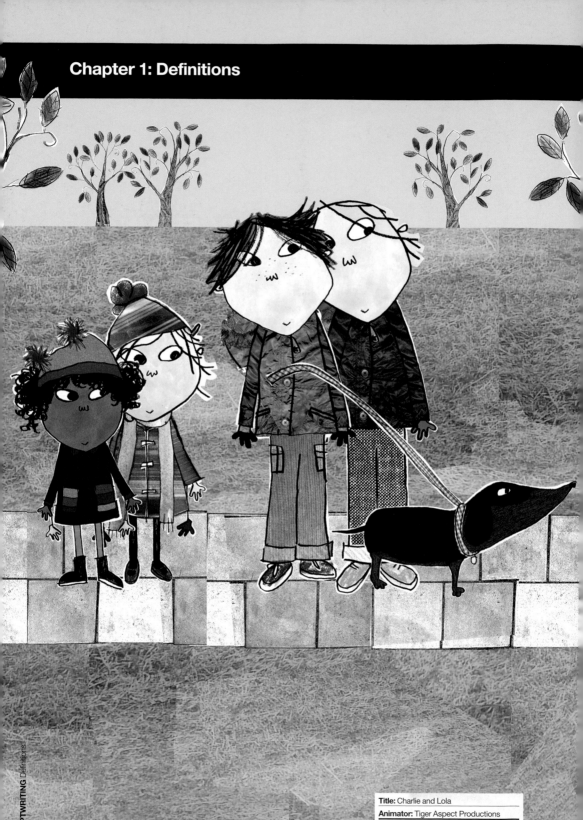

Title: Charlie and Lola
Animator: Tiger Aspect Productions

ANIMATION IS A PARTICULAR AND DISTINCTIVE FORM OF EXPRESSION. IF A WRITER, DEVISER OR CREATOR OF ANIMATION IS TO SUCCEED IN PROPERLY ENGAGING WITH AND EXPLOITING ANIMATION AS A FORM, IT IS CRUCIAL THAT THERE IS A COMPLETE UNDERSTANDING OF THE SPECIFIC VOCABULARY AVAILABLE IN ANIMATION, AS WELL AS THE SKILLS AND KNOWLEDGE REQUIRED TO EXPRESS IDEAS AS A 'TRADITIONAL' SCRIPTWRITER.

THIS FIRST SECTION EXPLORES THE DEFINITIONS OF WHAT AN ANIMATION SCRIPTWRITER COULD BE; THE CONTEXTS IN WHICH THE ANIMATION WRITER MIGHT EMERGE; AND THE 'LANGUAGE' OF ANIMATION, WHICH IS THE KEY TO WRITING PERTINENTLY FOR THE FORM, ENSURING THAT ANY ANIMATED FILM OPERATES AS A DIFFERENT FORM OF CINEMA OR TELEVISION FROM LIVE ACTION.

EVERY BOOK ABOUT THE ANIMATED FORM SEEMS TO ASK, 'WHAT IS ANIMATION?'. THIS IS NO SURPRISE BECAUSE ANIMATION OCCURS IN SO MANY DIFFERENT CONTEXTS, FORMATS AND DISCIPLINES. IT IS REPRESENTED IN SO MANY STYLES, TECHNIQUES AND TECHNOLOGIES – HENCE, A COHERENT DEFINING PRINCIPLE TO EMBRACE IT WOULD BE USEFUL.

In the digital era, an all-encompassing definition is increasingly difficult to find as the dividing line between live action and animation is now essentially effaced. Most of the time it is hard to tell one from the other, particularly in contemporary blockbusters, which seem to be principally made in post-production. On the other hand, we still know animation when we see it, especially in its form as a cartoon, a 3D stop-motion film, a computer-generated phenomenon, or sometimes, even when it is at its most photo-realistic. What is it then that still signals the difference and particularity?

Animation is still the art of the impossible; whether it be the fertile imaginings of independent film-makers represented in vivid symbolic images of inner states, or the seamless interventions of visual effects animators producing spectacle in major movies, animation remains the most versatile and autonomous form of artistic expression. In the pre-digital era, it was comparatively easy to argue that animation was a process art in which profilmic materials (drawings or items that represent ideas, objects or characters) were filmed 'frame-by-frame'. In between each frame an alteration of the materials was made to create the illusion of movement in phases of imagined action when the film was projected at 24 frames per second. For this kind of film-making such a definition remains pertinent. The determining aspects of this kind of practice are the self-conscious profilmic construction of 'motion' in figures, objects etc., and the notion of 'the frame' as the presiding increment by which this illusion is created.

In the digital era, it is still the case that animation mostly uses artificially created and previously conceived movement instead of transferring movement from the natural world. However, the frame is no longer the determining factor in the measure of the advancement of this movement. Master animator Norman McLaren suggested that: 'What happens between each frame is more important than what happens on each frame (Solomon, 1987).' This is one of the most important statements in defining animation, and ironically, it might even be more relevant in the digital era. The most significant aspect of the process is the self-conscious aesthetic and technical decision made by the artist in the incremental manipulation and progression of the materials. Though this does not necessarily have to occur between 'frames', it does still occur between the stage-by-stage accumulation of the 'movement' in the computer, and ultimately defines what is in rather than on the frame space, however fluid and changeable.

This is significant, because it preserves the idea of animation as a distinctive art and insists upon the idea of animation as a process in which progress is consistently concerned with, and measured by, creatively conscious devising strategies determined by the minutiae of needs.

INTERPRETATION OF MOTION
Animation, then, is simpy the creative interpretation of 'motion' as it is executed through the process of profilmic graphic execution and/or material construction, and configured as a recorded time-based

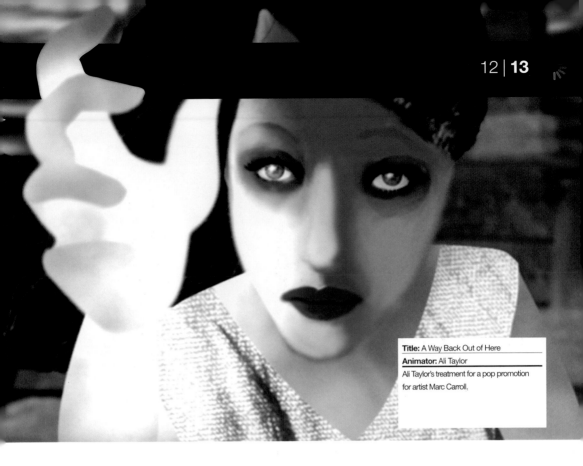

Title: A Way Back Out of Here
Animator: Ali Taylor
Ali Taylor's treatment for a pop promotion for artist Marc Carroll.

STORYTELLING

Think of the ways in everyday life that demand we construct and understand stories: telling others about past and future events; engaging with newspaper and magazine articles; reading comics, graphic narratives, journals, novels, and non-fiction; relating jokes and information in various generic conventions, guises, and instructions; and embracing poems, songs, images, etc. as different models of narrative. The writer and deviser can draw upon these everyday resources to create animated films.

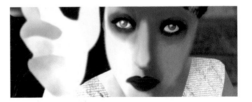

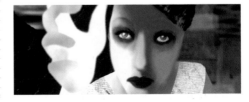

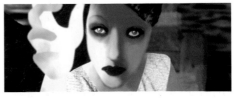

What is Animation?

outcome. Writers and devisers for animation need to grasp the implications of this statement if they are to create material that not merely apes what might be achieved in the context of live action, but properly exploits the distinctiveness of the medium.

While it remains important to embrace the increasing amount of literature about scriptwriting, this work rarely looks at animation as a distinctive phenomenon. Robert McKee writes:

'Here the law of universal metamorphism rules: anything can become something else. Like fantasy and science fiction, animation leans towards the action genres of cartoon farce (*Bugs Bunny*); or high adventure (*The Sword in the Stone, The Yellow Submarine*); and because the youth audience is its natural market, many maturation plots (*The Lion King, The Little Mermaid*); but as the animators of Eastern Europe and Japan have shown, there are no restraints (McKee, 1999).'

This observation at least acknowledges a key aspect of the animation vocabulary in 'metamorphosis', but soon retreats to a level of generality, which either aligns animation with live action film and its genres, or essentially gives up and says: 'Anything goes'. This does not really acknowledge the potential complexity of the process in animation, nor the collaborative aspects of generating material for a wide variety of both feature length and short films. Kathleen Gavin, co-producer of Tim Burton's *Nightmare Before Christmas* notes:

'Animation, perhaps more than live action, goes through an evolutionary process. There is a script, you start storyboarding and you work out the action. Then you realise "Oh, that doesn't quite work", so you go back and re-write part of the script. In animation you have to have writers who are willing and interested in being part of the process...You really need the writer to be involved when you are boarding because what you see on the screen is an amalgam of the work of the writer, storyboard artist, and director; it's very interactive (Gavin, 1994).'

At the heart of Gavin's point is the idea that the animation writer cannot merely write a script in a traditional fashion, but must also be consistently aware of the visualisation process and the role of the other artists involved – artists who are not only thinking of the ways in which something looks, but the ways in which it will move. This necessitates that the writer is not precious about the original work and becomes a competent deviser who contributes to the process from an informed point of view about what animation can achieve, which live action cannot.

LANGUAGE AND VOCABULARY

Back in the early 1940s, John Halas of the Halas & Batchelor Studios (later famous for making the first full-length British animated film, *Animal Farm* (1954), realised that potential sponsors for his films and the general public would not necessarily realise what was

Title: A Way Back Out of Here
Animator: Ali Taylor

Taylor seeks to work in a loose improvised style when preparing material, focusing on illustrating a basic storyline with initial sketches and storyboards, but working more intuitively in the final visualisation of scenes, prioritising the aesthetic appeal.

Title: Puleng
Animator: Ali Taylor

Ali Taylor's *Puleng* is set in Southern Africa; it is a tale of a daughter looking after her ailing father.

CREATION PRE-ANIMATION

It is useful to remember that animated films are normally essentially made in their pre-production phase, while live action films are made in post-production. Such is the labour-intensive process in making many animated films that the specific advanced preparation of material is crucial in executing the particular intentions of the piece, in the most economically viable and time-sensitive fashion. Live action normally accumulates much more material than it needs in order to create the film in the edit (e.g. numerous takes of scenes from different camera angles and perspectives; variations in the performances or interpretations of the actors). During the five-year cycle of making an animated feature, Pixar Animation will spend at least three years refining story and visualisation before animation begins. This alone places much greater emphasis on the work of writers, devisers and creators in pre-production, and stresses their significance.

different about animation and what it could achieve, especially as it was largely characterised by Disney cartoons and viewed mainly as children's entertainment. In order to describe what animation could distinctively express, Halas came up with some helpful vocabulary, which to this day serves as a useful reminder to potential writers:

Symbolisation of objects and human beings
Picturing the invisible
Penetration
Selection, exaggeration and transformation
Showing the past and predicting the future
Controlling speed and time (Halas, 1949).

Symbols essentially work to clarify and simplify an idea – a flag can represent a nation; a moving arrow, the direction of an invisible force, such as the wind; a single iconic soldier, the military ambitions of a whole country. Such devices can 'picture the invisible', too. Sound waves, magnetism, radar and other physical properties characterised by laws not visible to the eye can be rendered clear and apparent. Animation can also 'penetrate' interior workings of the body, a machine, or other kinds of complex inner states (dream, memory, consciousness, fantasy) and provides a literal and conceptual interpretation that allows them to be more readily understood. By selecting aspects that need to be visualised, certain elements can be accentuated or brought into the foreground for effect; thus, some aspects might be exaggerated or transformed to better reveal their properties or significance. All these elements can be contextualised within various time frames. For example, things can be represented from the long past and projected easily into the future. The speed and time in which things are presented can also be varied – a split-second can be extended, while millions of years can be truncated into a minute or two. The animator can intervene in these time frames by accelerating or showing in slow motion particular details. The versatility of the language of animation is not arbitrary. The writer must see these facets of the language as potential tools in script development and devising strategies.

These are not the only distinctive elements and applications, of course, but they serve as indicators of the diverse ways the animation writer can use orthodox scriptwriting methodologies and established genres, while also re-defining and augmenting these with a particular knowledge of strategies that are available in visualisation and animation techniques. These elements will be explored in the rest of this book.

There remains one fundamental point to take into account. Even if animation allows the possibility of using a different language of expression, it must be remembered that artists must have something to say and a method by which to say it. However animation might re-define 'narrative', story is still a central preoccupation of most approaches. As David Cohen, co-creator and producer of The Simpsons has remarked: 'Don't think that just because it's animated, you have leeway to make a string of crazy things happen. Really try to build a solid story as your basis. And if you really look at our shows, it's almost always with a strong "A" storyline. So keep your writing and the story organised (Blum, 2001).' This sense of organisation is implied in the emphasis on structure in this discussion, but also on the assumption that humans are natural storytellers, constantly configuring everyday existence into narratives to share with others.

Animation is the most pertinent and versatile language with which to embrace all versions and interpretations of 'narrative', breathing life into old stories and creating many new ones, enhancing the literal, realising the fantastic and supernatural, and visualising consciousness and concepts. Writing for animation is a particular exemplar of the old scriptwriter's adage of 'show, don't tell', but its specific visual emphasis requires that 'showing' is simultaneously 'interpreting' and 'illuminating'; and the act of 'telling', an architecture, a point of access, and a model of affect.

Title: Pocoyo
Animator: David Cantolla and Guillermo García (Zinkia Entertainment)

Pocoyo is an excellent example of pre-school animation, which encourages children to empathise with Pocoyo's curiousness, and his engagement with learning about new objects and environments. The director has deliberately used minimal backgrounds so that children concentrate on the character action, the moral outcome, and the new dance, which occurs in every episode.

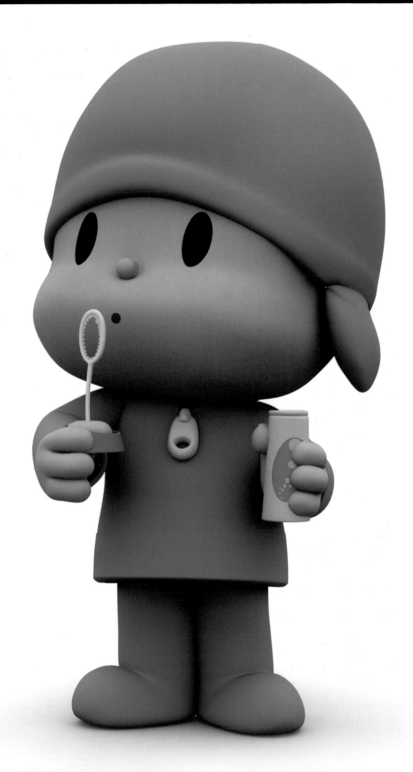

IN MANY CASES, THE WRITER GENERATES THE CORE MATERIAL FOR ANY ONE PROJECT, EVEN IF IT BECOMES HIGHLY MODIFIED OR CHANGED THEREAFTER.

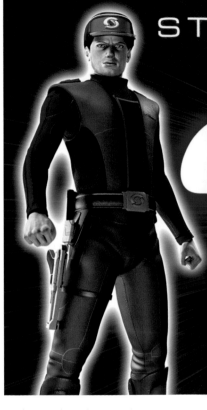

Title: Captain Scarlet

Animator: Indestructible Productions

Drawing from Gerry Anderson's original puppet series *Captain Scarlet*, this re-imagining of the series in CGI is a collaborative effort between writers, designers and computer animators working in a particularly cinematic style, reflected in the series promotional poster.

To a certain extent this is no different in animation. This is especially so if the writer is essentially creating what is in effect the initiating material by which the film is later visualised and further acted upon by a range of other 'storytellers' who view the original script from alternative perspectives.

For example, an animator may feel that a script idea does not lend itself to animation or there is insufficient action implied in the story events, and therefore decides to suggest an alternative possibility. Equally, there may be too much dialogue in a scene, resulting in a 'talking head' sequence, which seems insufficiently dramatised or open to visual interpretation. Inevitably, changes will be made in these circumstances; any one animated film will go through various processes before it is completed. Consequently, this creates different models of writing.

In all of the writing models (see table), scripting should be understood as a process of conceptualisation, visualisation and application, where the definitions applied to each process are in constant flux, readily overlapping and changing. Animation, under any condition, and using any technique, is largely created more self-consciously as it proceeds. Most live action work, while following a traditional script – however loosely – is ultimately an accumulation of material, which is effectively constructed in the post-production stage. In general, animation is configured in the pre-production stage and monitored and modified during production; this means there is a greater emphasis on the process as it occurs, rather than after it occurs. Simply, the act of execution in animation is not merely a matter of record, but of specific profilmic construction. As a result, it is subject to a consistent act of creative engagement and authorial impact. In 'animating' a scene the animator effectively dramatises the work and imposes a level of interpretation. This moves the film beyond words or preparatory images into creative motion in a way in which none of the previous stages are any less relevant to the final outcome. Scripting for animation is a very particular skill that draws upon traditional techniques, but insists upon its own processes and applications.

SCRIPTWRITING Definitions

ND BY FOR ACTION!

GERRY ANDERSON'S **NEW**

=APTAIN

SCARLET ™

"7HE WAR ON 7ERROR HAS BEGUN"

Models of Writing

Traditional scriptwriting for animation
An individual or a partnership writes a text-based script (with or without song lyrics and score) for an animated feature or television series using the standard conventions of language-based scriptwriting for a live action feature or television series.

Studio-process script development
A group of creative artists at a studio develops a script from an initial idea or brief, using a complex and incremental development process, employing written text and visualisation materials (i.e. character designs, sketches, storyboards, shooting scripts, animatics).

Series-originator writing
An individual, a partnership or key studio personnel creates a 'bible' for a television or Web-delivered series, which includes the core information and designs on characters, contexts, themes and proposed storylines along with the pilot or first series scripts. This information can then be passed on to other professional scriptwriters to write further material in kind and in style, without the involvement of the originating personnel.

Creator-driven writing/devising
An individual artist and/or a small creative team develops independent projects using a variety of strategies. These might include prose narratives adapted into storyboards; bullet-pointed story ideas leading to a conventional script; three-dimensional photographic storyboards etc.

WHILE ANIMATION CAN SHARE MANY OF THE FILM-MAKING CONVENTIONS OF LIVE ACTION, ESPECIALLY IN RELATION TO COMPOSITION, STRUCTURING SHOTS AND THE MOVEMENT OF THE CAMERA, IT HAS ITS OWN DISTINCTIVE VOCABULARY THAT MUST BE TAKEN INTO ACCOUNT (WELLS, 2006).

This distinctive language of animation can be summarised as follows (any one element (or more) might be intrinsic to an individual approach):

Metamorphosis
The ability to facilitate change from one form into another without edit.

Condensation
The maximum degree of suggestion in the minimum of imagery.

Anthropomorphism
The imposition of human traits on animals, objects and environments.

Fabrication
The physical and material creation of imaginary figures and spaces.

Penetration
The visualisation of unimaginable psychological/physical/technical 'interiors'.

Symbolic Association
The use of abstract visual signs and their related meanings.

Sound Illusion
The completely artificial construction of a soundtrack to support the intrinsic silence of animated forms.

The elements described essentially provide the writer with possibilities over and beyond those within the visual parameters of live action. It is worthwhile to remember that even when live action departs from its intrinsically 'realistic' representations and looks to special effects or work done in post-production, it often relies on animation and animated characters to carry 'inner-narratives' within the bigger story being unfolded. It should be stressed that these are not subplots, but narratives that are intrinsically related to what the animation allows the character, object or environment to actually do.

Title: MTV Ident
Animator: J. J. Sedelmaier
Sedelmaier seeks to use striking and immediate imagery for interstitials and idents, often drawing upon design and illustration in comic books and graphic narratives.

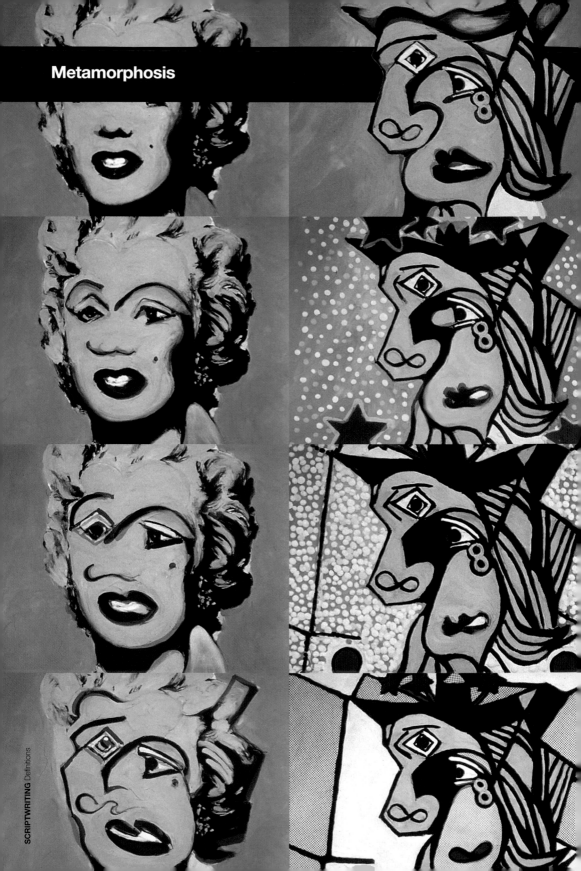

METAMORPHOSIS IS THE ABILITY TO FACILITATE CHANGE FROM ONE FORM INTO ANOTHER WITHOUT EDIT. MANY LIVE ACTION FILMS MIX FANTASY AND REALITY, AND SUCH STORIES BECOME NARRATIVES OF METAMORPHOSIS.

As Marina Warner notes: 'Metamorphosis is a defining dynamic of certain kinds of stories – myths and wonder tales, fairy stories and magic realist novels. In this kind of literature it is often brought about by magical operations; but as I discovered in the course of my reading, magic may be natural, not supernatural. [Metamorphosis can operate] as a prodigious interruption of natural development, and, by contrast to this…as an organic process of life itself [as it] keeps shifting (Warner, 2002).'

Warner identifies two different kinds of metamorphosis here, which are helpful to the animation writer. First is when a character, object or environment suddenly and profoundly becomes something else – for example, Bruce Banner transforming into the Hulk. The second occurs when the character, object or environment goes through organic changes as a result of the circumstances within which it exists – for example, Bruce Banner living his everyday life.

This in itself prompts several further variations on metamorphosis, which may be helpful to the writer in developing various characters or possible narratives:

Transformation
Literally becoming something else.

Mutation
Becoming a hybrid of two or more things.

Translation
Revealing something about the former state by becoming another state.

Propagation
Splitting, hatching, or doubling to create a number of changed elements or aspects.

Fundamental to animation is that metamorphosis is its intrinsic state. Any image can metamorphose into another and consequently, any story can be told through visual transitions from one pictorial element to another. Metamorphosis is the key and presiding aspect of the distinctiveness of animation. This sense that anything can 'flow' from one state to another enables the writer to take any number of possible short cuts, and lead the audience from one perspective to another without the traditional editorial process of cutting images together. This enables stories to be told in entirely different ways and to seamlessly bring together realistic exterior environments, contexts and situations with interior states of consciousness, dream, memory and fantasy. Animation trusts the viewer's capacity to move beyond the literal and conventional in order to embrace the flux of visual imagery and its treatment.

Title: Mona Lisa Descending a Staircase

Animator: Joan C. Gratz

Joan C. Gratz's Oscar-winning film *Mona Lisa Descending a Staircase* (1992) is an animated 'clay painting', which exemplifies the concept of metamorphosis. Carefully balancing the absolute control available in making an animated film with a sense of improvisation before the camera, Gratz notes: 'In *Mona Lisa Descending a Staircase* key paintings from twentieth century art needed to be reproduced as exactly as possible, but the transitions between these paintings were used to communicate the relationship of artistic movements, their formal and emotional content, and to entertain the viewer.' The sequence here shows the metamorphosis between Andy Warhol's screen print of Marilyn Monroe to Roy Lichtenstein's *Picasso*, demonstrating the playfulness of 'pop art' in engaging with cultural icons and stylings.

Condensation

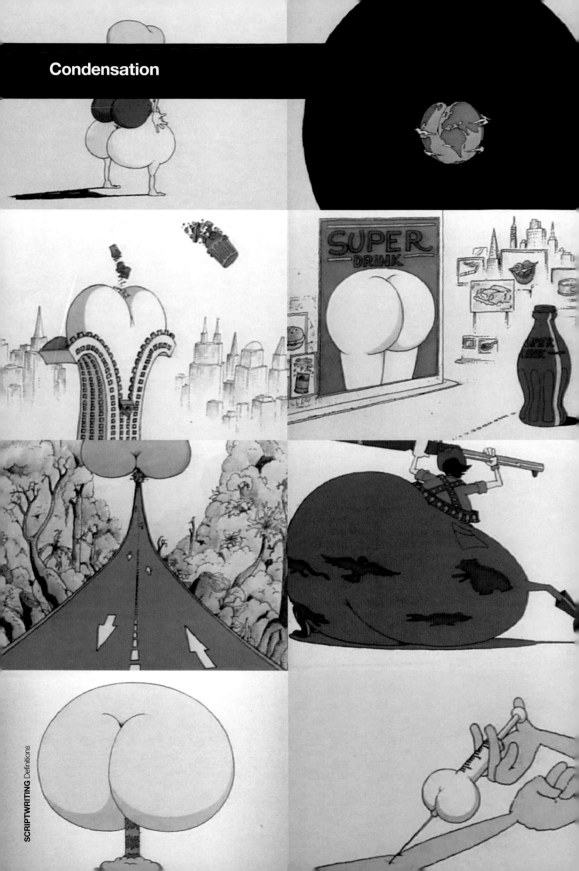

TECHNIQUES SUCH AS THE USE OF 'METAMORPHOSING' OR 'MORPHING' IMAGERY, AND OTHERS THAT FOLLOW HERE, ARE AT THE HEART OF THE WAYS IN WHICH ANIMATION CAN ACHIEVE AN ECONOMY IN EXPRESSION AND INTERPRETATION.

Title: Use Instructions

Animator: Guido Manuli

Guido Manuli's *Use Instructions* (1982) is an exemplary example of condensation. By using the central image of a bottom as the presiding metaphor for the 'excreta' of humankind, he can emphatically play out his ecological and cultural critique by showing corporate abuse; the destruction of the rainforests; the 'waste' of the space programme; drug addiction; the junk products of late industrial capitalism; and cosmetic surgery in direct, but highly suggestive images. There is a sense of what this amounts to in the image of the bottom-shaped world disappearing down a toilet in the final image. While some would argue that this is not a particularly subtle approach, it nevertheless communicates its message with directness and clarity.

Condensation in the animation process uses the minimum of imagery in order to suggest the maximum of narrative and thematic information. Individual images, sometimes parts of objects and environments, are used to represent the whole of that object and environment, or operate as symbols or metaphors for more complex ideas. Each animated story or expression effectively 'condenses' and compresses resonant visual representations and motifs, and focuses purely on the detail that will enhance the narrative form being employed by the writer of the piece. Animation for the most part abandons the 'depth' created in live action by long character development scenes and sustained dialogue, preferring the intensity of suggestion in visual composition and design.

Characters are far more defined by what they do than what they say; environments are highly pertinent to the action because they are specifically constructed to accommodate it; scenes are based on highly specific story needs or the terms by which a comic event is being determined; and the narratives draw their complexity from the denotative and connotative associations the images form rather than through the machinations of plot. Feature length animation echoes all the possibilities available to live action, but is also often constructed with the processes of condensation in mind.

SCRIPTWRITING Condensation

ONE OF THE MAJOR CHARACTERISTICS OF ANIMATED FILM IS THE ENDOWMENT OF ANIMALS, OBJECTS AND ENVIRONMENTS WITH HUMAN CHARACTERISTICS.

This is also sometimes known as 'personification', but in either instance, it is about trying to create fresh image forms while still providing an empathetic or identifiable human aspect. Our material world is largely inanimate and functional; the natural world is essentially organic and autonomous. At the same time, both worlds have a relationship to humankind, despite the sense of 'difference' and 'otherness'. This 'otherness' is reconciled in the arts, and most specifically in much animated film, by the imposition of human character traits that render material and natural artefacts familiar. This means that animation can facilitate the creation of dancing washing machines and villainous shrubs, and endow otherwise ordinary things with appeal, ability and abstraction. Conversely, items could be made unattractive, useless, and defined by a singleness of purpose. Simply, giving the material and natural world human characteristics enables them to become as various as humankind itself. While this is liberating for the writer in animation, it may also have its drawbacks and the contemporary viewer is extremely sensitive about representational issues. This is particularly the case with the portrayal of animals.

HALAS & BATCHELOR STUDIO
There is a long and honourable tradition of animal stories, myths and legends, where animals have

Title: Halas & Batchelor Studio

John Halas and Joy Batchelor of the Halas & Batchelor Studio created *Animal Farm*, making their animals far more 'animal-like' rather than amusing 'human' characters who merely look like animals, as is common in most cartoons. Anthropomorphism is used for a more serious purpose: defining key characters who are actually based on the principal political figures underpinning the Russian Revolution (Marx, Lenin, Trotsky etc.), with complex motivations and purposeful delivery. This inevitably necessitated a different model of writing and script development.

substituted for humans, so that points and issues could be raised while avoiding social, political and religious taboos. Such stories can thus talk about forbidden ideological, sexual, moral and cultural topics under another guise, where talking animals can play significant roles. Within the American cartoon tradition from the 1920s until after the Second World War, animals largely became funny distractions from the social despair of the Great Depression and the war itself, largely sacrificing their 'animalness' altogether, and merely becoming appealing comic types. In 1954, however, the Halas & Batchelor Studio released *Animal Farm*, making the animals far more like animals and less like humans, in order to underpin the seriousness of the political metaphor at the heart of George Orwell's famous fable. This tension about how animals should or could be represented continues into the contemporary era, where animals still predominate as lead characters in animated features, but also figure in animated shorts often addressing their plight and status.

For the writer, it is useful to remember that anthropomorphism in relation to animals can be thought of a little more precisely in the following two terms:

Theriomorphism
When someone or something has the form of an animal or beast.

Therianthropism
When someone or something combines with elements of an animal or beast.

Animation often plays with these ideas in the make up of its characters, but because these constructions can be literally achieved, different notions of character can be determined.

Anthropomorphism

Title: Thing

Animator: Australian Children's Television Foundation

The Australian Children's Television Foundation made a series called *Kaboodle*, which included animated stories. 'Thing' demonstrates how the domestic pet, normally a dog or a cat, can be re-cast as a monster, but made familiar and appealing through the use of anthropomorphism.

By thinking of the tension between realistic and fantastical behavioural elements in the construction of creatures, new types emerge (see 'Creature Types' table).

CLASSIFICATION TECHNIQUE

The various creature types (see 'Classification Chart') can be extended further and enable the writer to determine a vocabulary for an animal and object, which can facilitate the development of narratives or jokes. Animation writer, Stan Hayward, uses what may be called a 'classification technique' (Hayward, 1977) where he refers to instances in childhood play when things are converted by their functions and associations into something else, thereby demonstrating how people adept at graphic or verbal puns are doing something similar. This technique begins by classifying what an object is, and what its associations could be.

Once this is done, it is then comparatively easy to transfer these concepts in an animated narrative for a range of effects. This transfer is at the heart of many graphic puns where things are associated by their similarities in looks or function. Hayward describes this in a potential sequence from Hanna-Barbera's *Tom and Jerry* cartoons:

'Cat in the kitchen tries to catch mouse stealing food. He throws egg (missile) at the mouse. The mouse takes a frying pan (tennis racket) and hits egg back. The concept has transferred to a tennis match. The scene is now open for bread rolls, fruit, vegetables etc., to be used as tennis balls. There is also the parallel concept of a war, which could bring in using saucepans and kitchen utensils as tin hats and armour. Eventually the kitchen furniture might be rearranged as a fortress (Hayward, 1977).'

In using anthropomorphism, the writer is not merely considering the use of human characteristics in representing an animal, object or environment, but the range of possibilities in constructing new notions of character out of known associations and story principles.

Creature Types

Organism	Behaviour	Example
Real	Real	*Cats and Dogs*
Real	Fantastic	*Scooby Doo*
Fantastic	Real	*Monsters Inc.*
Fantastic	Fantastic	*Shrek*

Classification Chart – Horse

Classification	Association
A four-legged animal	Other four-legged animals (cows, sheep)
A mode of transport	Other modes of transport (cars, bicycles)
Something to sit on	Other things to sit on (chairs, stools, cushions)
Part of a cowboy's accessories	Other cowboy accessories (guns)

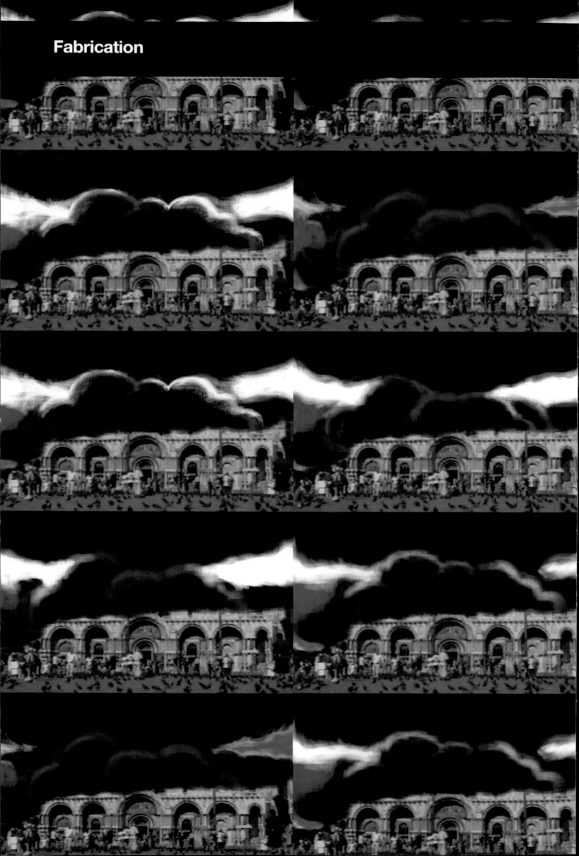

Fabrication

THE CONCEPT OF FABRICATION LEADS ON NATURALLY FROM THE PREVIOUS SECTION; IT RELATES TO THE PHYSICAL AND MATERIAL CONSTRUCTION OF ALTERNATIVE FIGURES AND ENVIRONMENTS.

Animation is especially suited to creating these imaginary figures and spaces because it can move beyond the material construction of such a context if required. The most important aspect for the writer to remember is that such fabrication must be pertinent to the world – however surreal – that is being created in the service of the characters and ideas. Re-inventing the known world or creating another still requires that it supports the 'inner logic' of the narrative environment being established. This is as much an economic issue as it is an aesthetic or conceptual one, especially if the setting is to be physically constructed. Importantly, the writer should not only think of fabrication as creating backgrounds, sets or locations, but as the creation of potentially symbolic non-human characters, machines, interfaces between objects and artefacts, and unusual uses of materials such as sand or wool, for instance, rather than the more obvious clay. This kind of thinking may facilitate a whole range of storytelling possibilities, which emerge from the orthodox uses and functions of the fabricated aspects, and the ways in which they are subverted and re-positioned.

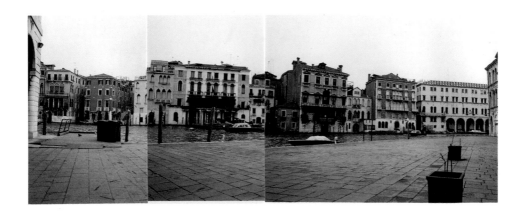

Title: Tango Nero

Animator: Delphine Renard

Delphine Renard's *Tango Nero* (2005) re-imagines Venice as a painterly 'underworld' in staging an enigmatic *noir*-style love story. It initially uses documentary photos of the city, then re-works the images digitally for physical and emotional effects.

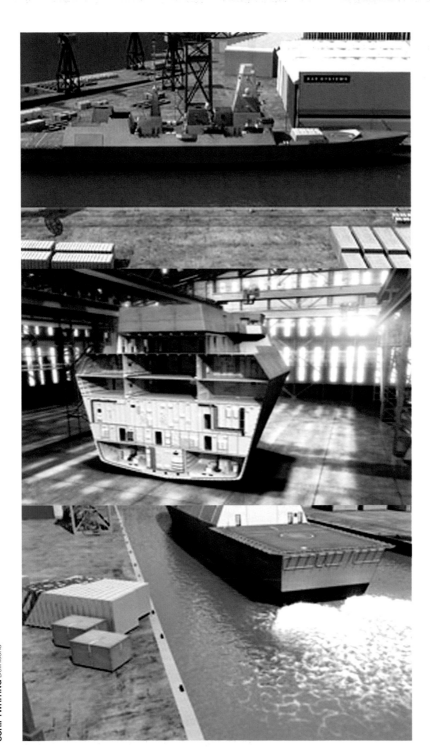

FOR MANY YEARS, ANIMATION WAS PARTICULARLY USEFUL FOR TRAINING AND INSTRUCTIONAL FILMS BECAUSE IT COULD PRESENT DIFFICULT CONCEPTS IN A VISUALLY APPEALING AND SIMPLE WAY, THEREBY MAKING IDEAS MORE ACCESSIBLE AND EASILY UNDERSTANDABLE FOR THE VIEWER.

This was mainly through the technique of penetration – where the interior mechanisms of complex machines or the interior workings of the body could be presented through graphic stylisation. Such things were essentially 'unimaginable', and their workings were hard to grasp, so animation's ability to 'penetrate' both the look and the function of the machine, and represent its uses and outcomes in motion enabled the viewer to better engage with things beyond their ability to envisage.

This ability to penetrate was appropriate not only in the depiction of interior mechanisms and the apparent alliance between animation and engineering, architecture and the sciences, but also to more creative artists wishing to depict the inner states of memory, fantasy, dream and consciousness. Animation can facilitate both approaches. It can depict the complexities of other disciplines through the use of simple and direct graphic visualisations, making facts and processes more appealing and accessible, and showing the workings of the mind. This 'penetrative' characteristic singles animation out as a distinctive medium of expression and

enables the writer to write confidently for public information and instructional projects, as well as for more psychologically and emotionally oriented stories.

Realtime UK, a company specialising in computer-generated 3D imagery and alternatives to traditional methods, was commissioned by BAE Systems, who required a 3D animation of its Type 45 Destroyer's build sequence. The sequence actually took place in three locations, so live action footage was required in three places, and the principles of assemblage needed recording in real time. The use of animation overcame these problems as it allowed for understandable and coherent sequences in simple graphic form.

The project required technical information from the client, but Realtime UK had complete freedom of expression and artistic control in building up a storyboard of the process. Realtime UK created an animatic which included all the camera work, basic motion, timings and aesthetic 'feel' of the sequences. The work also noted the lighting solutions for interior and exterior locations, and suggested how the animation itself would be fine-tuned. The sequences use creative storytelling and pertinent cinematography, while enhancing visual credentials with appealing effects. Ultimately, it is a narrative about the design process, but it is also an engaging animated film exhibiting the penetration technique, which enjoys critical and popular attention at presentations, exhibitions, trade shows and on the company's website.

Title: Type 45 Destroyer Build Sequence

Animator: Realtime UK

By stylising and simplifying the core processes of the building sequence of a destroyer, Realtime UK could both illustrate and conceptualise a generic model of construction meaningful to a range of viewers and potential clients.

SCRIPTWRITING Penetration

WHEN THINKING OF SYMBOLS OR METAPHORS, A WRITER MIGHT BELIEVE THESE THINGS TO BE OF A PURELY ABSTRACT NATURE; IN ANIMATION THESE CONCEPTS ARE ESSENTIAL TOOLS.

The necessity for an animation writer to think visually necessarily means that all the images envisaged for an animated narrative must be meaningful. In the first instance, they must provide specific information and give the viewer sufficient knowledge of the characters, context and the initial imperatives of the narrative. Thereafter, the images must not only provide developmental information, but also offer allusional resonance. The latter is crucial in moving the images beyond their function as the carriers of the story into areas where they take on symbolic association – signifying emotional states, political or ideologically charged ideas, social or material issues, or more abstract philosophical agendas. In essence, all animated images allude to the resonating meanings and affects of visual culture. From this perspective, the animated 'text' is simultaneously a moving pictorial narrative; a signifying engine alluding to established visual codes and conventions; an interrogator and interpreter of the history of arts and culture; and a vehicle by which all these aspects are revised and refreshed in a new way. A high degree of familiarity with visual languages and forms is absolutely essential for an animation writer. To write visually is to understand how to develop a technique that can play out the basics of storytelling, while imbuing the work with the range of symbolic association suggested here. All animated images are essentially hugely condensed signs, which contain the very essence of originality in the approach to narrative and its visual execution.

WRITING DIALOGUE

Though animation writers largely prioritise a 'show, don't tell' approach and emphasise 'descriptors', they still need to pay attention to the fundamental principles of writing dialogue outlined below:

Dialogue should only be used when required.

Normally dialogue aids the exposition of story and helps to reveal character, but should not self-consciously or explicitly do so in either case.

People rarely speak in direct emphatic statements, but hesitate, repeat, tail-off etc. Nevertheless, they naturally build anecdotal reportage of their lives and experiences. Listen carefully to individual kinds of expression and speech idioms.

No characters should actually speak in the same way. The use of individual expression and personal idioms prevent this happening.

Dialogue should not be too long or too stilted and should avoid a false or unnatural tendency to 'speechify'.

Dialogue must be consistent with the character portrayed. If a character is essentially inarticulate, he will probably say little; if a character is not particularly intelligent he may have a limited vocabulary; if a character is a natural performer and joke-teller, he may speak too much. These aspects will help define the character if used consistently and efficiently. Most people have a natural ear for what sounds plausible as natural expression, and quickly suspend disbelief if they find themselves thinking 'He wouldn't say that'. While not abandoning different, and sometimes aesthetically self-conscious approaches to dialogue and delivery, the integrity and believability of expression remains an important element in writing dialogue.

WRITING DESCRIPTORS

In any script 'showing, not telling' is vital, but this is especially the case in the animation script, because the main intention is to prioritise the visual process. The establishing descriptors at the beginning of, and during scenes, therefore, are particularly important. Such descriptors must accurately and vividly describe the time, place, location, context and story events taking place, giving some indication, too, of the protagonists' behaviour and imperatives as they execute their action. This must be achieved succinctly and directly, and facilitate interpretation. In effect, this is a 'blueprint' for the director to act upon.

Title: Saturday Night Live

Animator: J. J. Sedelmaier

Sedelmaier's work for *Saturday Night Live* is highly regarded and includes *The Ambiguously Gay Duo*, featuring comic book superheroes, Gary and Ace. They distract megalomaniac villains, who are uncertain whether they are gay or not. The playfulness of the piece is in the 'outing' of the homosexual subtext in the costumed superhero narratives such as *Batman and Robin*. This movement from subtext to 'text' is often a key aspect of the re-invention of established stories. Symbolic association need not be purely abstract. Here the symbolic overtones are drawn from the representations of superheroes, and are challenged by innuendo in the dialogue and a re-working of the iconography to reveal subtext and to play with the stereotypes and formulaic expectations of superhero narratives.

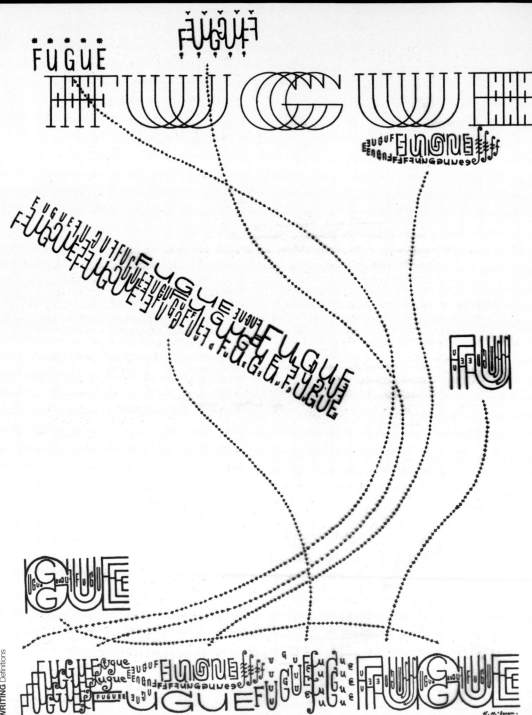

THE SOUNDTRACK IS FUNDAMENTAL TO ALL MOVING IMAGE NARRATIVES AND INDISPENSABLE TO BOTH LIVE ACTION AND ANIMATED FILMS.

Inventive sound design is hugely important in supporting any visual narrative and is highly instrumental not only in providing authentic sound for realistic action, but for soundtracks which might define more abstract aspects of the story, including allusions to psychological or emotional states and unknown worlds. Much of the sound in live action film is diegetic – motivated by the action that is being recorded in dialogue, natural sound, atmosphere etc. On the other hand, non-diegetic sounds are imposed from outside of the action that is being recorded – this could include music, effects and voice-overs. All soundtracks inevitably go through a long period of post-production, and are embellished and adjusted to match the live action imagery in the most appropriate and dynamic of ways. As a result, soundtracks are a combination of live recorded sound and additions are made in post-production. It is crucial to remember that the animated film soundtrack is completely artificial. It has to be completely constructed, must accommodate all the facets of a live action track, and be made highly specific to the animated image.

So, how should the animation writer approach the nature of sound in animated film? This is sometimes a helpful place to start because sound is often the determining factor in how an animated film might actually proceed. In one sense, this could be through a traditional script where the dialogue is very important and where the recording of the performance of the dialogue might determine the first sense of the narrative of the piece. On the other hand, the writer may not include extensive dialogue, but suggest a piece of music or a lyric to accompany a series of images, or indeed, may be responsible for writing the editorial script selected from a range of recordings of real people in conversation (or in interview). In all these instances the writer is determining both the words that should be heard and the kinds of visualisation that should accompany them.

SOUND CHOICES

In the early years of cinema, animated films were accompanied by musicians playing live, who oscillated between literally interpreting the on-screen events with pertinent renditions of popular songs or counter-pointing the narratives and gags with alternative unexpected tunes and music signatures. This 'language' passed into the sound cartoon. Its two greatest exponents – Carl Stalling at Disney and Warner Bros, and Scott Bradley at MGM – epitomised these approaches. Stalling composed soundtracks of multiple fragments of popular songs and music, while Bradley created original resonant scores with additional sound effects.

Title: Fugue
Animator: Norman McLaren

As part of his working method, master animator Norman McLaren would think about the structures and defining principles of musical forms as preliminary scripts from which to develop illustration and interpretation. These manuscripts show his dedication to thinking through the creative process in making 'visual music', not merely as an act of felt experience, but as a model of research into the relationship between textual and image forms.

Title: Max Miller
Animator: Brian Larkins

ONCE THE ANIMATION WRITER HAS A SENSE OF THE LANGUAGE AT THEIR DISPOSAL AND A RECOGNITION OF THE CONTEXT IN WHICH THEY MIGHT WORK, IT IS ESSENTIAL TO GENERATE RELEVANT AND ENGAGING MATERIAL. NO SCRIPTWRITER IN ANY FORM CAN MERELY RELY ON THE MUSE DESCENDING. ALL SCRIPTWRITERS HAVE TO BE WRITERS ALL THE TIME – LISTENING, OBSERVING, ABSORBING AND CRUCIALLY, SEEING EVERYDAY EXPERIENCE AS THE POTENTIAL SOURCE FOR CREATIVE NARRATIVES.

IT IS VITAL THAT THE SCRIPTWRITER IS ALWAYS CONSCIOUS OF THE POSSIBILITIES OF NARRATIVE IN WHATEVER FORM, IN ANY SITUATION. HAVING A CONSTANT SOURCE OF POSSIBLE STARTING POINTS AND AN INTRINSIC KNOWLEDGE OF THE PARTICULAR LANGUAGE WILL ENABLE THE ANIMATION WRITER TO EMBARK ON A PROJECT.

BY ADDRESSING THE CORE LANGUAGE DEFINED IN THE PREVIOUS SECTION, A WRITER MIGHT BE ABLE TO IDENTIFY A STARTING POINT.

For sound to operate as a point of departure, it is fundamental to move beyond the ability to hear and to cultivate the creative tool of listening. It is crucial for the animation writer to have an ear for particular kinds of music, lyrics, dialogue, everyday sound, noise, atmospheric ambience and silence itself.

The following examples address the use of sound as a basis for initial ideas and starting points. The first is by ex-students of the Arts Institute at Bournemouth in the UK, Richard Haynes and Mikolaj Watt.

THE TYPEWRITER (2003)

Most people are highly responsive to music, whatever the style or type, and have favourites that are charged with associations, provoking particular moods or inspiring a level of interpretation. Norman McLaren said that he learned his approach to animation during his high school years when he only had a radio. The music he listened to would stimulate in his mind images of various colours, shapes and moving forms, rather than provoke specific narratives in the traditional storytelling sense. For the most part, McLaren understood music as evocative rather than descriptive.

Haynes and Watt's film *The Typewriter* is based on Leroy Anderson's music. Embedded within its structure is an implied set of actions or events, and a general tone and rhythm that suggests a mood – in this case one of optimism and efficiency as the typist 'plays' an old style typewriter as if it were a musical instrument. Already suggested here is a character typing, engaging with the machine as a musical instrument while struggling to keep pace with the increasing tempo of the music, and the reams of paper emanating from the typewriter. This scenario is then 'fleshed' by the nature of the character, the choreography of the interaction between the character, the machine and the environment, and the aesthetic styling of the piece, which echoes the design

sensibility of United Productions of America (UPA) and the independent cartoons made in the United States during the 1970s.

The character has to have a particular appeal and match the needs of the dramatic action. The angular awkwardness yet gauche warmth of the character helps to invest the typewriter with a playful, adversarial personality.

In this particular case it is important to remember that there is only descriptive music. The sound of a typewriter is used against a musical 'narrative'; there is no dialogue and the emphasis is purely on the visual depiction of a story event and the facilitation of the action in the piece through the versatility of the character.

Haynes and Watt's storyboard is a concise and cinematically astute shorthand for the intended narrative, essentially locating the core action in its environment and suggesting the action is effectively a dance-style performance by the main character.

The extended arms and legs of the character serve the exaggerated performance in 'playing' the typewriter, moving it beyond any notion of lyrical performance; they stress the comic excess of the actions and emphasise the precision of the timing in relation to the movement.

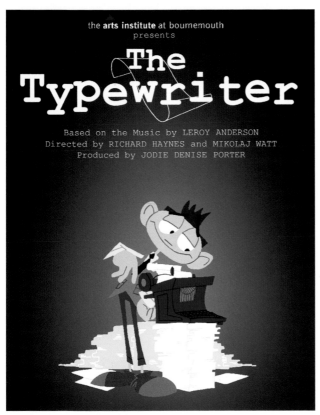

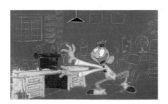

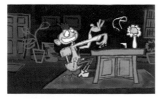

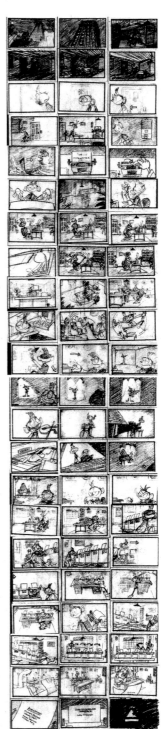

Title: The Typewriter
Animator: Richard Haynes and Mikolaj Watt

Haynes and Watt's preparatory materials are a good example of the ways in which design is intrinsic to visual storytelling, evoking a particular period and mood, which is readily related to the quality and styling of the music. The music and visual material become the narrative here, playing with a particular incident as the core principle of the film. The audience understands the sensibility and meaning of the film through the musical story and character idiom rather than traditional dialogue, scene development, exposition etc.

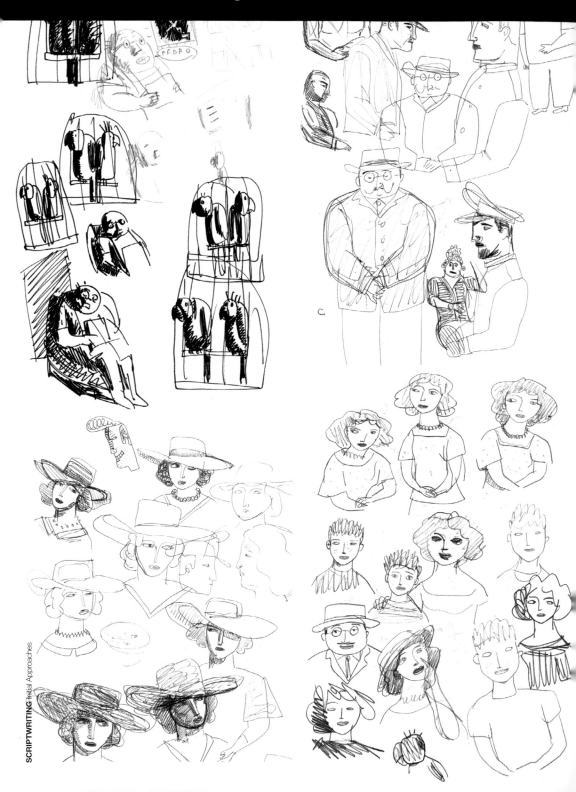

In this example the animation writer is concerned with how the character interprets the music, and it is his physical actions that become the core narrative of the piece. It is the animation that develops the scenario, rather than other preoccupations such as dialogue, conflict or story building in relation to following scenes.

MORIR DE AMOR (2004)

Gil Alkabetz's multi-award winning film, *Morir de Amor*, is a tour de force narrative exploring the ways in which sound can be instrumental in telling a story; it is especially persuasive because it demonstrates that sound can be purely literal (the actual sound that something makes) or the provocateur of memory, arousal, fear, comfort, and a host of other emotions. In effect the film shows a core awareness of the way in which sound guides the perception of time, space and action, and consequently becomes the chief engine of the storytelling process.

Two caged parrots rattle their cage and play out their response to the general tedium of the day while their owner is having a siesta. This is reflected in the simple black-line drawings and the monochrome *mise en scène*. Meanwhile, on the parrot food box held by their owner, two parrots are depicted in lush colours, an image that foreshadows the colourful memories the parrots are later to provoke in the narrative.

The soundtrack and its visuals are crucial in establishing the tension between nostalgia and lived reality; each sound becomes the touchstone for recollection, revelation and revision. As the parrots hear a car, one salivates. The sound of the parrots' fervent mastication prompts memories of flowing water, buzzing bees and birdsong – the backdrop to a country picnic undertaken by the owner, the owner's wife, and their chauffeur, Pedro. The sound of the car passing is also the prompt for the parrots' recollection of the car engine when they first heard it in the country, an aural cue for the seamless transition between the real world and the parrots' memory – and the same event experienced as a dream by the parrots' owner.

Title: Morir de Amor

Animator: Gil Alkabetz

Alkabetz takes a typical *ménage à trois* narrative and freshens it by seeing the story from the parrots' point of view; the prompts of the sounds associated with each environment; and the memories for which these become effective catalysts.

This is a very good example of how animation condenses comparatively little material into its narrative, while achieving the maximum degree of suggestion. The parrots imitate the sound of wine pouring at the picnic, the music on the victrola, the sound of the couple kissing and their owner saying 'bye bye', as he leaves his wife to capture some parrots to give her as a gift. With great attention to acoustic detail, Alkabetz also includes the parrots' parodic aping of the crackle of the record as the needle passes through its groove, and thereafter, their closely lip-synched mime of the French standard, 'Morir de Amor' (Dying of Love), sung by Charles Aznavour. Alkabetz cleverly uses the record itself to determine the shift in mood in the narrative. When it is first played by the owner's wife, it is an instrumental version of 'Remember When', but once her husband has departed, she turns the record over and plays the song 'Morir de Amor'. The lyrics give additional resonance to the story, and add another layer of meaning: A cruel world has disapproved of me / With no compassion it sentenced me / Instead I have no fear / To die of love.

The most amusing yet provocative aspect of the film is when the parrots recall the moment when the wife and chauffeur make love in the owner's absence. They remember a plane passing overhead and proceed to play out a parody of seduction, impersonating the wife and chauffeur kissing, and her more amorous moans as

SOUND AND IMAGE ———

All forms of sound – music, dialogue, noises, audio effects etc. – can act as a stimulus for possible narratives.

Diegetic sound is drawn from the people, objects and environment in the film.

Non-diegetic sound – additional music, noises, effects etc. – are added to the soundtrack for symbolic and storytelling effect. In animation both have to be artificially constructed, and the sound design is instrumental in the pace, timing, rhythm and aesthetic style of the film.

Descriptive music normally has an implied story element or dramatic motif, while evocative music may suggest a more abstract interpretation.

Lyrics are also helpful in determining a narrative.

———

she cries out 'Pedro!'. The moment of orgasm is depicted as a spiralling montage of fishes swimming, bees buzzing and birds singing, which are not merely an illustration of the parrots' imaginative memory, but their owner's troubled dream-state.

As the sexual liaison reaches its climax, the parrots are captured in their owner's net. Their owner awakens to the parrots' constant repetition of 'Pedro, Pedro', in the midst of a thunderstorm. Recalling his dream, he looks at the photographs in front of him, and sees for the first time that his son's shock of ginger hair is shared by the chauffer. His realisation prompts a heart attack, and in slumping to the floor, he drops the parrot food.

Cleverly, Alkabetz uses sound again to foreground two parallel issues – the lumps in the parrots' throats, dry from hunger and holding back tears, palpitate in time with the last heartbeats of their dying owner. Bugs claim the dropped parrot food, and the parrots accept that they cannot be fed and that their owner is dead. They break into 'Morir de Amor' again, and in a slapstick nuance to the finale of the film, fall off their perch.

Sound has been the key storytelling tool in this film, catalysing all the visual dynamics of the narrative. There is no dialogue. The parrots are not anthropomorphised to the extent that they have voices, but they are given human reactions to their situation. At first, they are prompted to remember their capture, but then, more importantly, the circumstances by which all their lives changed irrevocably. Though this is an advanced piece of work and carries with it the authority of an experienced artist, it nevertheless uses all the strategies that can be adopted in initially developing a story.

DEVELOPING A NARRATIVE FROM SOME INITIAL STARTING POINTS

Use personal experiences, memories and anecdotes as potential narratives – in this case memory is the subject of the film.

Use 'sense memories' – everyone has memories that recall particular sights, smells, sounds, touch, and tastes; in this case, the sensual aspect of the film is evoked through the ways sound provokes or defines 'feeling'.

Use, revise, or adopt established narratives – in this case, a song and the associative aspects of sound – to develop a new one.

Use and revise traditional story premises – here, the love triangle or *mènage á trois* is invoked in a different way.

Use observation and imagination – for example, the detailed nuances of human and animal action and the more performative and surreal aspects of the narrative.

Use oppositions and comparisons – in this case, black and white and colour; the old owner compared to the young chauffeur; romance versus reality.

Use known iconic imagery or visual symbols such as the use of colour and black and white; the owner's room and the cage as a prison; the countryside as 'freedom' etc.

Title: Morir de Amor
Animator: Gil Alkabetz

The parrots' colourful memories reflect their owner's troubled state of mind.

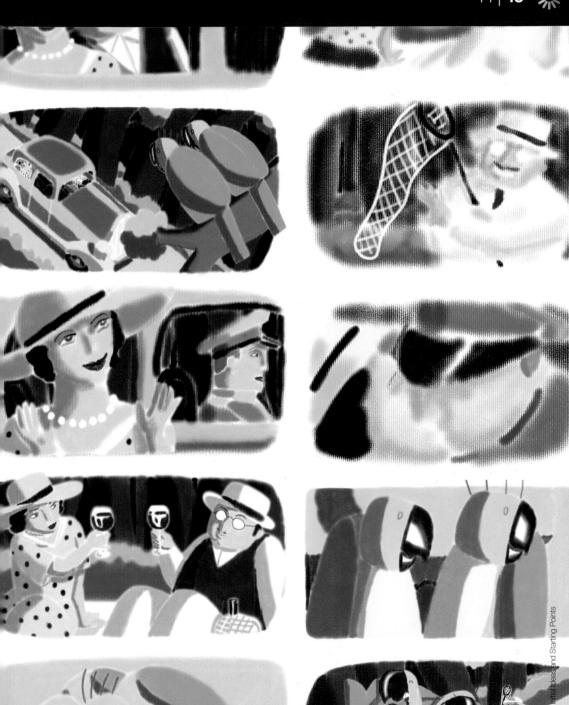

WHEN 'INNER LOGIC' FAILS…

Because animation can accommodate any idea or visual principle, it is sometimes hard to create a consistent 'inner logic'. Critics, for example, took the feature film *Barnyard* to task because cows with pronounced udders were gendered as male. On the one hand, animation has always allowed animated characters to embrace a flux of gender positions in any one narrative (see virtually any *Bugs Bunny* or *Tom and Jerry* cartoon), but on the other hand, if such a decision, made in the spirit of getting cheap 'udder' laughs, undermines the wider thematic or narrative principle, it is clearly inconsistent and not worth having.

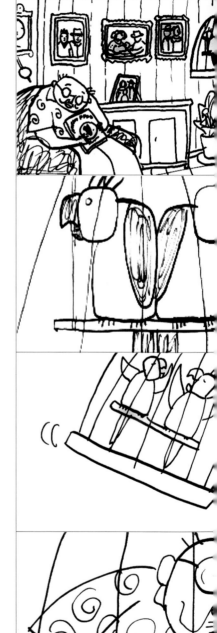

Title: Morir de Amor

Animator: Gil Alkabetz

The black-and-white 'prison' the old man and his caged parrots experience is vividly juxtaposed with the colourful memories of a romanticised summer day when the parrots were free and yet to be caught.

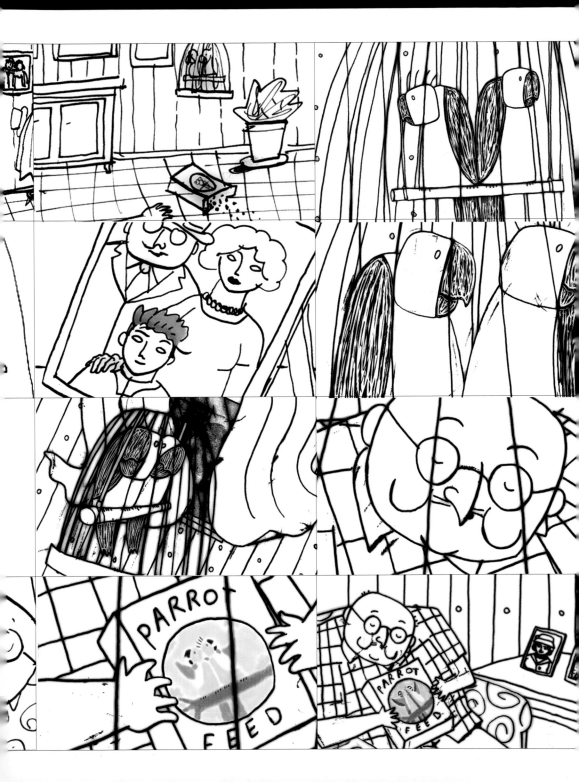

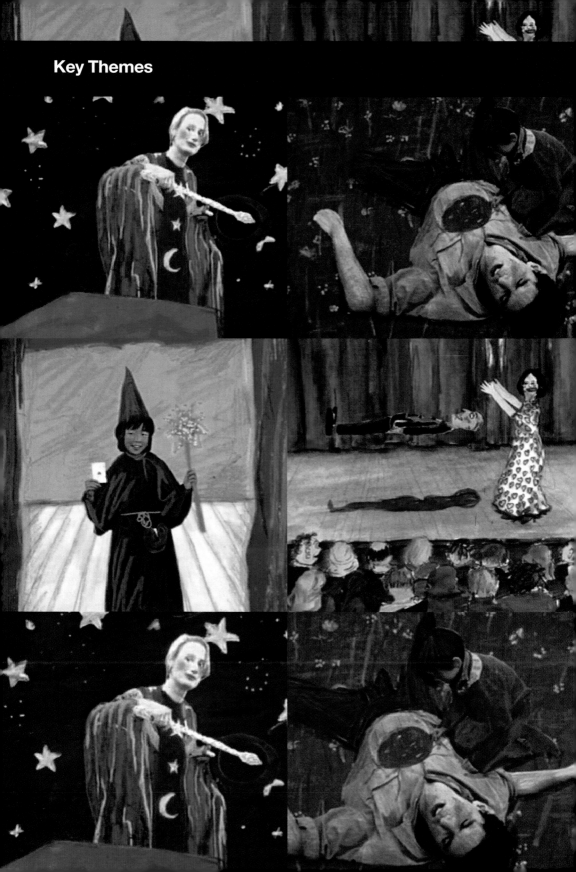

Key Themes

IN THE PREVIOUS SECTION, SOUND WAS USED AS A 'TAKE-OFF' POINT TO ADDRESS HOW ANIMATED NARRATIVES MIGHT BE DEVELOPED AND USED AS STIMULI TO GENERATE NEW MATERIAL.

No writer or deviser of an animated film draws ideas from out of the ether – there is always a place from which ideas can be prompted and thereafter developed.

This section takes this principle further and illustrates the possibilities of working through a key theme or core plot. Simultaneously, there will be further examples of material generated from various established sources.

ILLUSION IS ALL (1988)

The first example is the recording of children's responses to a key theme and using this as both the soundtrack for the film and the stimulus for the imagery. This technique is used in many animated films but most famously, in Nick Park's *Creature Comforts*. Here the writer's role is to solicit material by interviewing subjects and thereafter to select and edit material for the best anecdotes or points of discussion to stimulate visual interpretation. The script in this instance is about identifying the most engaging and entertaining views and opinions, which help to dramatise the animation, and most importantly, it reveals information or insight about a key theme.

Title: Illusion is All

Animator: Australian Children's Television Foundation

In exploring the core theme of illusion the film moves from the literal understanding of illusion as a magician's trick right through to the understanding of illusion as the essential suspension of disbelief in all viewers and readers when engaging with a narrative fiction. Crucially, unpacking the different meanings of a term might immediately offer a conceptual structure to an animated narrative, which can readily deploy 'metamorphosis' to show and illustrate changing ideas and perspectives.

In *Illusion is All*, the key theme was the concept of illusion and the writer's first imperative in using the 'key theme strategy' was to delineate how it would be used. In a more narrative-based story, illusion could have been a key theme in a tale about magicians, deception or the tensions between something imagined and actual reality. In this case, the children initially defined illusionism as something that magicians did.

Eventually, the children started to recognise that if illusionism was essentially a performance designed to amaze and amuse, then anyone might be capable of doing it.

Further, it became clear that if audiences were complicit in being deluded and distracted, they were willingly suspending their disbelief, temporarily abandoning their sense of reality in order to experience different kinds of pleasure and insight. Simultaneously, the viewer could experience fantasy and reality. The writer has moved the animation to the point where in enabling the children to express their own revelation about their investment in stories, they have made a universal point about the illusion of narrative. This self-reflexive strategy prompts additional material.

Any key theme could be chosen or revealed, but it is essential that the narrative structure:

Defines and delineates the core theme.

Illustrates the theme effectively through literal and more abstract interpretations.

Addresses its implication and effects.

Reveals its relevance to the target audience.

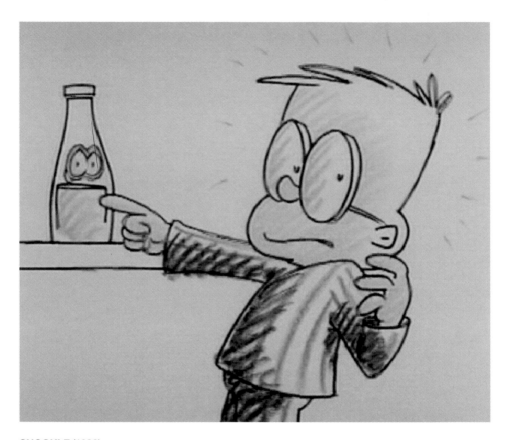

SNOOKLE (1988)

Snookle takes the established key theme of 'the genie in the bottle' and revises it for the children's audience. It should be noted that such a theme is especially pertinent to animated interpretation because it already includes aspects of metamorphosis and a range of potentially magical effects that might be easily achieved in animation.

A little boy finds the snookle in a milk bottle on his doorstep. The snookle – designed merely as a pair of free-floating eyes – has the ability to respond to its master's every thought, and in anticipating his master's action, carries it out before he does. Initially this seems very appealing to the little boy as he is both empowered and served.

All of the boy's wishes, implied instructions and intended actions are carried out by the snookle. Inevitably, the boy begins to weary of what is, in effect, his own powerlessness, as the snookle takes over his life.

Eventually, the snookle goes too far and insists upon picking the boy's nose; this becomes the moment when the boy realises that he must rid himself of the snookle in order to win back his autonomy and independence.

He tricks the snookle back into the milk bottle, and then leaves it on the doorstep of his next door neighbour where inevitably, the same things happen again. This is a simple story that sends a direct message about the need to willingly take responsibility for one's own actions. It may seem that there are attractive short cuts to the things humankind desires, but such opportunities rarely come without consequences. For the writer this is a key theme, which determines what the narrative must do if it is to properly reveal the intended message. The story must reflect this trajectory, and in doing so, it uses a traditional narrative model.

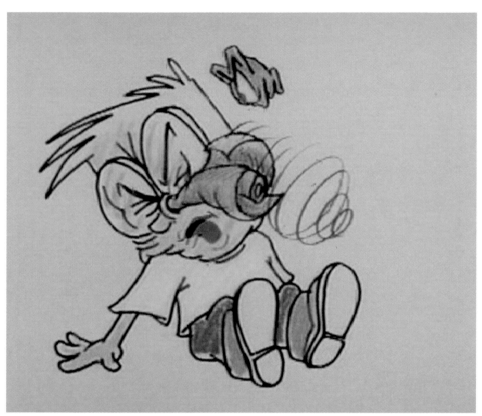

Title: Snookle

Animator: Australian Children's Television Foundation

Many children's narratives have one single central character with whom the audience is invited to empathise and share an adventure.

TRADITIONAL NARRATIVE MODEL

The normality of the situation is established at the beginning of the story, which features a little boy living in an ordinary street, next door to an old lady.

The story then provokes an inciting incident – in this case the recognition and acquisition of the snookle – as its provoking story premise.

The narrative develops and enhances its story premise by showing the powers and effects of the snookle; a conflict also arises when the boy no longer wants what the snookle brings to him.

The boy finds a resolution to the problem by re-capturing the snookle and placing the milk bottle on another doorstep.

The story can then move to its denouement or its climax. A denouement is normally an explanatory ending; a climax is an explosive conclusion.

THIS IS A STORY LADDER

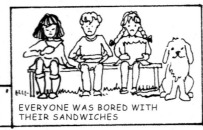

1 EVERYONE WAS BORED WITH THEIR SANDWICHES

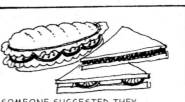

2 SOMEONE SUGGESTED THEY ALL SWAP AND EVERYONE AGREED

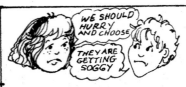

WE SHOULD HURRY AND CHOOSE

THEY ARE GETTING SOGGY

3 THEY TOOK SO LONG CHOOSING THAT THEY WISHED THEY HAD NOT STARTED

4 WALTER STOLE EVERYONE'S FAVOURITE SANDWICH. SO THE CHILDREN WERE STILL UNHAPPY

STORY LADDER AND STORY FRIEZE

The simple narrative structure underpins many narratives and sequences and is very useful as a story-building tool. The Australian Children's Television Foundation encourages this with the story development exercises shown: the four panel story ladder and the story frieze. Most structural elements such as this may be helpful in developing the core aspects of a main plot before adding subplots and more complex narrative embellishments.

Title: Trevor's Huge Adventure

Animator: Australian Children's Television Foundation

The films made by the Australian Children's Television Foundation are often accompanied by teaching materials. The story ladder and story frieze represent ways in which children might begin to develop narratives, normally by using the story structure of establishing a character and/or place, creating a problem for the character, developing the problem, and then seeking out resolution. *Trevor's Huge Adventure* demonstrates this and finds a witty resolution, which relates closely to the theme of the story – aspiration and ambition, and its possible consequences. This structure can vary, of course – the children's sandwich narrative continues to build its problems, but when such visual narrative building is allied to a revelation of a theme, it can prove an important teaching, learning and creative process.

STORY FRIEZE FOR TREVOR'S HUGE ADVENTURE

TREVOR STARTED TO CATCH PREY THAT WAS SMALL BUT AS TIME WENT BY...

HE CAUGHT LARGER AND LARGER PREY. IN HIS ATTEMPT TO CATCH A PLANE, HE ACCIDENTALLY LAUNCHED...

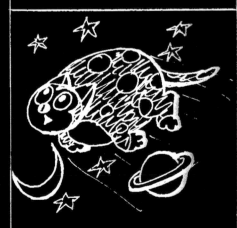

HIMSELF INTO ANOTHER GALAXY WHERE....

HE BECAME A SMALL PREY TO AN EXTRATERRESTRIAL HOUSE PET!

ANIMATED FILM SCRIPTS HAVE A GREAT DEAL IN COMMON WITH LIVE ACTION WORK AND USE MANY OF THE SAME APPROACHES THAT CHARACTERISE THE DEVELOPMENT OF LIVE ACTION SCREENPLAYS.

This section looks at some of the dynamics of traditional scriptwriting and applies them to animation. While the imagery must convey important narrative information and symbolic associations, it must always be rooted in a particular vision and outlook. For the writer, this is usually initially drawn from personal experience and the knowledge and interests that might duly inform a specific approach. When developing a traditional story, four major components must be considered:

When is the story set? Does its historical period and context influence the narrative?

How long is the story? Is it taking place over an hour or over thousands of years?

Where is the story set? Does the 'geographical' aspect of the story make a difference, and if so, how, and in what way?

Who is at the centre of the narrative and in what ways does this determine dramatisation and significant dramatic conflict?

These questions all serve to define the narrative world of the story, but more importantly its limits and parameters, so that the writer can generate the possible and plausible narrative events that emerge from the created world. As previously indicated this does not mean that the world has to be intrinsically realistic and respond to the normal characteristics of the everyday environment, but rather, the world created, however surreal or magical, must respond to its own clearly delineated logic. This is the enabling device in educating the audience about the potential of the world they are psychologically and emotionally investing in. It also determines how the writer can be creative in the narrative. For the most part, a story is only successful if the story

events – however fantastical they may be – emerge from the limited laws of the world the writer has defined. The writer can only be effective if there are particular decisions made about what is included and excluded from the created world.

DEEP STRUCTURES
These 'laws' can of course be affected by other factors and expectations, largely determined by common problems:

The codes and conventions associated with genre.
The established principles of core plots.
The seemingly open, potentially anarchic.
Vocabulary available in animation.

What exactly are the major plots that inform many stories, time and time again? Robert McKee has identified the following plots or 'deep structures':

Maturation
Coming of age/rites of passage story.

Redemption
Central protagonist moves from 'bad' to 'good' through moral re-alignment.

Punitive
The 'good' protagonist turns 'bad' and is punished.

Testing
Willpower vs. temptation/surrender stories.

Education
Deep change from negative concept of life to positive.

Disillusionment
Deep change of world view from positive to negative (McKee, 1999).

TWENTY MASTER PLOTS IN FILMS

Quest: *Wizard of Oz, Jason and the Argonauts, Star Wars.*

Adventure: James Bond films; *Indiana Jones; Wind in the Willows.*

Pursuit: *The Terminator; Alien;* Slasher movies; *Roadrunner* cartoons.

Rescue: *The Searchers; The Seven Samurai; Thunderbirds.*

Escape: *The Great Escape; Midnight Express; Midnight Run.*

Revenge: *Hamlet; Death Wish; The Sting; Fatal Attraction.*

Riddle: Hercule Poirot films; *Columbo; 2001: A Space Odyssey; D.O.A.*

Rivalry: *Prince of Egypt; Dead Ringers; Chariots of Fire.*

Underdog: *Cinderella; One Flew Over the Cuckoo's Nest*

Temptation: *Dr Faustus; Men Only; Take Me.*

Metamorphosis: *The Metamorphosis; Dracula; Wolfman.*

Transformation: *My Fair Lady; Dr Jekyll and Mr Hyde; Toy Story.*

Maturation: Disney features; *Great Expectations; Stand by Me.*

Love: Screwball comedies; *Betty Blue; Casablanca.*

Forbidden love: *Romeo and Juliet; The Hunchback of Notre Dame.*

Sacrifice: *Casablanca; Thelma and Louise.*

Discovery: *Where There's Smoke; The Man in the White Suit.*

Wretched excess: *Trainspotting; Othello; Apocalypse Now.*

Ascension: *The Elephant Man; Rocky; The Full Monty.*

Descension: *Raging Bull; Se7en; Citizen Kane; Planet of the Apes (Tobias, 1995).*

Ronald Tobias, though, suggests that there are twenty 'master' plots (see table). While these plots inevitably overlap and are even open to some debate, they are pertinent in identifying recognisable story trajectories that are helpful to the writer when starting to develop a plot. Both for the writer and the audience, elements of the narrative will be immediately recognisable and anticipated – the writer, though, must develop the key skill of presenting afresh a story where the audience gets the emotional, physical and intellectual fulfilment it wants, but not fully in the way it expects.

Title: 25 Ways to Quit Smoking

Animator: Bill Plympton

This image shows one of the alternative and unorthodox methods used to help smokers quit in Bill Plympton's film.

SCRIPTWRITING Core Plots

Core Plots

SILENCE IS GOLDEN (2006)

The following advice on core plots is from leading British Animator, Chris Shepherd, who used both live action and animation in his films *Dad's Dead* (2002) and *Silence is Golden* (2006):

'Try and make sure that you know what the story is about, and perhaps, more importantly, whose story it is. In *Silence is Golden* it was really the little boy's story, but as I was writing, developing and shooting it, it had quite a lot about his mother, and the back story of his seemingly mad next door neighbour. If you get too distracted by the other stories, and you put too much in, things can get confusing, and the audience doesn't know who they are supposed to feel for, or identify with.

'A good story will constantly give you clues about what might happen next, posing questions or concerns for the viewer and leaving traces to pick up on until things are resolved at the end. Place clues through your story and they are the hooks that keep people interested.

'If you are true to what you know, what you've experienced and observed, and what you want to express, then that 'truth' will come out in the work, even if the story you want to tell might seem a bit far-fetched or unusual. Normally truth is stranger than fiction anyway, and if you can capture that then people will recognise it. Audiences don't have to like your characters to find them interesting so long as they can see the truth.

'Another thing I would say about devising and developing material is to take into account the collective input of those you are working with. In *Silence is Golden*, I auditioned the little boy who finally played the part, but the way I wrote it did not suit his London accent and delivery, so I went away and wrote it again for him because he was right for the role. Also, the actors improvised and did additional takes to demonstrate their ideas – some of which I used and some I rejected in order to 'keep on script'. In the editing suite, my editor made important observations and really improved the script as it was written by fully realising the order and impact of certain lines and incidents.

'Sometimes when you write, it looks OK on paper, but when you are actually working on it you have to make sure that whatever happens, and whatever is said, is what the scene actually needs.

This might mean that what was written disappears altogether, gets shortened, lengthened, or just changes in some way. Sometimes it even stays the same! The script is a blueprint, a guideline, a reference point – it can change. But give yourself a good starting point. A good script should ultimately – even with the changes – make a good film. Try to have a point of view and show that through the characters and scenes, and hopefully that will create an original story.'

While Shepherd effectively uses the core principles of building a narrative, he effectively makes his plots original by using the particular nuances, oddities and obsessions of his characters to delineate narrative; he employs animation to depict acts of memory, imagination, and perception. His multimedia style means he can also use a range of animation techniques from 3D stop-motion, computer generated animation and traditional drawn material.

Title: Silence is Golden

Animator: Chris Shepherd

Shepherd animates the sketch book of the young boy at the heart of his narrative, literally playing out the boy's more brutal and imaginative construction of 'Mad Dennis'. By using different kinds of animation techniques, Shepherd can dramatise each situation, which may initially seem fixed and literal, and reveal its subtext or point of interest.

Title: Silence is Golden

Animator: Chris Shepherd

Shepherd demonstrates the consequences of 'hell fire' as church ministers visit Dennis, a lonely and disturbed man. Here both the metaphysical and metaphorical in the script are surreally enacted with special effects.

BRAIN

Pain

A Dan
Brain
You a
Reta

Den

dinner
stains

shirt
hangs out

Spastic
Elastic
Twatstic

kr
H

Core Plots

TANGO NERO (2006)

Delphine Renard's *Tango Nero* (2006) is an independent short that uses live action sequences as the underpinning template for a highly painterly style of rotoscoped animation.

Renard cleverly uses elements from a range of core plots to create an enigmatic love story. The backbone of the story is essentially a pursuit narrative in which aggrieved members of the Mob pursue a man who owes them a gambling debt. He agrees to pay it off by stealing a precious jewel from St Mark's Basilica in Venice. The man's attempted crime is witnessed, however, by a young female tourist. When the girl is discovered, she scuffles with the assailant and swallows the precious stone. Although she attempts to escape the man's attentions, he kidnaps her in the hope that he can ultimately recover the gem.

Suspense is created by how the story might be resolved, but employs aspects of rivalry and forbidden love as the man and woman conduct their 'star-crossed' romance. The narrative resists any notion of discovery, leaving the couple's fates unresolved. Crucially, this kind of incident- or event-led narrative is highly suitable to the animated short form – it is the concentration on the narrative and aesthetic details that constitute the story. The chance encounter between the man and the woman is the inciting incident to an atmospheric *noir*-like plot, in which the engagement with the audience is effectively about the suggestion of underlying intrigue, threat and passion.

Like many animated films it is the intensity of suggestion in the visual minutiae – the styling, the design, the representation of emotion and psychological states – which is at the core of the 'plot', sometimes only hinting at the major structures cited previously, but using them as a reference point by which animation signals its departure from established conventions and generic norms. This is particularly interesting for the writer to address in relation to genre, the next aspect of the discussion.

Title: Tango Nero
Animator: Delphine Renard

Renard's painterly technique required that live action become 'blue-screened' and composited with new backgrounds, with effects such as smoking added later. The smoke becomes a dragon, moving the image from the literal to the symbolic.

Title: Captain Scarlet

Animator: Indestructible Productions

ANIMATION IS OFTEN CONSIDERED A GENRE. HOWEVER, IT IS NOT A GENRE – IT IS A FORM. IF IT IS UNDERSTOOD AS A GENRE IT IS MISTAKENLY REPRESENTED AS PURELY CHILDREN'S ENTERTAINMENT. FROM THE OUTSET OF ANIMATION'S DEVELOPMENT THIS HAS REMAINED AN ISSUE FOR ANIMATORS AND WRITERS. ANIMATION CERTAINLY ACCOUNTS FOR EXCELLENT CHILDREN'S PROGRAMMES, BUT IT IS ALSO CAPABLE OF MUCH MORE. ANIMATION HAS ALWAYS HAD TO FIGHT TO BE RECOGNISED AS A FORM. AS A RESULT, WRITERS NEED TO BE AS RESPONSIVE TO THIS ISSUE AS TO THEIR CREATIVE EFFORTS.

THIS SECTION LOOKS AT ANIMATION AS A MODE OF EXPRESSION. IT MAKES REFERENCE TO HOW ANIMATION DRAWS UPON ESTABLISHED GENRES AND HOW IT IS DEFINED BY ITS OWN GENRES, WHICH IN TURN RELATE TO THE SPECIFIC CONDITIONS OF ANIMATION AS A LANGUAGE.

PHIL PARKER SUGGESTS THAT WRITERS MUST TAKE INTO ACCOUNT WHAT HE CALLS A 'CREATIVE MATRIX' (PARKER, 1999). AT ANY ONE TIME, THE WRITER MUST ADDRESS THE LINKS BETWEEN GENRE, FORM, STORY, STYLE, PLOT AND THEME.

This is a highly pertinent delineation of the writer's mutually pressing agendas, but in many ways, working in animation requires that the writer must be aware of a number of key determining factors, which will inevitably affect the ways in which writing or devising material is carried out. While arguably live action is moving closer and closer to a variant of animation with its reliance on animated special effects and post-production interventions, it still differs in being largely determined by the needs of classical cinema. These needs are based on narratives that are predicated on the actions of key protagonists as they encounter obstacles and problems in the negotiations of their goals; usually within a story framework informed by a logical and linear cause and effect; operating nominally within the 'material' world; and normally, despite variations on dramatic conflict, resulting in the resolution of their issues and attaining their desires at the end.

ANIMATION MATRIX VS. CREATIVE MATRIX

In animation, visualisation is essentially a design-led concept and operates as an expression of thought, feeling and emotion in its own right. Rather than being led by the Creative Matrix suggested by Parker, animation writing is actually defined by determining the relationships between technique; material and technological needs; method and process; and core theme/idea as they combine and relate to service the visualisation

process. In many ways, Parker's Creative Matrix only becomes a possible subset of 'method and process'. The relationship between these aspects is expressed in the Animation Matrix (see box out).

These relationships are best revealed by example. If a live action film-maker essentially knows that it is necessary to record 'actuality' (on location or set) with the camera, the animation writer knows that everything required to make the film is of a profilmic nature, and that every aspect of the film is intrinsically artificial and illusory. Some significant decisions have to be made, therefore, which serve this approach. The choice of a technique will inevitably suggest the material and technological needs of the film, which in turn prompts the method and process by which to facilitate the core theme or idea. All this simultaneously feeds into the visualisation of the work in preliminary sketches, narrative drawings, designs, storyboards, provisional animatics etc., particular to the intended outcome.

As the table on page 64 shows, 'script and/or visualisation materials' are common to all approaches. The term 'script' is used to effectively mean a traditional script that shares a great deal with its live action counterpart. There are always variations, but the crucial point for the animation writer is that an acute awareness of how stories, ideas and aesthetic principles are

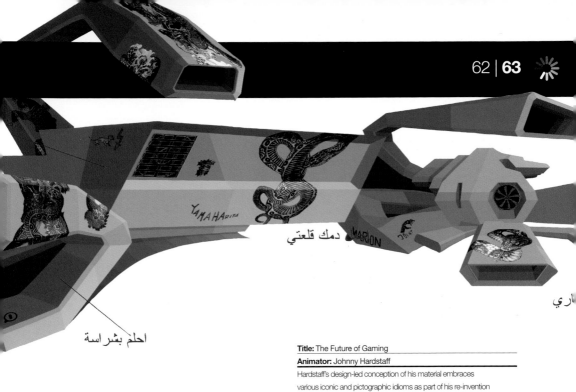

احلم بشراسة

دمك قلعتي

Title: The Future of Gaming

Animator: Johnny Hardstaff

Hardstaff's design-led conception of his material embraces
various iconic and pictographic idioms as part of his re-invention
of contemporary technologies, making his 'machine' at once
familiar and strange.

PHIL PARKER'S CREATIVE MATRIX

THE ANIMATION MATRIX

The Animation Matrix

ELEMENTS OF THE ANIMATION MATRIX

TECHNIQUE	MATERIAL AND TECHNOLOGICAL NEEDS	METHOD/ PROCESS	CORE THEME/IDEA (Examples)
Computer generated animation	Computer; chosen software; digital 'cinematography'	Script and/or visualisation materials; creation of computer environments, characters, effects etc. to digitally manipulate	In the early development of CGI, geometric, glossy, 'plastic' forms were easier to create than humans, so the technique best facilitated narratives that featured these aspects e.g. *Toy Story*
3D stop-motion animation	3D sets; puppets or clay models; physical effects materials; flexible camera set up	Script and/or visualisation materials; creation of sets, puppets, objects, artefacts, forms to physically manipulate	Creating specific 'worlds' is central to the animated form; for surreal, dreamlike, yet physical and material worlds, 3D stop-motion is the core 'fabrication' method e.g. *Alice*
Drawn animation	Paper; pencils; drawing board; light box; rostrum camera	Script and/or visualisation materials; greater use of development materials in the final execution of motion and layout	Drawing still plays a role in most animated films; anything that can be imagined can be drawn and made to move e.g. *Spirited Away*
Alternative or experimental animation	Any materials; a method of recording	Script and/or visualisation materials; greater possibility of directly recorded improvised material and/or focus on form, colour, shape etc. for its aesthetic outcomes	This method often foregrounds the working process of the artist, uses fine art principles, and is more non-objective, non-linear and abstract in form e.g. *The Cabinet of Jan Svankmajer*

communicated through purely visual means is as important, if not more so, than description and dialogue. It requires a broad understanding of the wide range of narrative strategies that can underpin an approach to visualisation, and chief among these is genre.

CODES AND CONVENTIONS

Genre may be viewed simply as a set of typical codes and conventions – and thus expectations – that characterise a particular narrative structure. These traits and tropes have evolved through the telling of such stories, and find themselves repeated, freshened, modified and sustained as a genre evolves. Clearly, genres overlap and mix freely in many narratives, but the dominant generic characteristics survive. Arthur Asa Berger suggests the following conventions in popular culture genres (Berger, 1997) (see table below). These conventions inevitably provide a visual coding to a piece and are useful short cuts in establishing a particular milieu. Equally, they suggest story scenarios, and the task for the writer becomes how to use generic expectation to surprising yet satisfying ends. Animation writers use traditional notions of genre (Wells, 2002), either using the conventions to express contemporary ideas and themes, or often through parody, playing on the audience's knowledge of the conventions for comic effects. Animation, though, has some particular qualities that influence the writer's possible approach. Simply, in creating an animated film, the writer, animator or director foregrounds an awareness of, and a method in which, generic codes will be used and adapted.

GENERIC CODES AND CONVENTIONS IN ANIMATED FILMS

ELEMENT	WESTERN	DETECTIVE	SPY	SCI-FI
Time	1800s	Present	Present	Future
Place	American West	City	World	Space
Hero	Cowboy	Detective	Agent	Spaceman
Heroine	Schoolmarm	Damsel	Spy	Spacegirl
Villains	Outlaws	Killers	Moles	Aliens
Plot	Restore law and order	Find killer	Find mole	Repel aliens
Theme	Justice	Discovery of killer	Save free world	Save world
Costume	Cowboy hat	Raincoat	Suit	Space clothes
Locomotion	Horse	Beat-up car	Sports car	Spaceship
Weapon	Six-gun	Pistol and fists	Pistol with silencer	Ray gun

SCRIPTWRITING The Animation Matrix

PHIL MITCHELL, IAN PEARSON, GAVIN BLAIR, AND THE LATE JOHN GRACE, CREATED *REBOOT* IN THE EARLY 1990s, DEBUTING THE SERIES IN 1993 AS THE FIRST FULLY COMPUTER-GENERATED CHILDREN'S TV NARRATIVE.

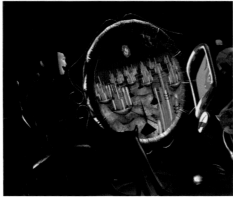

Title: ReBoot

Animator: Mainframe

ReBoot uses the computer environment as the context for its stories, while also using the computer to create it.

REBOOT (1993 ONWARDS)

Mitchell remained one of the lead writers on the series for a considerable period, developing the quasi-science fictional world of Mainframe in which Bob, Enzo, and their friend, Dot Matrix, battle with two viruses, Megabyte and Hexadecimal.

The computer environment was used as the context for the story. As the series unfolded, more heroes and villains have been added to the main cast, and narratives have embraced a whole range of plot possibilities. Mitchell and his colleagues have skilfully combined these elements, reaching out to a crossover audience with knowing adult references and playful engagement with generic possibilities – an aspect that is common to virtually all animation. Animated films and television programmes are usually made by adults and, even when they are made for children, there is inevitably an adult element to the stories, or at the very least a degree of contradiction, ambiguity or ambivalence, which allows adults to enjoy the material on a different level. Mitchell has sought to exploit this in his writing, and in the script extracts, it is possible to identify how he has used genre, plot development strategies and shared cultural knowledge as useful writing tools.

REBOOT – 'NULLZILLA'

The title 'Nullzilla' signals the use of a Godzilla-like creature made up of computer nulls. In this episode Mitchell foregrounds his use of genre by referencing the horror film *Bride of Frankenstein*. There follows a lovely revised version of the creation of Frankenstein, but Mitchell and his writing colleagues are careful to properly integrate the expectations of the film with the world of Mainframe – this involves looking for puns that resonate both in relation to the computer and the genre or plot parodied.

REBOOT – 'ANDRAIA'

In this episode, Mitchell and his co-writers, Ian Pearson and Susan Turner, use an aspect of the narrative to achieve two things: exposition and foreshadowing. Bob's lecture serves to work as a vehicle by which to define the rules of conduct in relation to the presence of games within the mainframe of the computer. This is effectively an exposition of the narrative possibilities when the game becomes part of a potential story, and a foreshadowing of the introduction of the 'AndrAla' character, as well as the dramatic conflicts that are later to take place as the main characters take on a game player – the user.

The episode concludes with an extended action sequence in which Bob, Dot, Enzo and AndrAla battle the game player – such a sequence requires effective action descriptors, which allow for the clear visualisation of the nature of the story events.

```
"Nullzilla" (9508) 10/11/95 Pink Pages 2.

Mike and Skuzzy jump. Mike hardly missing a beat.

        MIKE THE TV
    Coming soon to a vid-window near you. A
    Dino de Horrendous production of the
    classic, 'Bride of Frankenome' You'll
    CHILL at the good doctor's performance.
On Mike's screen a Binome made up as Dr Frankenome rants in
front of a binome One made up as Frankenome's monster, which is
lying on a table. The word CHILL in 3D lettering is super-
imposed.

        FRANKENOME
        (losing it)
    Throw the switch, Bye-Gor!
Dr Frankenome catches a switch thrown to him.

        FRANKENOME
    Thanks!
He flips the switch and the monster suddenly comes to life,
waving arms about.

        FRANKENOME
    It's compiled, it's compiled, ha ha ha
    ha!
        MIKE THE TV
    You'll THRILL at the love interest!
The word THRILL in 3D lettering is super-imposed. A 'Bride'
monster hisses cat like at Frankenome's monster.

        BRIDE
Hiiiiiissssssssss.
        MIKE THE TV
And the spills…
The word SPILL in 3D lettering is super-imposed. Dr Frankenome
drops a jar containing a brain.

        FRANKENOME
Oooops!
ON HEX
        HEXADECIMAL
(very angry)
I've seen this before!!!
```

```
"AndrAIa" (9509) As Air Script 10.

        BOB (cont'd)
    or hide. If you do get trapped in a
    Game, help or stay out of the way. Leave
    it to the professionals. Finally, rule
    number three — Defeat the User. Either
    by destroying it or winning the Game.
    Now any questions?

Bob looks around the room.

        BOB
    Yes. You there — with the hat.

        SPATS
    Yes, is it always a good idea to ReBoot?

        BOB
    ReBooting usually provides equipment and
    knowledge that help you in a Game, but
    not always. Remember the story I told
    you about Enzo rebooting as a damsel.

        CROWD
    (laughter)

        BOB
    Any other questions?

Bob look around the room, taking at a young female binome,
who has I (heart) you on her eyelid.

        BOB
    (embarrassed cough)
    Heh hem.

        NUMBER 7
    How many types of Game sprites are there?

Bob uses a slide show of various Game sprites to illustrate
the following speech:

        BOB
    There are five subsets. Aggressives,
    defensives passives, chaotics and a
    recent addition, Artificial Intelligents.
    Aggressives, only attack the User.

        BOB
    (voice-over)
    Defensives try to block or delay anything
    that comes their way. Chaotics are the
    most dangerous, they try to destroy
    anything that moves, User or Mainframer
    alike. Passives tend to help by
    (MORE)
```

FAST FILM (2003)

In *Fast Film* Virgil Widrich uses genre in a 'revisionist' way, using animation to interrogate the deeper structures of plot or storytelling techniques within Hollywood's classical narratives. The film is composed of 65,000 photocopied stills from over 400 notable Hollywood feature films from the silent era to the present day. Widrich and his team viewed over 1200 films selecting images and sequences, which in their photocopied form were folded into three-dimensional objects, and then re-composed and animated into a narrative about the codes and conventions of genre films.

The plot is as follows: a woman is abducted; a man seeks to find and save her; the man confronts a villainous enemy who seeks to thwart him in a series of spectacular chases. From the writer's perspective it is the recognition of this basic narrative and the number of times it is repeated and revised in film that becomes the self-conscious subject matter of this animation. As a result of working with already existing images, the writer's job here is to establish continuities in the visual dynamics of the piece in order to use the images afresh and allude to classical narrative. It therefore operates as a clear model of condensation in which the maximum degree of suggestion about the clichés and stereotypes of Hollywood films is presented in the minimum of allusive images.

The storyboard in effect becomes a combination of suggestive narrative images drawn directly from the original movies and partly constructed images (folded or cut-out) alluding to the technique involved, and the revised version of the images in the new story.

Widrich and his team carefully delineated the formulaic aspects of different kinds of action sequences: for example, a train chase is broken down into getting on a train, getting under a train, and splitting a train. By cross-cutting newly configured elements from films such as *Sherlock Jnr (1927); The General (1927); The Lady Vanishes*

s028_c080	s028_c085	s028_c090	s028_c100	s028_c110
s028_c120	s028_c130	s029_c010	s029_c020	s029_c030
s029_c040	s029_c050	s029_c070	s029_c080	s029_c090
s029_c095	s029_c100	s030_c010	s030_c020	s030_c030

(1938); The Train (1964); Butch Cassidy and the Sundance Kid (1969); Runaway Train (1985); To Live and Die in LA (1985) and Broken Arrow (1996), the construction of narrative events and emotive visual cues could be readily revealed yet re-worked. By breaking down sequences in this way, the film demonstrates the core principles and units of action in any one story event and these are invaluable to the writer when constructing descriptors in scripts. Directors often construct such sequences, but the writer can give very clear indicators of the way dramatic action should unfold. Widrich used animation to foreground these structural elements as his dramatic action and the subject of his film.

The film can be read as an implicit history of Hollywood and cleverly shows the formulaic aspects of the hero's journey (the key narrative in most story constructions) and the way it is informed by variations on spectacular action: the role of the heroine as a passive subject; the clichéd aspirations of the villain or monster in their

alternative underground worlds; the sense of resolution played out through chases and conflicts; and principally, the romantic kiss and embrace shared by the hero and heroine. These conventions are highlighted, but ultimately revised through animation – their limited resonance and meaning are exposed and playfully critiqued. The self-figurative and self-reflexive nature of the piece invites the viewer to see the transparency yet basic appeal of live action narrative formula, while acknowledging the self-conscious art, technique and intensity of suggestion in the animated form.

Title: Fast Film Story Board
Animator: Virgil Widrich

In a re-invention of the conventional storyboard, Widrich uses a mixture of key frames from the Hollywood narratives he has chosen, and collaged images that signal the ways in which frames will be ultimately be composited and re-animated.

s030_c040 s030_c050 s030_c060 s030_c070 s030_c080

s030_c090 s030_c100 s031_c010 s031_c020 s031_c030

s032_c010 s032_c020 s032_c030 s032_c035 s032_c040

s032_c060 s032_c070 s032_c080 s032_c090 s032_c100

SCRIPTWRITING Considering Genre

OVER AND BEYOND ITS ENGAGEMENT WITH ESTABLISHED GENRES AND SUB-GENRES, ANIMATION HAS ITS OWN 'DEEP STRUCTURES'.

The following examples reveal how the writer is defined through them and how they may be self-consciously used to prompt a particular approach. A mixture of historical and contemporary examples are combined here to suggest models of best practice and to note how some approaches have evolved through key moments in animation and cultural history. There are seven deep structures characteristic to animation.

The formal structure is the precise delineation of limited rules as the boundaries of a specific world or the particular condition by which the animation can be executed (i.e. a preconceived set of conventions).

This can be adopted in every narrative or an already structured piece such as a song, poem or piece of music, which the animation must specifically interpret or illustrate.

The writer in this case would either create a set of parameters or conditions that define the specific story, write a poem or song pertinent to the piece, or write the descriptors for the visualisation of such a piece. Writers must always bear in mind the relation and relevance of their material to the intended audience.

CREATURE COMFORTS (2004 ONWARDS)

Aardman's *Creature Comforts* series, based on Nick Park's original Oscar-winning short, has two highly specific formal conventions. First, its soundtrack is based on the freely solicited responses of the general public to stated topics, which constitute the theme of each episode. Second, an animal character is dedicated to a section of the soundtrack and is placed within a particular environment, as if it were being interviewed for a documentary.

The inventiveness of the work lies in the gathering and selection of materials used; the level of detail in the animals' gestural performances; and the visual gags played out in the background as the characters speak. This minimalist format poses major challenges to the writers and creators. Producer Gareth Owen lists the core considerations of the pre-production process:

Which characters/situations would be interesting from a human aspect and from an animal perspective?

Gags (sight gags, verbal gags, slapstick, silent gags, black comedy, suspense gags, repetition gags, surprise gags, funny gags, events happening separately and coming-together gags, derailing gags, innuendo gags, understatement gags, ironic gags).

Working out potential answers then working out the questions.

New animal characters.

Repeat characters – which regulars could be involved? How can the episode-specific characters stretch across other areas?

Types of interviewees – age range, voice textures, job types.

Potential subject/story arcs.

Title: Creature Comforts

Animator: Aardman Animation

Creature Comforts features animal characters matched to real voices drawn from the British public. This presents animated animals in a new way and highlights Aardman's signature style performances featuring minimal gestures and glances.

Jersey Cow. — Bath & N

'Time was spent writing interview questions around the themes and trying to cover as many aspects of a theme as much as possible. The aim for the series was to:

Increase extremes – highs and lows of enthusiasm.

Get more audio diversity – more ethnic, age and voice texture diversity.

Get more regular characters that spread across more episodes.

Provide more one-off gags.

Have more background action.

Branch out more from talking heads.

'We found that interviewing people *in situ* – either doing their jobs or hobbies, or catching people unawares on the street – got us some great material. The interviewees generally forgot they were being recorded and were completely relaxed. It also meant that they were talking about something they felt passionately about.

'We told our interviewers to leave a lot of gaps before jumping in with their next question – an uncomfortable silence would more often than not be filled in with the ramblings of the interviewee and produced some of the best material we got. In fact we found that the onus of getting good material quite often lay with having a good interview technique.

'To this end, we tried out about 20 interviewers and asked them to go out and interview ten different types of people, preferably with local accents and to include a couple, a child, a brother and sister, a mother and daughter etc. to get a range of characters from their area. The first interviews covered a broad range of topics within 45 minutes. This served the dual purpose of finding good characters and good interviewers.

'We then had the interviews transcribed and digitised into our edit system. We had a team of writers who

trawled through the interviews, listening out for choice material, looking for potential new characters and scenarios. These selections would be fed on to an edit timeline.'

Owen's remarks are helpful in identifying the writerly traits and skills required as a creator and deviser, and further, the material available to a writer at a more advanced stage of the production. Material has to be developed and in this example the core skills of soliciting material from the public required pre-planning and inventive approaches when interviewing. This documentary styling requires a more journalistic acumen and a capacity for conversational questioning to stimulate natural rather than contrived responses. At the same time, the interviewer needs to keep in mind the overall themes and strategy for the programme to help direct aspects of the possible answers. Selecting the right kinds of people is important here not only in a spirit of representational variousness, but also for the range and dynamics of voices required for the soundtrack.

Title: Creature Comforts

Animator: Aardman Animation

Here are some images revealing some of the backstage preparations for the *Creature Comforts* series at Aardman. Original sketches and storyboards are converted into 3D puppets and models, and choreographed within appropriate 3D contexts and environments.

These issues become equally important for the writer once the material has been gathered and editorial choices have to be made with regard to the general theme, the story arc and super objective of each episode, and the balance of joke types in relation to the process of visualisation. Within the formal conventions of the programme, there remains the prerogative to create as much variation as possible without losing the overall 'feel' of the piece. The writer needs to be especially sensitive to this last point, because the choices that are made to speak to an implied story still need to reflect the peculiar nuances and tendencies of British culture, which Aardman Animation are so attuned to in all their work.

ANY ANIMATION THAT SPECIFICALLY REVEALS THE PREMISES AND PURPOSES OF ITS OWN UNIQUE CONSTRUCTION FOR CRITICAL AND COMIC OUTCOMES FALLS INTO THE DECONSTRUCTIVE CATEGORY OF ANIMATED DEEP STRUCTURES.

YOLK

In some senses this is common to all animation, but in this particular case pieces that deliberately foreground the presence of the animator, the process by which animation is made, and the self-conscious 'call and response' between animated characters and their creator will be explored.

The writer in this case would need to demonstrate an intrinsic understanding of the methods, processes and history of animation, but equally, would need to create a scenario in which these aspects are pertinently used. Particular recognition would need to be paid to the implied relationship between the characters, the animator and the audience.

WHO I AM AND WHAT I WANT (2005)
Who I am and What I Want, a film by Chris Shepherd and David Shrigley, based on Shrigley's graphic narrative, is a good example of an adaptation from an already established visual source, and a complex example of deconstructive animation. While the most obvious examples of deconstruction in animation are foregrounded in the cartoon itself as playing directly with the conventions of the cartoon, this kind of work essentially deconstructs different modes of representational drawing, and self-consciously reveals and enhances them in animation. This is a highly instructive case of how one form – subversive, satirical, sometimes political cartooning – becomes another: an animated film. The process from Shrigley's original work to the creation of a very amusing yet dark and absurdist animation has a number of aspects, which are very useful for the animation writer to take into account.

The original book is divided into three sections: 'Who I Am', 'What I Want' and 'The Modern Mind'. Though the book features the character Pete in Shrigley's signature style, it was Shepherd who recognised that significant attention to a specific story would be required to accommodate what are effectively a range of singular observations of Pete's experience and perspective.

At first, all the images from Shrigley's book were scanned and ordered, but it soon became apparent that many would be discarded and emphasis would be placed on the first two sections. Shrigley's individual drawings suggest a range of interpretive possibilities in their own right, and service a 'narrative' that the reader might imagine, but Shepherd imposes a beginning, middle and an end – a three-act structure, which characterises most successful film narratives, whether in the short or long form.

Title: Who I Am and What I Want
Animator: Chris Shepherd

David Shrigley's subversive cartoons are adapted and re-contextualised by Chris Shepherd's sense of animated storytelling, drawing Shrigley's sight gags into a coherent narrative.

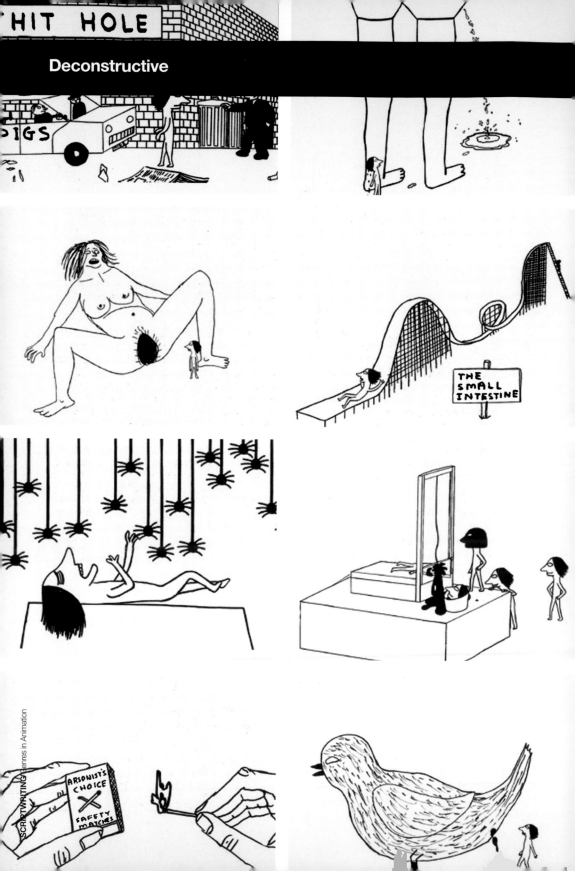

Shrigley and Shepherd exchanged ideas, sketches and opinions. The duo initially responded to Shepherd's observation that each drawing represented 'a moment', either pregnant with what could happen or concluding something that had happened. It was crucial to create story events where things were happening, and any implied action was made literal and extended. In effect, Shepherd moved the imagery from merely being stand-alone gags or observations, into something that approximated a storyboard.

In consequence, the images are not only functioning for their content, but for the ways in which they inspire dramatisation. This is related to both what is present and absent in the image and prompts questions about what should be retained and added to a potential story. Shepherd suggested, for example, that Pete should have a home in the woods, which reflects his opening monologue in the book: 'My name is mushroom; my name is toadstool; my name is spore; my name is fungus; my name is mildew; my name is bog, fen, marsh and swamp; my name is truffle; my name is bacteria; my name is yoghurt. But you can call me Pete.' Further, placing Pete in the woods configures him as a primal force of nature, almost part-animal, part-human, but either way placed outside 'civilisation' and the established social order.

The images in the film provide clues to Pete's background and define him as a distinctive character – an alternative kind of hero who for better or worse is his own man, happy to live outside the stifling codes and conventions of civilised culture. This distinction is ably facilitated by Kevin Eldon's vocal performance as Pete,

which is formal, polite and singularly untheatrical, thus making the incongruity between Pete's 'realistic' observations and his 'imaginary' desires that much more stark, and consequently, much more amusing and shocking.

Presenting the character within a more formalised story structure while retaining the immediacy of a string of visual gags, and using the character to tell his own story makes the piece more subjective and coherent. The film is a tour de force stream of consciousness where anything goes, and the animation can fully facilitate the interpretation of the character's projected desires.

Anything that can be imagined can be animated, and as Pete almost free-associates from one desire to another, it is not merely the form that can accommodate this, but the construction of the character. His appealing dysfunctionality operates on two levels: as anti-social and threatening, and as outlandish and amusing. The character treads a fine line between the orthodoxies of the real world we can in some way relate to, and a madness that either becomes appealing through its playing-out of repressed desires, or challenging because it is genuinely lawless. This black humour clearly defines a take on the world grounded in 'absurdism' – effectively, the only way to deal with life's chaotic and complex agenda is to laugh at it.

Title: Who I Am and What I Want

Animator: Chris Shepherd

Images in the film provide clues to the main character's background and defines him as an alternative kind of hero.

IN OFTEN OPERATING AS A VEHICLE FOR INDIVIDUAL EXPRESSION, ANIMATED FILMS PROVIDE THE CONDITIONS FOR STATEMENTS AND VISIONS, WHICH MAY BE READ AS POLITICAL IN THE PERSONAL AND MORAL SENSE, OR POLITICAL IN THE IDEOLOGICAL OR ETHICAL SENSE.

This can range from propaganda to public information films, educational tracts to social comment, and may be seen as a core aspect of aesthetic and narrative choices in a high proportion of animated films.

Using the political structure, the writer would need to have a strong understanding of political, ethical and moral debates, and a range of strategies by which to write effectively on behalf of certain points of view. The writer must present ideas in a balanced way from equally valid perspectives. It is often argued that propaganda is comparatively easy to write when directed against a perceived enemy, while public relations is at its most effective when having to find a positive spin to a potentially negative situation. This kind of political writing is essentially about communicating ideas effectively from the perspective of those seeking to express them, with a view to persuading an audience to believe and embrace these ideas.

HALAS & BATCHELOR CARTOONS

Most of the examples in this book are based on contemporary approaches to making animated films, but it is also possible to look back for very specific examples of exemplary writing technique. Indeed, the writer should always watch all kinds of animated films to observe how films are made, how ideas and themes are conceived, and how writers contribute to the process. In 1940 John Halas and Joy Batchelor formed

Title: Animal Farm

Animator: Halas & Batchelor Cartoons

Animal Farm is the first full-length British animated feature, and functions as a persuasive adaptation of Orwell's fable about the Russian Revolution; an apt story conducive to American Cold War propaganda in the mid-1950s; or a story about utopian triumph or perpetual revolution.

Halas & Batchelor Cartoons (Halas and Wells, 2006), which became the most enduring and influential British animation studio for the next 55 years. The studio is perhaps best remembered for the first full-length British animated feature, *Animal Farm* (1954), and distinctive wartime propaganda and post-war reconstruction public information films.

The studio's work was absolutely fundamental to the success of the Ministry of Information's propaganda output during the Second World War, and most particularly the strategy of the Central Office of Information in educating the public about the newly introduced legislation that would create the Welfare State in the post-war era. Its effectiveness was largely based on the fact that while embracing Disneyesque techniques, it made work that was much more informed by European modern art, yet combined this with an intrinsic understanding of the British sensibility and outlook. For this, the studio was reliant on the script work of Joy Batchelor, who applied wit and irony to her highly self-conscious and thoughtful approach to the needs of each brief. Her work spoke directly to a British audience

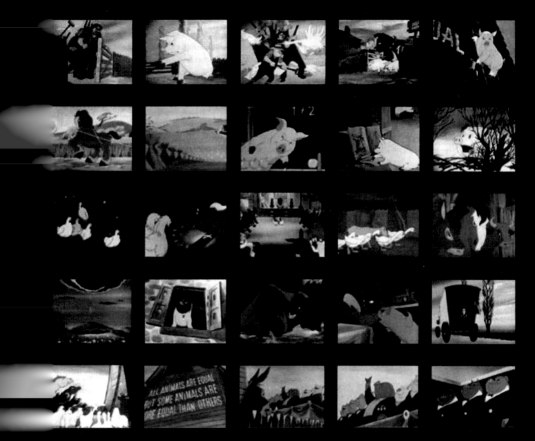

first, yet achieved universal qualities and attributes. It was Joy Batchelor who realised that however powerful and effective the visual was, it was vital to consider narrative, especially for British viewers, who embraced stories more readily than purely pictorial cues.

Batchelor's approach was predicated on script development as a model of problem solving, and crucially, finding simple solutions to often quite difficult narrative problems. Batchelor was always pragmatic. She recognised that: Although the budget is the responsibility of the producer, the scriptwriter has to be aware of it to avoid the common pitfall of gaily writing in crowd scenes or battles on land and sea, etc., which are costly and unrewarding to animate, and better left to live action.'

Batchelor recognised that the initial idea or challenge, and the time frame accorded to it, was the key point of address when embarking on a script, especially if it was of more serious import and purpose than the normal entertainment cartoon.

In the contemporary era of 'research-led' art, Batchelor was clearly ahead of her time, but ultimately stressed that: 'Situations must arise from the story and they must be visual at the idea stage. It is a stern discipline, but the economy of means is part of the strength of animation in putting ideas across.' The studio was very successful in putting ideas across in wartime propaganda shorts like *Dustbin Parade* (1941) and *Filling the Gap* (1941). It was in the post-war *Charley* series that the studio had its chief success. The propaganda films made during the war were preaching to the converted about wartime unity and collective action or training invested recruits, but it was a completely different thing to address and educate the public about how their lives were to change, as the government unfolded the Beveridge Plan. Both these kinds of films, of course, had a political agenda: the first was concerned with moral, ideological and pragmatic 'rightness' in the face of the Axis threat; the second, the political intervention of social policy and planning. This meant a slightly different approach

Title: Charley's March of Time

Animator: Halas & Batchelor Cartoons

Charley was an 'everyman' figure who embodied the audience's distrust or misunderstanding of the Labour government's new legislation. The writer must recognise the importance of creating an 'empathetic' rather than sympathetic character if important ideas and messages are to be communicated.

Charley's March of Time (1947)

The studio's *Charley's March of Time* (1947), was created to tell the public about the nature and impact of the National Insurance Act, due to come into operation from July 1948. Batchelor realised that this was a difficult task; the public needed to know about the value of payments and benefits, but had no experience of such a system. Batchelor's research gleaned more information about the development of the Act and the essential facts the public would need, but it was remembering what animation as a language could do which enabled her to resolve the seemingly insurmountable challenge the studio faced: 'It was not until we remembered

that our medium could play tricks with time, that our two main script problems were resolved.'

Consequently, the film evolved using an important technique, deploying a voice-over of a seemingly authoritarian government official, speaking simultaneously to Charley and the audience. The voice-over is a significant writer's tool, because it can provide information and direct the narrative. It can also operate as a character if necessary, delivering exposition or in more personal stories, internal monologue. In this instance, the voice-over figure provides the context for the change in social policy and operates as a sounding board for Charley's response. He begins:

July the fifth this year sees the fulfilment of centuries of social legislation, when the new National Insurance Acts come into operation. For the first time, everyone, or almost everyone in the United Kingdom can ensure against want. There will be sickness and unemployment benefits, retirement pensions, maternity grants, death grants, widows' benefits, guardians' allowances, industrial injuries benefits. Under the new acts, everyone will be required by law to make a weekly contribution to the scheme.

As one would anticipate, Charley reacts in much the same way as the public audience would:

Charley: *What! You mean I've got to pay all that every week – what a geezer!*

Commentator: *Yes, and so will 22 million other people.*

Charley: *You can keep it; I'd rather go back to the days before we had any of your wonderful insurance…*

Charley is then projected back in time; the voice-over intones:

It's no good running away from things even if you go right back to the beginning of time. The first living creature to discover land was no doubt, looking for security. In the Middle Ages, men banded together to protect themselves. In times of danger the castle spelt security. As time went on there were other dangers to be faced. One of the greatest was unemployment. To be thrown out of work meant begging in the streets. The first Poor Law system was established in Elizabeth's reign, and was followed by a compulsory poor relief rate. Another constant peril was sickness. With the breadwinner laid low, he and his family were likely to starve. And should he die, his dependants had to rely on the workhouse. By an act of 1733, each parish had to provide a workhouse, and people who refused to work there got no relief. In 1834 the Elizabethan poor laws

were amended and by now a new danger had arisen… industrial injury. It was not until 1897 that the first Workmen's Compensation Act made employers liable for injuries to workers in a few dangerous industries, and paved the way for further improvements. The first old age pension, a few shillings a week for the over 70s, came into force in 1908.

Finally, the modern era arrives, bringing only the threat of industrial injury, the slow process of corrective social legislation in speaking to human needs, and the onset of old age. Charley finally concludes that enough is enough, and all the benefits of the National Insurance system become clear and attractive to him.

Charley: *Phew, am I glad to be back, the things I've been through.*

Commentator: *Well, does it cost too much to avoid all that? And only a scheme like this can afford you such high benefits. Come on now, it's worth it, isn't it?*

Charley: *Every penny of it. Come to think of it, I'm paying quite a lot now in bits and pieces. I'm just in time to find out all about it before the scheme starts.*

The approach to the writing arose simply by engaging with what a character would do to seek security in a variety of contexts where he was abandoned to the arbitrary and chaotic social conditions of various moments in history. The contemporary viewer is then forced to review their own perspective and social context and accept the apparent benefits of the new system. Such a script encourages empathy with the trials of the central character and an acceptance of the logic of resisting the suffering and insecurity he has endured. After experiencing such oppressive and sometimes barbaric treatment, it is entirely logical for Charley, and by extension the audience, to willingly embrace the apparent succour of the Welfare State. This is an exemplary example of political writing, but more significantly, a clear strategy for a particular kind of writing for animation per se.

Abstract

Title: Norman McLaren at work in his studio

McLaren was rightly acclaimed for the film work he did, drawing and painting on film stock. However, this was not a purely spontaneous act and required pre-planning in its parameters and intended outcomes.

THE ABSTRACT DEEP STRUCTURE INVOLVES ANIMATION THAT IS EXPLICITLY EXPLORING NEW TECHNIQUES AND APPROACHES, OFTEN IN A NON-OBJECTIVE, NON-LINEAR FASHION.

It sometimes undertakes to explore material propositions of expression, and almost universally resists traditional conventions of understanding and interpretation. This kind of work tends to operate as a model of anti-narrative, only implying its codes and conventions of construction. It is in this that the writer may find an approach in thinking about the symbolic, metaphoric and mythic meanings embedded in forms, colours and shapes.

The writer in this case is normally invested in using form rather than text as a tool of expression. This allows for a more associative or intuitive means of creating work despite sometimes using the more formal methods of composition.

BLINKETY BLANK (1955)

As previously stressed, writing for animation can be construed in any number of ways. Within the context of abstract film it can be understood as an aspiration to test the limits of non-objective, non-linear imagery and to explore the concrete principles of colour, shape, form, size etc. Norman McLaren, one of animation's master auteurs, saw his scripts as either pre-production or post-production technical notes, recording the ways in which the experimentation with technique operates as a mode of personal expression. *Blinkety Blank* is an animated film made without the use of a camera. Engraving was done directly on black emulsion-coated film with a penknife, sewing needle and razor blade. Here are some of McLaren's notes for *Blinkety Blank* made in 1955:

'Animating directly on opaque black film poses the problem of how to position and accurately register the engraved image from one frame to the next. To bypass this problem *Blinkety Blank* intentionally set out to investigate the possibilities of intermittent animation and spasmodic imagery.

'On the majority of the frames there is nothing at all. When such a movie is projected at normal speed, the image on a solitary frame is received by the eye for a 48th of a second, but due to after-image and the persistence of vision, the image lingers considerably longer than this on the retina, and in the brain itself it may persist for several seconds until interrupted by the appearance of a new image.

'To make play with these factors was one of the technical interests of producing *Blinkety Blank*. Sometimes, for the greater emphasis, I would engrave two adjacent frames, or a frame-cluster (a group of three or more frames); sometimes it would thus solidify some action and movement; at other times the frame-cluster would consist only of a swarm of disconnected, discontinuous images, calculated to build up an overall visual "impression". Here and there, to provide much needed relief from the staccato action of the single-frame images and frame-clusters, I introduced longer sections of contiguous frames with a flow of motion in the traditional manner.'

McLaren is effectively basing his approach on a number of research questions rooted in the nature of how images are ultimately read and perceived by the audience. This pursuit of different ways of seeing, both on behalf of the artist and the audience, is at the heart of abstract expression. This mark-making may well express the intuitive signature of the creative initiative as it happens, while potentially operating as an unconscious or pre-conscious expression of feeling. Such film-making invites the audience to embrace aesthetics for their own sake and to interpret the material on personal terms and conditions.

The key issue in McLaren's work seems to be the apparent abandoning of text as the presiding language of script. The text is merely re-defined as the formalist record of applied research and expression, and the

script as a set of formalist directions and principles, often described by McLaren as a 'study'.

McLaren was preoccupied with the 'line', not specifically as the intrinsic signifier of motion in drawing but as a formal way of defining space, measuring time and alluding to implicit kinds of movement. The engagement with the line was essentially to create a proposition that could be tested, so the script is a technical and visual record of creative problem solving.

Abstract film works on different terms and conditions. Like word or number puzzles, which have their own method to secure resolution, the abstract film can explore its own materiality, modes of expression, and physical laws to create a desired outcome. Although demanding something different from the audience, there are inevitably points of connection and interpretation, so it is equally worthwhile to explore an abstract film of another kind in order to address where these points of contact and connection can arise.

Title: Lines Vertical

Animator: Norman McLaren

McLaren's 'dope sheet' for *Lines Vertical*, which is in effect a graphic mapping of the position of lines in the frame, and the timing required for their motion and position across the screen.

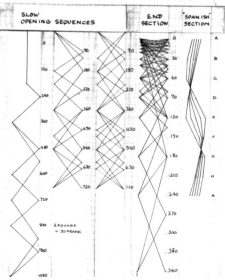

FABLE (2004)

Film-makers Anja Perl and Max Stolzenberg, formerly of the Filmakademie in Baden, have a particularly fresh approach to the use of new animation technologies and the creation of surreal and unusual stories. The writer in this instance is looking to create a different kind of narrative, which may not be immediately accessible or open to ready interpretation; but like McLaren's formalism, it has its own aesthetic and philosophical engagement.

Abstract work normally refutes the conditions of the classical narrative entirely, or plays with and critiques these conventions. It is important to remember, though, that the creators of predominantly classical texts are always seeking to freshen such narratives with unconventional strategies – sometimes borrowed from the anti-narrative/non-narrative traditions. On the other hand, the devisers and makers of anti-narrative/non-narrative works often look to models of storytelling that actually include more arbitrary or fantastical elements anyway (e.g. fairy tales, myths, fables). Perl and Stolzenberg's *Fable* falls into this latter category.

Using an image-led storyboard Perl and Stolzenberg create a narrative in which a man with a goldfish bowl head encounters a man who attaches a lollipop to his jacket and a fairy offering a wish. The film may have an underpinning linear structure, but there is clearly a high level of abstraction here. The writer might think of ways in which differentiation can occur through associative thinking in order to create an inner logic to the story, which works on its own terms, but operates differently from classical, formulaic and predictable stories. Even though it is clear that anti-narrative and non-narrative films work differently, it is rare that the abstraction does not have a deep structure. In animated film it is often the case that the techniques employed work as a self-conscious commentary on the idea of the abstract. In the case of *Fable* it is worthwhile to compare its strategy to the conditions of classical narrative to note how it has achieved its sense of differentiation, associative conditions and fresh inner logic (see table).

Title: Fable

Animator: Anja Perl and Max Stolzenberg

Perl and Stolzenberg's photographic storyboard indicates the broad choreography and direction of the piece, and demonstrates the mix between everyday action and the simple abstraction of giving the main character a goldfish bowl head.

1/01

der Mann mit dem Goldfischglaskopf
tritt aus dem Haus ...

1/03

Kameraschwenk

1/02

verriegelt seine Tür ...

Er tritt an den Bürgersteigrand und
betrachtet kurz die Menschen, die
an ihm vorbeiströmen.
Dann schaut er links...

und geht los ...

1/04

schaut rechts,

CLASSICAL VS. ABSTRACT NARRATIVE

Classical Narrative	Abstract Narrative	*Fable*
Cause and Effect	Arbitrariness	The consequences of having a goldfish bowl head re-determine the nature of cause and effect for the protagonist as he/she operates like a goldfish.
Linear Progression	Non-linear Progression	While the walk undertaken by the protagonist is straightforward enough, it is fraught with the dangers and different conditions determined by having a goldfish bowl head.
External Dramatic Conflict	Internal Dramatic Conflict	The protagonist, in seemingly not having an orthodox objectivity, responds both to material and imagined experience, but they both have the same status as reality because of his re-configuration as a character.
Central Protagonist	Absent/Many Protagonists	The protagonist is clearly a central character, but because we do not know his intrinsic objective or motivation, he remains symbolic and alienated.
Dominant Story Objectives	Non-objective Narratives	While there are story events, they seem arbitrary and unpredictable, and accrue around the central character's difference.
Consistent Reality	Inconsistent Realities	There are multiple realities present from the material to the supernatural world, but they co-exist within the inner logic of this imagined narrative space.
Closure/Resolution	Open/Unresolved	The purpose and outcome of the film remains enigmatic and problematic.

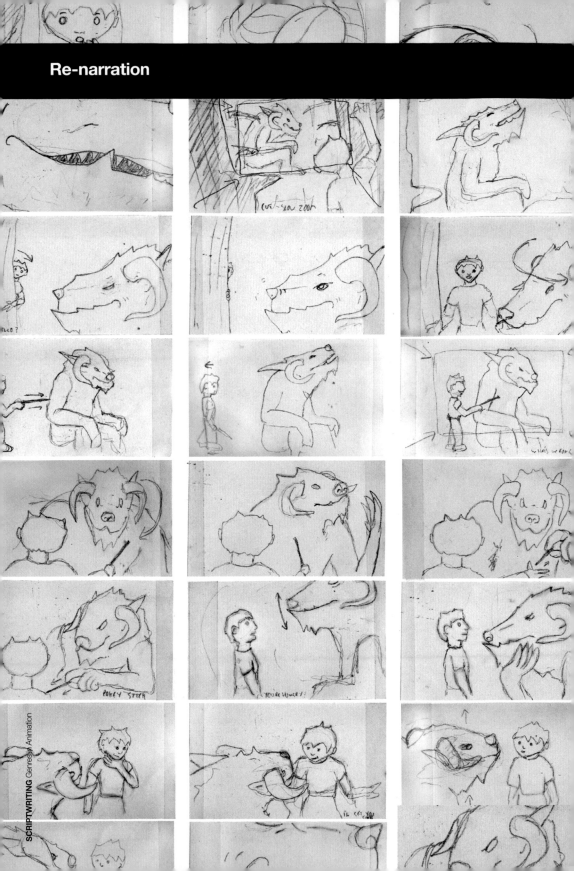

RE-NARRATION WORKS IN TWO PARTICULAR WAYS. FIRST, IN THE RE-INTERPRETATION OF ESTABLISHED STORIES, MYTHS AND FAIRY TALES, AND MOST IMPORTANTLY, IN THE RE-USE OF THE CORE STRUCTURAL TROPES DRAWN FROM THEM.

Second, in the re-determination of a particular narrative or series of story events, purely by presenting them from a perspective that could only be created using the distinctive vocabulary available in animation. The former uses the textual expectations of such stories as stimuli for revision and re-direction, while the latter re-imagines literal and linear narratives from a different viewpoint that can only be visualised in animation. Many animators have re-narrated established stories such as *Red Riding Hood* or *Snow White*, or re-narrated less well-known stories or narrative strands from the point of view of an object, animal or form that does not possess a voice.

In re-narration the writer has the benefit of drawing upon any number of texts to re-invigorate or re-direct the story, subverting expected outcomes or merely using themes and motifs from established stories as the launch pad for a new narrative. Further, the writer can develop a fresh approach by looking at narrative from a different, neglected perspective, but one predicated on using the language and vocabulary specific to animation, which can liberate new ideas and new models of visual storytelling.

THE MONSTERS THAT ATE TERRORISTS (2006)

Re-narration in animated film is quite common. Writers, devisers and animators are often inspired to re-write or re-work dominant motifs, structural elements or core points of narrative stimuli as the conditional elements of a new story. This is often used in parodies or mock versions of various genres, but at a deeper structural level it becomes a pertinent tool in story development.

Robin Fuller, formerly of the Norwich School of Art and Design, developed *The Monsters that Ate Terrorists* in a number of formulations, which necessitated re-narration across forms. Fuller first wrote his tale as a narrative prose story designed to be a children's book, with appropriate illustration. This is an extract from it:

One day Jimmy was out playing. He was playing his favourite game, which was to run around until he found something interesting and then to poke it with a stick. As he was looking for the next interesting thing, he heard a very strange noise. Thinking that it could have been a three-legged alligator or a kangaroo in a cowboy hat or something even better, he went to investigate.

He followed the noise through the trees and the bushes until, sitting against an old log he saw a great, hairy monster, all horns and hair, big ears and pointed teeth. As Jimmy hid behind a tree, the monster let out another long mournful howl and it looked so sad that Jimmy began to feel sorry for it.

'Hello,' he called out, but the monster just sniffed the air and moaned to itself. Moving slightly closer, Jimmy called out again but the monster just snivelled and paid him no attention. Finally, bored of being ignored, Jimmy marched up to the monster and poked it with his stick.

The monster let out a sobbing howl that seemed to Jimmy like the saddest noise he had ever heard.

'What's wrong?' he asked, giving the monster another little poke.

Title: The Monsters that Ate Terrorists

Animator: Robin Fuller

Fuller creates his wolf-like monster in a stage-by-stage process that facilitates the technical aspects of making the puppet move, but more importantly, creates a distinctive creature fitted to his fairy tale premise.

SCRIPTWRITING Re-narration

Re-narration

'What's wrong?' cried the monster irritably.

'What's wrong? I'm stuck in this stupid wood, I'm starving hungry and now some horrible little boy is poking me with his horrible pokey stick.'

'You're hungry?' asked Jimmy.

'I'm the hungriest,' moaned the monster, 'I haven't eaten in forever.'

Jimmy looked at the monster sitting all alone in the woods, moaning about its hungry belly. He looked at the monster and thought that it was definitely the most interesting thing he had found in a long, long time.

'I can get you some food,' he said.

Fuller is careful to focus upon the visualisation of his scenario, taking into account the dominant motifs in children's storytelling – the curious child, the consequences of imaginative play, the friendly monster and the narrative 'glue' of food-sharing – using them in a way that naturalises the grotesque and establishes the conditions of the relationship, domesticating the fantastical. Here is Fuller's adaptation:

(Fade up on a wooded parkland, Jimmy runs into shot, he is a boy of about seven with messy, blonde hair. He wears a plain T-shirt and ripped jeans, as he runs he is waving a stick around, obviously having a great time.)

Narrator: One day Jimmy was out playing. He was playing his favourite game, which was to run around until he found something interesting and then to poke it with a stick.

(Jimmy continues to charge around until he spots something on the ground…some roadkill which he pokes with his stick.)

Narrator: As he was looking for the next interesting thing, he heard a very strange noise. Thinking that it could have been a three-legged alligator or a kangaroo in a cowboy hat or something even better, he went to investigate.

(Cut to close-up of Jimmy as he reacts to the off-screen noise and goes to investigate.)

Narrator: He followed the noise through the trees and the bushes until, sitting against an old log, he saw a great, hairy monster, all horns and hair, big ears and pointed teeth. (Show Jimmy's reaction to the monster, then a quick series of close-up shots of the monster, its teeth, eyes etc. Finally show the monster in full. Jimmy

hides behind a tree and watches the monster howling in despair.)

Jimmy: Hello?

(The monster makes no response.)

Jimmy: Hello? (louder)

(The monster pays Jimmy no attention, it just sits and snivels to itself. Jimmy marches up to the monster and pokes it with his stick. The monster lets out another sobbing howl.)

Jimmy: What's wrong?

(Jimmy pokes the monster again.)

Monster: What's wrong? What's wrong? I'm stuck in this stupid wood, I'm starving hungry and now some horrible little boy is poking me with his horrible pokey stick!

(As the monster talks irritably, it snatches the stick from Jimmy and begins poking him back.)

This establishing scene is facilitated by the use of the voice-over storyteller, a pertinent device that is drawn from the child's experience of being read to, and which further domesticates the unusualness of the story premise of the child meeting a potentially threatening monster. Fuller successfully translates the descriptions in his prose narrative to descriptors and draws upon the exchange in the prose to create dialogue. He adapts one mode of storytelling into another, effectively dramatising the initial story. This dramatisation is in essence the creation of story events, and thereafter, a clear directive for visualisation. This in itself not only prompts the storytelling aspect of the storyboard, but also the important focus in developing the appropriate 'look' of the monster.

Re-narration in this context is two-fold: it takes the dominant motifs of a sub-genre of children's stories, and re-works them in a more personal work; second, it moves the story from one context to another through dramatisation and visualisation.

Title: The Monsters that Ate Terrorists
Animator: Robin Fuller
The final form of Fuller's friendly, wolf-like monster in the re-narration of The Monsters that Ate Terrorists.

PARADIGMATIC ANIMATION IS BASED ON ALREADY ESTABLISHED TEXTUAL OR PICTORIAL SOURCES. TEXTS CAN RANGE FROM NOVELS TO PLAYS TO POEMS, BUT THEY ARE NORMALLY WELL-KNOWN AND SOMETIMES ALREADY CHARACTERISED BY VISUAL INTERPRETATIONS.

Pictorial sources are principally from comics, graphic narratives, illustrated children's stories or novels, or design-led cultural resources in the public domain. These texts and visual premises are the intrinsic content and styling – the paradigm – for the animated version. These established textual and pictorial sources can also be specifically created for animated films, most notably feature length works, and particularly characterise the 'production bibles' for the animated series when the design and literary characteristics of the show must remain consistent.

The writer either works to adapt the core source materials with fidelity and sensitivity, or has the opportunity to create the whole 'world' of an animated film or series. Creator-driven television series are informed by a consistency in the narrative frameworks, the conceptual issues played out through the characters, and the overall design. In either case a paradigm of work is being created, which could be subject to repetition and development.

64 ZOO LANE (2000)
The central premise of the paradigmatic model is the creation of a particular and fixed model of work that becomes a paradigm in itself. Its originators and others work specifically with the bible that has been developed for the paradigm to make further work in keeping with the style. This is particularly important for series work, features operating as sequels, and works referencing or directly using the materials and meanings of an original

creation. For example, any films made with Nick Park's characters *Wallace and Gromit* would need to embrace the codes and conventions of their previous adventures; anyone seeking to work with the particular styling of *Yellow Submarine* would need to use the design principles of Heinz Edelmann. More regularly, the creation of a paradigm is pertinent for the specific and sustained 'world' of any one series, both for the children's market and adult audiences. Below is part of the production bible for *64 Zoo Lane* – developed by the late John Grace, formerly of the Animation Academy, Loughborough University:

Lucy lives at 64 Zoo Lane, next door to the zoo. At night, Georgina the Giraffe knocks on the window of Lucy's attic bedroom. The little girl slides down the neck of the giraffe to join the zoo animals. A different animal stars in each episode of 64 Zoo Lane *and recounts his or her own story to Lucy.*

Each episode is structured as follows:

1. Title sequence (1 min. 30 secs.)
At the end of the title sequence Lucy slides down the giraffe's neck and lands in the zoo.

2. Zoo sequence (approx 1 min. 30 secs.)
The following animals are always present in the zoo: Georgina the Giraffe, Molly the Hippo, Giggles and Tickles, Boris the Bear and Nelson the Elephant. Other 'guest' animals can also make an appearance.

3. Animal Story (approx. 7 mins.)

A story narrated by an animal. The stories are set in a variety of wild places.

4. Zoo sequence (approx. 30 secs.)

The animals say goodnight to Lucy.

5. Credits (approx 30 secs.)

Settings for Animal Stories:

North Pole: *Plenty of snow and ice.*

Australia: *Trees with spiky leaves, gum trees, rocks painted with aboriginal paintings, billabongs, the Great Red Rock.*

South America: *Steep mountains, valley, cacti, cave.*

Africa: *There are a number of different settings in Africa, but all these places are close together so the animals can move from one environment to another.*

Title: 64 Zoo Lane

Animator: John Grace and An Vrombaut

Lucy is drawn into the story world of each episode by Georgina the Giraffe, implicitly inviting the viewing child to come along and share the adventure in the same way as Lucy.

Paradigmatic

Title: 64 Zoo Lane – Georgina the Giraffe

Animator: John Grace and An Vrombaut

Friendly, talkative, very outgoing, theatrical, aspires to a career in show business.

Title: 64 Zoo Lane – Zed the Zebra

Animator: John Grace and An Vrombaut

Cool character with Elvis hairstyle, loves running very fast, proud owner of 'Go Faster Stripes', a bit of a boaster. Favourite activity: running, looking at his own reflection in the waterhole. Posh accent.

Plot and Structure

Stories should have a simple structure. The stories revolve around simple everyday conflicts between characters (no 'goodies vs. baddies' conflicts). Most of the stories are linear. Repetitions are often used.

Language

The voice-over should sound like a children's story book, especially at the beginning of the stories.

It also needs to fit the character who is telling the story. For example:

'Henrietta lived in the Zambam river with the other hippos. It was nice there because there were no crocodiles so the hippos could splash in the water as much as they wanted. But Henrietta wasn't like the other hippos. She was...HAIRY!'

Dialogue should sound natural. Difficult words should be avoided unless they are either explained or the meaning is clear from the context.

Humour

Puns should be avoided. It is far better to rely on visual or character-based humour. Silliness is very much appreciated.

Character Descriptions

(See images and captions for samples of character descriptions).

A Few Dos and Don'ts

Animals can move freely within one continent, but cannot travel to other continents.

Stick to native animals (no dromedaries in Australia or penguins in the North Pole).

If a character appears in a story set in one continent, it cannot appear in a story set in a different continent. For example: Ribit the Frog lives in Australia. Ribit cannot appear in a story set in Africa, although of course we can have other frogs croaking in the Zambam river.

No humans, human footprints or litter left behind by humans or any other signs of human civilisation.

Props should always be made of materials the animals can find in their natural environment. Keep props simple (no machines). Don't set a story within a story. Avoid flashbacks.

This paradigm is available to all the writers on the series who use these principles to create appropriate stories. The crucial aspect to this kind of writing is creating the specificity of the world or environment, the key characteristics of the protagonists, and the conditions that consistently underpin and inform the creation of each episode. Most episodes are based on revealing the key characteristics of the protagonists, and making a positive point to children about mutual co-operation and kindness.

Title: 64 Zoo Lane – Nelson the Elephant

Animator: John Grace and An Vrombaut

Older character, serious, a bit authoritarian, but has a heart of gold. Loyal, easily provoked. When he sets himself a task he will never give up.

Title: 64 Zoo Lane – Doris the Duck/Toby the Tortoise/ Kevin the Crocodile

Animator: John Grace and An Vrombaut

Doris – Feisty, bossy, talkative, impulsive and sticks up for friends.
Toby – Slow-talking, slow-acting, but quite sensible.
Kevin – Friendly and cute, easily led.

Title: 64 Zoo Lane – Giggle and Tickles

Animator: John Grace and An Vrombaut

Two cheeky monkeys who love to tease and play tricks. Often talk and move together. Sometimes argue.

PRIMAL ANIMATION DEPICTS, DEFINES AND EXPLORES A SPECIFIC EMOTION, OR STATE OF CONSCIOUSNESS, OFTEN ILLUSTRATING DREAM STATES, MEMORY, SURREAL FANTASY, MEDITATIVE CONDITIONS AND HEIGHTENED SENSES OF INARTICULABLE OR UNSPEAKABLE EXPERIENCE.

This kind of work is probably the most distinctive of the deep structures, and the one that most powerfully defines the uniqueness of animation in interpreting and literally illustrating the human condition.

The writer has the opportunity to seek out the best ways in which a visual mode of expression can best exemplify an internal sense of being. While this is extremely hard, being attuned to psychological, emotional and physical imperatives in humankind can prompt particular approaches, which once more use the distinctive apparatus of the animated film to apprehend these feelings and emotive outcomes. Sometimes the techniques used, once they are actually envisaged and executed, make what seems private and singular a common and universal experience when embraced by an audience.

DEADSY (1990)
Primal animation shares some of the conditions of abstract animation as it largely privileges an anti-narrative approach in order to capture interior states of consciousness – memory, dream, fantasy, the insularity of a solipsistic experience, emotional conditions etc. – which actually find their best expression in the freedoms of the animation vocabulary. This kind of animation also tends to re-define the parameters of both sound and image, in the desire to properly give vent to 'inner voices', alternative perspectives, and ideas

or thoughts, which are essentially 'unspeakable' or 'inarticulable' at some level. This work is especially difficult for the writer, as for the most part, this kind of expression is determined by the visual imagination. This conceives images to suggest agendas and emotions beyond the limits of words, while still keeping the material comprehensible.

David Anderson's *Deadsy* is a combination of xerography and puppet animation. Xerography, in this particular instance, involves the filming of a live performance by an actor, followed by the transfer of still images of his performance on to videographic paper. These images are photocopied and enlarged, and then rendered and drawn on before being re-filmed on a rostrum. The effect is to distort and degrade the image to give a haunting and hallucinatory quality to the character known as Deadsy – a symbol of apocalyptic despair aligned with shifting sexual identity.

Deadsy is one of the 'Deadtime Stories for Big Folk', thus signalling its relationship to the dream state and, most particularly, the nightmares experienced by adults. The film re-creates the dream state of deep sleep and reveals profound anxieties about death and the instability of gender and sexuality in its central character, Deadsy, who oscillates between being represented by a skeletal

model and a distorted human figure. The film continually blurs lines in its representation of life and death, masculinity and femininity, and the physicality of sex and violence. Russell Hoban's monologue for Deadsy is particularly effective as it echoes the corrupted nature of the images by creating a post-apocalyptic language, slurring and mixing words together. The following is an extract from *Deadsy*:

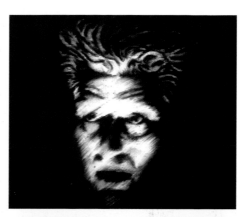

When Deadsy wuz lil he like din do nuffing big he din do nuffing only lil ooky-pooky deadsy byebyes like he do a cockrutch or a fly he din do nuffingbig. He werkin his way up tho after wyl he killa mowss O yes my my. He like that he like killing mowssis nex he done a rat or maybe it wuzza cat I dunno reely. He like that you know it give him like a MMMMM HMMMMM you know it give him like a BIG RUSH O so good wut I'm sayin. Yes yes it make him hear music in his head BIG stiryo in his head thats what he hearin.

Wel Deadsy hun garoun dinnee. Yes he did he hun garoun he growin alla time O so fine he growin his BIG LONG skellingtin MMMMM HMMMMM you know he growin his ROCKME ROLLME RATTLEME BIG BONUS you know his BIG BONUS how the girls all luvvit how he rattel roun the clock with his big bonus makin music O man wut he dun he dun them grate big gigs.

Deadsy tho he know evabody din love him. O yes he wuz big he wuzza reel MEGAGUY only he din have enuf luv in his life he wannit mor of it. Thats when it come to him Im gonna MMM HMMMM O YES IM GONNA GROW OOOOH GONNA GROW AHHH GONNA GROW GRATE BIG SEXO-THINGYS GONNA BE

MIZZ YOUNIVERSS

Then evvabody will luv me.

Hoban decided to create a corrupted future tongue for the voice-over – a language half-discernible by its resemblance to English, but actually a coarsened and limited 'pigeon' expression, describing the conditions of an apocalyptic environment, but also the shape and form of a primal state. Hoban effectively revises the script by revising the language. In this instance, the writer has contributed profoundly to creating a new kind of script, which speaks to the conditions of primal animation itself.

Title: Deadsy

Animator: David Anderson and Russell Hoban

Deadsy is an important example of approaching script and visualisation from an unorthodox perspective while embracing traditional methods. Hoban's corrupted language re-invents character and voice-over storytelling.

SCRIPTWRITING Primal

Title: Johnny Bravo
Animator: Van Partible

THIS SECTION IS COMPOSED OF TWO DETAILED CASE STUDIES. ITS INTENTION IS TO SHOW HOW TRADITIONAL APPROACHES TO STORY DESIGN INFORM SOME APPROACHES TO WRITING ANIMATED STORIES. THE TERMS AND APPROACHES AVAILABLE TO CONVENTIONAL SCREENWRITERS ARE PRESENT HERE AND ARE DEFINED WITHIN THE PROCESS OF CREATING SERIES-BASED ANIMATION FOR CHILDREN. THE FIRST CASE STUDY – *CHARLIE AND LOLA* – EXPLORES THE WHOLE PRODUCTION PROCESS FROM INCITING IDEA TO COMPLETED SCRIPT, WHILE THE SECOND CASE STUDY – *WILLIAM'S WISH WELLINGTONS* – LOOKS AT THE CENTRAL ROLE OF STORYBOARDING AND A SIMPLE APPROACH TO NARRATIVE BUILDING THROUGH PROBLEM SOLVING. THESE TRADITIONAL APPROACHES CREATE APPEALING WORKS FOR CHILDREN THAT REMAIN DISTINCTIVE FROM OTHER FORMS OF CHILDREN'S ENTERTAINMENT.

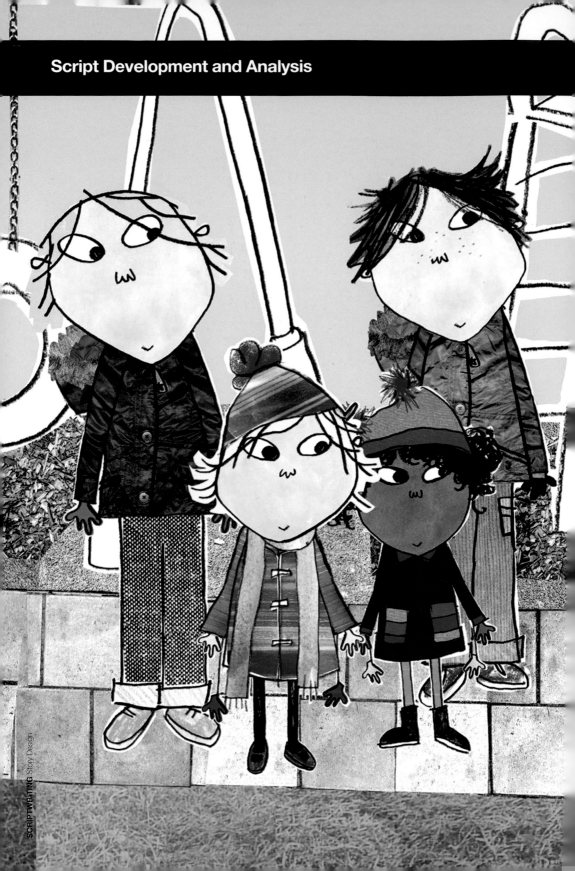

TO BE A WRITER IN ANIMATION, ONE MUST COMBINE THE SKILLS AND KNOWLEDGE THAT UNDERPIN TRADITIONAL SCREENWRITING WITH THE UNDERSTANDING OF ANIMATION AS A PARTICULAR LANGUAGE OF EXPRESSION, WHICH MAY BE EXECUTED THROUGH A VARIETY OF TECHNIQUES.

Charlie and Lola is an animated children's television series created by Tiger Aspect, based on the distinctive stories and designs of Lauren Child. It is a good example of an animated narrative, which is a type of script that makes constant demands of the writer. It also affords analysis of some of the specific conventions of traditional screenwriting. The following discussion examines an episode of *Charlie and Lola* called 'We Do Promise Honestly We Can Look After Your Dog' from its inception to its broadcast.

THE INCITING INCIDENT

The writers try to establish the inciting incident that will prompt the story. This is also sometimes called the premise. The key to this is to remain consistent with the principle of Child's stories: to be true to children and to represent their idiosyncrasies, idioms and outlook with as much integrity as possible. From the writer's perspective this relies on using observation and experience, recalling all the key aspects of being a child, seeing and knowing children, and privileging the child's point of view. The most common idea informing this perspective is the notion that children are preoccupied by 'little issues', which in their

Title: Charlie and Lola

Animator: Tiger Aspect Productions

The episode, 'We Do Promise Honestly We Can Look After Your Dog' has four main characters: Charlie and Lola, and their friends, Marv and Lotta. The main action is established in a park.

sensibility become epic and serious. The task for the writer is to represent this faithfully without being patronising or too knowing, as the tone can easily become ironic rather than sincere. Possible inciting incidents embracing this idea might include discovery of a wobbly tooth; sitting next to someone new at school; taking the stabilisers off a bicycle or discovering nits.

All such inciting incidents need to prompt a possible storyline, but must equally fit in with the presiding world in which Charlie and his younger sister, Lola live – a world in which the pair share a loving bond. Charlie readily cares for and protects his sister, even though Lola has a sometimes 'maverick' and playful sensibility. It is this tension between Charlie's sense of responsibility and Lola's more off-the-wall imaginative innocence and carefree outlook, which is at the core of most stories.

In this episode, Lola is playing with Charlie, and pretending he is her pet dog. This is an example of their imaginative play, and Charlie comments: 'At the moment Lola really, really wants to have a dog. But Mum and Dad say she can't because our flat is too small and Lola is too young to look after it.'

This is effectively the contextual premise of the episode, because Lola's desire to have a dog is already being played out through her games with Charlie. It establishes that the episode will probably provide an opportunity for Lola to look after a real dog. It is this moment in Scene Four that provides that inciting incident:

4. EXT. PARK. DAY

On sound the little scimper scamper of tiny doggy feet. We see a photo path receding into the distance. Then the receding brown behind of long-haired sausage dog. This is Sizzles, faithful friend to Marv. Sizzles's behind wiggles in a strange off-kilter fashion and his wonky tail tips to one side. Tiny tap dancing doggy claw noises accompany this. Very cute.

The lead comes out of Sizzles's collar and at the end of it are Marv and Charlie. Hands in pockets, wrapped up and hunkered against the cold. They walk along with Sizzles in boy-bonding silence. Photo trees and clouds, drawn benches and other stuff.

Over the above shots…

Charlie: *(O/S) So one day Dad took us to the park. There was me and my friend Marv. Lola and her friend Lotta. And Sizzles. Sizzles is Marv's dog. Lola loves Sizzles. But so does Lola's best friend Lotta.*

On sound breathless, girly witterings – lots of simpering 'aaahs', 'oh, looks' and 'little, tiny cutesy' as four pairs of stripey-tighted, brown-booted legs scamper excitedly behind Marv and Charlie. These legs are fast and jerky to their slow solid tramps.

Pan up to reveal Lola and Lotta cocooned in coats, hats, mittens and scarves, the tips of their noses blushed red with the cold.

They gaze adoringly at Sizzles.

Lola: *You ask.*

Lotta: *No you.*

Lola: *No you.*

Lotta: *No you.*

Lola and Lotta accompany this with little nudges towards the big boys ahead.

Lotta nudges Lola into Marv who stops and turns to look at both of the girls. Lotta goes instantly shy and turns the other way like in peep behind the curtain. A pause and then Lola takes a deep breath…but then nothing. Lotta nudges Lola from behind.

Lola: *Marv can we look after Sizzles?*

Lotta nods her head in shy agreement to this question.

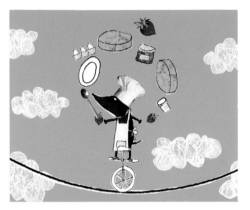

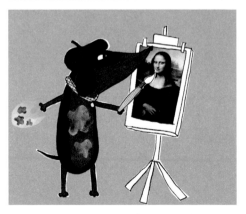

Title: Charlie and Lola

Animator: Tiger Aspect Productions

These images employ Child's signature style mix of drawn, cut-out and photographic elements. The photographic elements normally constitute the foregrounded aspects of the image.

Marv: *Lola do you know about dogs?*

Lola looks at Sizzles as if checking that she does know everything about dogs.

Lola: *Yes I do. Everything.*

Lotta, still with her back turned.

Lotta: *[Small voice] So do I.*

Lola: *We know that Sizzles is a very extremely, very clever dog.*

Lotta sidles nearer to Lola.

Lotta: *[stage whisper] What about tricks.*

Lola: *Yes, and we know he can do really very good tricks.*

Lotta gaining courage now, but still with her back half turned.

Lotta: *And if he wanted he could absolutely roll over.*

Lola: *And jump over things. All sorts of things.*

Lotta: *And speak English.*

Lola: *And walk on two legs. And dance. Definitely I think.*

Both girls gasp excitedly.

Lola: *[wide eyed] Lotta, do you know I think Sizzles can do really ANYTHING.*

Awed silence as the two girls consider this momentous thought...Sizzles just carries on walking in front of them doing nothing in particular. A flurry of leaves and one flies towards camera wiping like a curtain.

This scene not merely establishes the inciting incident of the girls' plea to take care of Sizzles, but the echoed relationships between Charlie, Lola, Marv and Lotta. It also establishes a story event composed of beats, which leads to a particular dramatic outcome. A beat is normally composed of an action and reaction that leads to an exchange or movement in behaviour. The first beat is Lola and Lotta's reaction to the dog in the face of the boys' indifference; the second is when the girls argue about who should ask Marv whether they can look after the dog. This is resolved when Lola finally makes the enquiry. The

third beat is Lola and Lotta's response to Marv's question, 'Lola, do you know about dogs?', to which they advance an escalating list of Sizzles's apparent skills and abilities, leading to the dramatic outcome of the fantasy sequence that then follows:

5. FANTASY MONTAGE

1. Sizzles, dressed as a chef, is juggling plates and foodstuffs, whilst on a monocycle. Applause.

2. Red velvet curtains part to reveal Sizzles, he howls/sings a wonderful doggy rendition of 'Figaro' and then bows. Applause.

Or 2.b. Sizzles dressed as a French artist dabs at his easel. Reveal it's the Mona Lisa. Applause (see top left).

3. Sizzles, dressed as a gymnast, is backflipping, cartwheeling and somersaulting from one corner of a rug to another. He triumphantly puts his arms in the air as gymnasts do. Ecstatic applause (see bottom left).

DEVELOPING A TREATMENT

The scenes from the above episode are a long way off from the point when the creative team draws up a prose brief. This notes how topics might be developed, how various ideas might be included, and suggests a storyline with a possible three-act structure and narrative crisis. This brief is then given to an assigned writer, who begins working on a treatment, with a scene breakdown and indicative gags. The evolution of the material remains in some degree of flux, but there is an important stage where the writer, having developed a prose story outline, has this commented upon by the script supervisor (see check list on page 107).

The prose story outline may serve to be enough to move towards creating a full treatment, but other methods are also employed in some projects. This might include developing a more formal step outline, an event analysis, and a story synopsis.

STEP OUTLINE

The step outline echoes the story outline, but is usually a more detailed document breaking the story down scene by scene. It formally breaks down the story into a sequence of numbered scenes, and essentially describes each scene in about two sentences. The first sentence normally describes the action, the second defines the significance of that action.

EVENT ANALYSIS

An event analysis takes up the step outline and identifies the key story events in the evolving plot, and subjects them to a thorough analysis (see table on page 107). This adds a great deal to the development of more complex scripts as it takes into account all significant movements of action, explains the action in terms of plot and character, and identifies the significant 'movements' of individual characters. It also explains the desired outcomes for the audience with regard to an unfolding understanding of, and empathy with, the narrative; maps out the anticipated emotional responses of the audience; and provides a clear idea of the movement of feelings, throughout the narrative development. This concept is evident in Scene Six:

6. EXT. PARK. DAY
Real life again. Shot from Sizzles's POV of the four faces of Marv, Charlie, Lotta and Lola looking down on him blinking.

Lola: *Sizzles is the cleverest dog ever, anywhere.*

Changing POV we see Sizzles standing motionless and unmoved. He really is an incredibly stupid, non-reacting dog.

Marv: *Watch this. [Forcefully] Sizzles. Sit.*

Sizzles does nothing.

Charlie digs his hands deeper into his pocket. Looks down at the ground. This is an embarrassing moment for his friend.

Lola and Lotta look hopefully at Marv.

Marv wrinkles his nose. He tries again.

Marv: *[Encouraging] Sizzles! Sit! Sit! Sit, Sizzles?*

Lola and Lotta look back at Sizzles. Who very slowly and under no duress sits. Marv breathes a sigh of relief. Lola and Lotta clap violently added to little jumps of joy.

DOOF! Suddenly a football flies through the air and comes to a bouncing rest just by Marv. Marv picks the ball up.

On sound the kick, thud and shout of a football game. Marv hands the ball to Charlie.

Marv looks at the ball then at Sizzles. He is torn.

Charlie: *We could play just one game, Marv?*

He sagely looks at Sizzles. All of the others look at Sizzles as well.

Marv: *Who is going to look after Sizzles?*

Lola and Lotta's eyes blink slowly in heavenly realisation. Close-up on the two girls' eyes as they dart an excited look between them.

A pause and then Lola and Lotta in perfect unison, unleash their excitement by bouncing up and down. Over and over again. Higher and higher. As if the highest jumper gets the dog.

Lola: *Me!*

Lotta: *Me!*

Lola: *Me!*

Lotta: *Me!*

Charlie looks at Marv and at the football. Marv wrinkles his nose, still unsure.

Charlie: *It's only for a little while. He'll be OK with Lola and Lotta.*

He looks at Lola and Lotta.

Charlie: *[convincing himself] I'm pretty sure he will.*

Marv: *[deadly serious] OK. But you do know there are lots of rules if you want to look after Sizzles.*

The description of this scene when in development would be quite straightforward:

Marv tries to make Sizzles 'sit' on his command and after some delay, the dog obeys. Marv and Charlie become aware of a nearby football match, which they want to join. Lola and Lotta seize the opportunity to ask to look after Sizzles while they play. Marv has his doubts, but is persuaded to leave the dog in their care by Charlie. Marv sets some rules that Lola and Lotta must obey if he is to let them look after Sizzles.

The specific aspect that moves the plot forward is the transitional means by which Lola and Lotta finally get to look after Sizzles. The boys want to play football, so eventually, under certain conditions, leave the dog in the girls' care. An important element of this scene is the moment of foreshadowing provided by Marv's demonstration that Sizzles will sit on command. This becomes important later, when the girls need

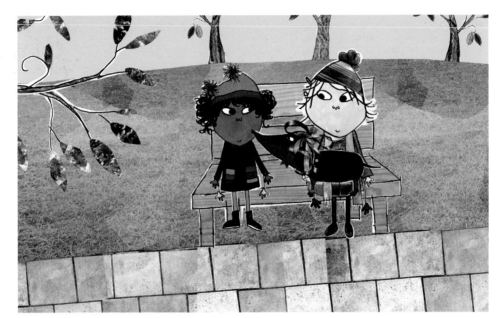

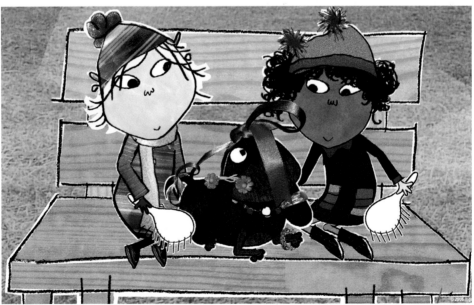

Title: Charlie and Lola

Animator: Tiger Aspect Productions

Lola and Lotta dote on Sizzles, tying a ribbon on to him to make him look presentable, while simultaneously the designers show him as the gift or present he represents to the children.

to establish Sizzles's identity when he becomes confused with another sausage dog in the park.

The specific aspects of the scene that progress the characters are very significant: Lola and Lotta become the primary characters by ultimately seizing the opportunity to look after the dog, and Charlie and Marv recede to become the secondary characters playing 'off-screen' soccer. Importantly, Marv has helped to create suspense in the scene by first seeking to make the dog obey him, and then, second, in his doubt and anxiety about relinquishing responsibility for Sizzles. These function as beats in the scene and lead to the dramatic outcome of Marv setting the rules by which the girls can take charge of Sizzles.

The writer's requirement from the scene is a dramatic mechanism by which the girls take responsibility for looking after the dog. By using the boys' desire to go and play football while ensuring the dog is in safe care, the scene achieves its aim. For a children's audience, this transition is not an ill-considered abandonment of the dog. It is in this that the writer properly aligns the structural and emotional requirements of the narrative.

The audience – predominantly children (and watching parents) – would need to understand that in a perfectly acceptable way, the girls are now caring for the dog, and the boys are playing football. At the emotional level, there may be some small anxiety that the girls cannot really look after the dog, but in principle, there will be excitement that the girls can now finally play with Sizzles. The tone remains playful and innocent, but nevertheless carries with it dramatic importance as Lola and Lotta are now in charge of the dog and become the focus of the story.

STORY SYNOPSIS

If deployed, the story synopsis starts to offer a more objective summary of the story, essentially describing it from 'the outside'. Simply, this is a seven- or eight- paragraph summation of the plot, which properly establishes the main characters, settings and story events, while also describing the key conflicts of the characters, their motivations, outcomes and resolution. Crucially, the summary seeks to describe the ending in a way that ties up all loose ends. In many senses, the story synopsis is not merely about how the story will work but what it is about, and why the story will work effectively. This episode might have been described as follows:

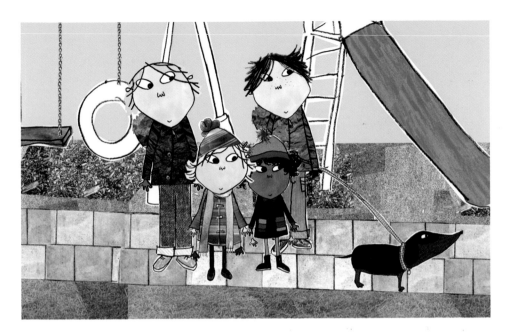

Charlie, ten, and his sister, Lola, five, are playing a game in which Charlie is pretending to be a pet dog. Lola longs to have a dog, but her parents have said she is too young and their flat is too small to accommodate a pet.

One day, Charlie and Lola encounter Marv and Lotta in the park, walking Marv's dog, Sizzles. Marv is Charlie's best friend and Lotta is Lola's best friend. While the boys walk together silently, the girls stare in awe at the dog and wish they could play with and care for it. They imagine that the dog has all sorts of skills and abilities. Marv demonstrates, though, that only with extensive persuasion, will Sizzles actually 'sit'.

Charlie and Marv become aware of other boys playing football in the park and wish they could play. The girls realise that this is an opportunity to ask to look after the dog. After having some doubts and establishing some rules, the boys leave Sizzles in the girls' care.

The girls dote on and play with the dog, but fall into an argument about who knows more about dogs, and who is 'more in charge' of Sizzles. Preoccupied with their escalating exchange, the girls don't realise Sizzles has gone.

The girls search for the dog in the park, trying not to alert the boys. At first they feel quite anxious as they cannot find him, when suddenly, Sizzles emerges from behind a

Title: Charlie and Lola
Animator: Tiger Aspect Productions

The main characters are established for the series, and re-dressed for each particular situation or location. Character identity is defined by consistency and with each change of clothing or addition of props, the core aspects of the original aesthetic and representational design must remain the same.

tree and all seems well. Immediately, however, another sausage dog exactly like Sizzles also emerges.

The girls try to distinguish between the two dogs by persuading them to 'sit'; in their eyes, this is the 'clever' characteristic that marks Sizzles's distinctiveness. He does eventually 'sit', but is soon followed by the other dog. Sizzles remains unidentified, as the other owner walks away with one of the dogs.

Charlie and Marv return and once the girls explain what has happened, identify the dog by his dog tag. The girls claim that they knew about this all along, relieved that they have the right dog, and end the episode reiterating Sizzles's special talents and qualities.

Script Development and Analysis

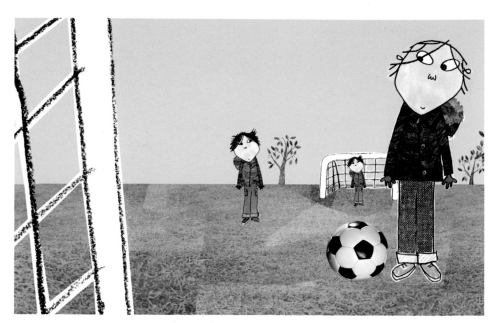

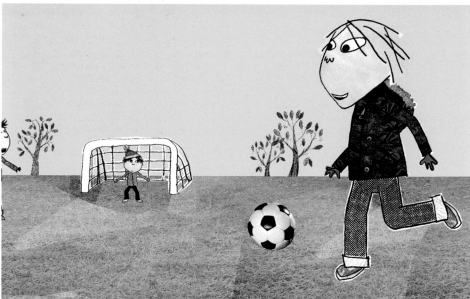

Title: Charlie and Lola

Animator: Tiger Aspect Productions

The simple games children play become the core dramatisation in each episode, and must carry narrative purpose. When Charlie goes to play football, Lola and Lotta have an opportunity to take charge of Sizzles; this in turn prompts the developing narrative.

ELEMENTS IN EVENT ANALYSIS

Describe the scene, including all the characters in it and what action actually takes place.

Address what aspect of the scene specifically moves the plot forward and makes the scene meaningful to the overall story.

Address what aspects of the scene signal a development in the primary and secondary characters in the scene.

Address what the writer wants from the scene in relation to its place in the overall story and the emotional tone required of the scene.

Address what the audience is supposed to take from the scene (key information and understanding emotional outcomes).

Title: Charlie and Lola

Animator: Tiger Aspect Productions

Sizzles is surrounded by the things he is forbidden to have. As Marv lists these prohibitions, the images are removed from the screen and Sizzles becomes increasingly downcast.

SCRIPT SUPERVISOR'S CHECKLIST

The story outline must be consistent with the style and tone of the series.

Any additions made should enhance what is already suggested.

Suggest the omission of narrative proposals that are inappropriate or 'not in style'.

The narrative must speak to the distinctive visual possibilities available to animation (i.e. using symbolic or representational motifs rather than confusing or time-consuming action).

Both dialogue and story events should be played out in children's idioms and outlook.

The story outline must be clear and all story events unambiguous (this is particularly important for children's stories).

All elements that are intrinsic to the story outcomes must be included at the appropriate time in the story outline (i.e. important actions, which could be turning points later in the narrative, are where the audience can properly see their significance and later effect). This can be an aspect of foreshadowing.

The quality/appropriateness of the gags/story events must be evaluated and recognised either as something to be included or changed.

The ending must offer a clear and conclusive outcome to the narrative.

Script Development and Analysis

THE TREATMENT

Preparatory materials for a project must include:

The main character profiles/story 'idiom'.

Approaches to design and its execution in animation.

The inciting incident – effectively 'the premise' of the story, largely determined alongside a research and development stage.

A prose brief.

A prose story outline.

A step outline.

An event analysis.

A story synopsis.

When the above are available, the project can then proceed to a full treatment, which must address theme, character, plot and structure.

The preparatory materials must establish the most fully realised prose narrative of the story, with all of the core motivations and objectives of the story made clear. They should have a level of descriptive detail and occasionally some indicative dialogue, which properly defines the nature, purpose and development of the story. The treatment must fully present and explain the 'hows' and 'whys' of the story structure and resolve any active questions that the story has posed in its telling. In the final scene, the girls believe they have let Charlie and Marv down, and in not being able to identify the right dog, may have lost Sizzles. This prompts the active question: 'How can this situation be resolved?' The scene concludes:

Lola and Lotta exchange an extremely grave look, biting their lips in worry.

'Uh-oh.' Charlie is looking on bemused. Marv is happy with Sizzles.

A pause, then Lola and Lotta can't hold back any longer, and confess…in very loud whispers, overlapping sentences. Each of the girls' words run into each other as they try and explain.

Lola: *Charlie…we had Sizzles and we were looking after him…*

Lotta: *And then…*

Lola: *He sort of went for a walk…without his lead.*

Lotta: *And then…*

Lola: *We couldn't see him anymore…*

Lotta: *And then…*

Lola: *We saw him but he wasn't one anymore he was two Sizzleses.*

Lotta: *And so…*

Lola: *And so I'm not sure that Sizzles is Sizzles now.*

Charlie takes the lead from Lola and bends down to the attached tag on Sizzles' collar. Charlie turns back to the girls and beckons them over. They bend down and see the tag.

Charlie: *[quietly reads it out] Dog number. 144. Sizzles. Owner: Marv Lowe. 5a Crocodile St.*

Marv: *[To the girls with bravado] That's his dog tag. It's got his name and address on it, in case he gets lost.*

The two girls look at each other open-eyed.

Marv: *All dogs have them. (Pause).*

Lola: *We knew that actually Marv.*

Lotta: *(nodding) All dogs. Just in case they get lost.*

Charlie can guess exactly what might have gone on.

Charlie: *Yes, that's right. Just in case they get lost!*

Charlie does one of his Oliver Hardy looks to camera.

Charlie: *Now, come on. Dad's waiting.*

Lola and Lotta exchange a 'phew-that-was-close' look as they carry on their way. As they depart we hear their dialogue fading…

Lola: *But Sizzles would never get lost.*

Lotta: *No he's a very extremely, very clever dog.*

Lola: *He can do anything.*

Lotta: *He can do absolutely anything.*

THE END

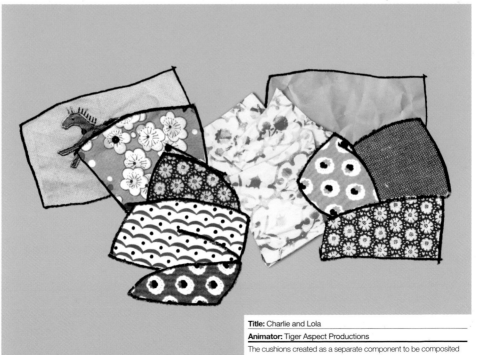

Title: Charlie and Lola

Animator: Tiger Aspect Productions

The cushions created as a separate component to be composited into the main image above.

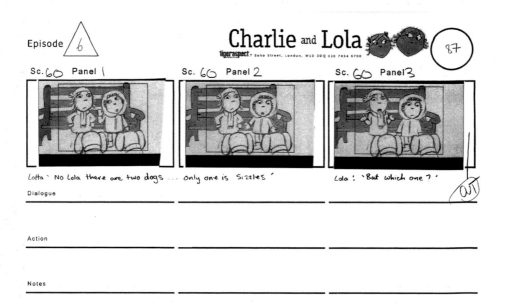

Episode 6

Charlie and Lola

tigeraspect 7 Soho Street, London, W1D 3DQ 020 7434 6700

87

Sc. 60 Panel 1 Sc. 60 Panel 2 Sc. 60 Panel 3

Lotta: 'No Lola there are two dogs ... only one is Sizzles' Lola: 'But which one?'

Dialogue

Action

Notes

The treatment must answer all plot questions, clearly resolve any structural needs the story has, and reveal its core themes through the actions and resolutions of the characters.

DEVELOPMENT ISSUES
Having developed a full treatment with a clear scene-by-scene breakdown, the writers check that the script remains true to the original vision of the *Charlie and Lola* world. The story is reviewed and checked to make sure that it readily prompts and is facilitated by the particular vocabulary available to animation. The author engages with the dialogue and overall style in anticipation of the particular needs of the design. Once the script has been refined and finalised, the project moves to voice recording and storyboarding.

VOICE RECORDING
The provisional script (see script extracts) is recorded by real child actors, who are encouraged to improvise and deliver the script as written to heighten the naturalistic and spontaneous 'feel' of children responding to a situation for the first time. This soundtrack, matched to the storyboards and the script, is shot in an 'animatic' that gives the strongest sense of the timing and rhythm of the story before it is fully animated and the episode completed.

STORYBOARD
As with many animated films, the storyboard essentially represents the core visualisation of the narrative and

underpins the development of layout. This includes the essential blocking of the action in its background, context or environment – a 'shooting script' – which suggests how the animation will be photographed in relation to televisual or cinematic conventions. In this case, facilitating fantasy locations or sequences is the key work of the art director. Art directors create these sequences and develop key frames of the characters and environment, while 'fabricating' new contexts that speak to Lauren Child's specific design sensibility.

The 2D styling of *Charlie and Lola* corresponds to childlike drawings and the empathetic feel that the stories are seeking to create. The writers make sure that the narratives are character-centred and issue-led, insisting upon the integrity of innocence and naivety in the stories, so that they do not become adult, or in some way, ironic.

This analysis of *Charlie and Lola* has sought to demonstrate the process by which episodes are written, while addressing a range of traditional methods by which many scripts are developed more formally. The next example, *William's Wish Wellingtons*, uses the full storyboard from the programme to reveal a simple storytelling technique based on the creation of narrative problems or active questions, and their immediate resolution in sequential development of the unfolding story. It is a straightforward technique and a fundamental method employed by writers in story development, no matter how complex the story may become.

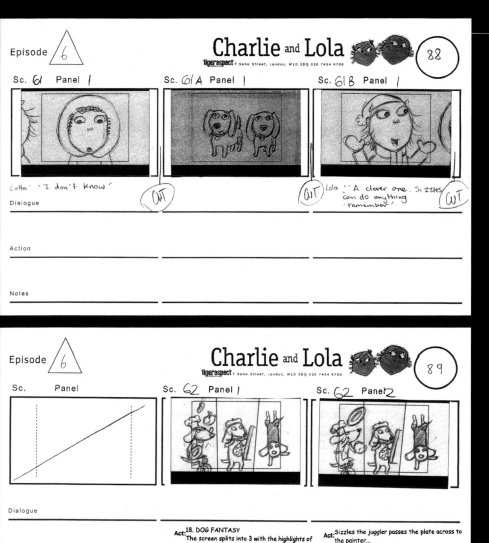

Title: Charlie and Lola

Animator: Tiger Aspect Productions

The storyboarded animatic engages with the choreography
of the scene and seeks to enhance the capacity of the animation
to make the necessary visual statement and its attendant
meaning and affect.

THE CHILDREN'S SERIES *WILLIAM'S WISH WELLINGTONS* FEATURES A SMALL BOY WHO OWNS A PAIR OF 'WISH WELLINGTONS', WHICH, WHEN HE PUTS THEM ON, ENABLE HIM TO WISH FOR ANYTHING HE WANTS.

This simple narrative device is most often used to transport William into a new context for adventures, which he shares with his pet dog, Barksure. The series has a number of simple story premises, which give each story clarity and help structure the narrative in a way that the pre-school audience will readily understand.

'WILLIAM AND THE CAMEL' – STORYBOARDS
The following storyboards tell the complete story of 'William and the Camel' and represent a simple writing strategy, which is not merely common to most children's series or episodic narratives, but to most story development structures. The storyboard itself was finalised and then produced as an A4 booklet for ease of handling and presentation among staff at the Hibbert Ralph Studio. It includes compositional information, provisional timings and occasional suggestions for shooting the material, but its essential purpose is to tell the story in a simple and direct manner.

STORYBOARD ONE
This signals the title and opening sequence and establishes the principal characters: William and his dog, Barksure. They are playing in the sandpit at William's house. The first story event – Barksure digging in the sand and showering William – suggests the initial premise. Associating the sand with the desert, William wonders what it would be like to visit one. This uses the convention of the 'thought bubble' to envisage the scene.

STORYBOARD TWO
The 'pop' of the thought bubble prompts the wish sequence common to most episodes, which places William in his new environment where the story will take place. The desert is typified through the imagery – sand, palm trees, pyramids, and camel riders – so the first point of amusement comes when William arrives dressed as if he is going on a typical British

beach holiday. This reinforces the common experience of the pre-school audience and the playfulness in the storytelling.

WILLIAM'S WISH WELLINGTONS – EPISODE STRUCTURE

William is seen in everyday situations that could be common to any small child.

William loves his pet dog and faithful companion, Barksure, who often participates in his adventures.

William uses his 'wish wellingtons' not to be acquisitive or to gain material goods, but to project himself into new and exciting experiences.

William never wishes for anything beyond the innocent desires of a small child and only uses his wellingtons to solve problems in a spirit that could be imagined by a small child.

William's narratives are whimsical and amusing in a way that small children would appreciate; they do not seek to attract a crossover audience with the use of more sophisticated adult humour or scenarios.

William uses his wishes to prevent himself coming to harm, and to further his adventures.

Title: William's Wish Wellingtons

Animator: Hibbert Ralph Studio

The following 16 storyboards are from an episode of *William's Wish Wellingtons* – 'William and the Camel'.

214 seconds
30

William and the Camel

3 sec

75

WILLIAM + BARKSHIRE ARE PLAYING IN THE SAND PIT.
TRACK IN.

3 150

BARKSHIRE STARTS DIGGING.

2 200

WILLIAM IS SHOWERED WITH SAND.
HE LOOKS AT BARKSHIRE IN DISGUST...

2 250

... AND THEN WONDERS WHAT IT MUST BE LIKE
IN THE DESERT.

1½ 287.5

PAN TO BUBBLE

2 337.5

BUBBLE POPS.

1 sec 362.5

WILLIAM MAKES A WISH.

2 412.5

C.U. BOOTS + SPARKLES.

2 462.5

512.5

WILLIAM POPS ONTO SAND.

3 587.5
539.5

WILLIAM REMOVES HIS SUNGLASSES AND LOOKS
AROUND.
" THIS IS A VERY BIG BEACH ! "

637.5
2 589.5

Storyboarding – Narrative as Problem Solving

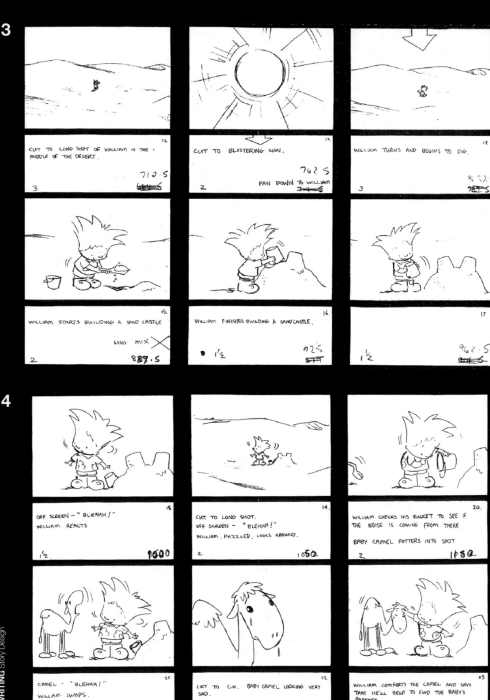

3

CUT TO LONG SHOT OF WILLIAM IN THE MIDDLE OF THE DESERT.
712·5
3

CUT TO BLISTERING SUN.
762·5
PAN DOWN TO WILLIAM
2

WILLIAM TURNS AND BEGINS TO DIG.
832·
3

WILLIAM STARTS BUILDING A SAND CASTLE
LONG MIX
2 887·5

WILLIAM FINISHES BUILDING A SANDCASTLE.
725
1½

962·5
1½

4

OFF SCREEN - "BLEHHH!"
WILLIAM REACTS
1½ 1500

CUT TO LONG SHOT.
OFF SCREEN - "BLEHHH!"
WILLIAM, PUZZLED, LOOKS AROUND.
2 1050

WILLIAM CHECKS HIS BUCKET TO SEE IF THE NOISE IS COMING FROM THERE.
BABY CAMEL POTTERS INTO SHOT.
2 1050

CAMEL - "BLEHHH!"
WILLIAM JUMPS.
1175
3

CUT TO C.U. BABY CAMEL LOOKING VERY SAD.
3 1050

WILLIAM COMFORTS THE CAMEL AND SAYS THAT HE'LL HELP TO FIND THE BABY'S PARENTS.
1300 MIX
2

SCRIPTWRITING Story Design

STORYBOARD THREE

The shot of William in isolation and the close up of the blistering sun suggest the first ways in which the scenario is problematised; this is made less threatening for the pre-school audience by William continuing to make his sandcastle. This is important because the writer is considering how the story will develop through the challenges to the central protagonist, while at the same time reassuring the audience.

STORYBOARD FOUR

All narratives attempt to incorporate a super objective that is the central purpose of the story, which encompasses all the story events moving towards a resolution. Here, William encounters a baby camel that has lost its parents; the story now becomes focused on William's efforts to help the camel find them. This is also a significant point of empathy and identification for the target audience whose central relationship is with their parents and whose chief anxiety is probably being apart from them. Such a super objective for the story also invests William with a key narrative purpose.

STORYBOARD FIVE

The narrative uses the theme of 'the quest' as William and the camel set out to find the camel's parents. From this point, the story is based on a range of problems and difficulties, which prevent William reaching his goal. William's attempts to overcome the problems become the objectives by which he seeks to secure the super objective of finding the camel's parents, and this becomes the dramatic conflict in the episode. The various obstacles prompt William to use his 'wish wellingtons'. The writer must use the established terms and conditions of the series because William could simply wish to find the camel's parents and leave the desert. The writer must commit to the pure artifice of storytelling and not break the rules by which the situation has been established. This means maintaining the inner logic that has been created for William's world. William does not see his wellingtons as a vehicle by which he has super powers, but as a mechanism to resolve the immediate issue at hand in his adventure. The story must also represent a logical way of thinking, which could be understood by the pre-school audience.

5

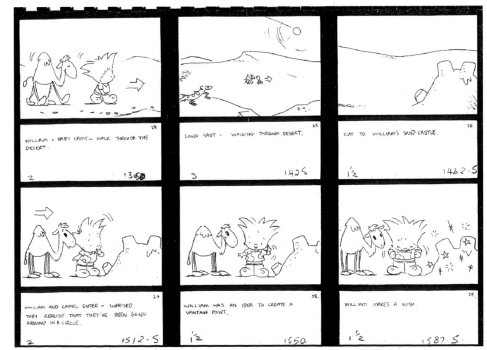

WILLIAM + BABY CAMEL WALK THROUGH THE DESERT.
2 1350

LONG SHOT - WALKING THROUGH DESERT.
3 1425

CUT TO WILLIAM'S SAND CASTLE.
1½ 1462.5

WILLIAM AND CAMEL ENTER - SURPRISED. THEY REALISE THAT THEY'VE BEEN GOING AROUND IN A CIRCLE.
2 1512.5

WILLIAM HAS AN IDEA TO CREATE A VANTAGE POINT.
1½ 1550

WILLIAM MAKES A WISH.
1½ 1587.5

SCRIPTWRITING Storyboarding – Narrative as Problem Solving

STORYBOARD SIX

William wishes for his original sandcastle to become larger in order to acquire a vantage point. This creates a story event based on metamorphosis, where using the particular vocabulary in animation, one thing can literally turn into another. The apparent resolution of one problem, however, has to be immediately followed by the emergence of another obstacle. The sandcastle is too crumbly to climb up and William realises he must wish again for a more secure and solid vantage point.

STORYBOARD SEVEN

William and the camel are hurtled to the top of a pyramid – a useful deployment of one of the key stereotypical images of the desert. While the writer is often encouraged not to pursue clichés or use stereotypical elements, these can be valuable visual shorthand, and ultimately, it is the way in which they are used, and not merely their use, which determines their effectiveness. In this case, a narrative problem is resolved in a way pertinent to the environment in which William and the camel

exist. William and his companion can now see for miles, and for the writer, the new challenge is to create the next aspect of the story through what they immediately see. Both characters see an ice cream kiosk. An adult audience might anticipate that this is a mirage, but at this stage, the writer must try and imagine what a child would like and think. The story objective of getting an ice cream has great appeal both to the character and the watching pre-school audience.

STORYBOARD EIGHT

No matter how fast the characters run, they are unable to reach the kiosk – confirming that the kiosk is a mirage. The writer recognises the disappointment for the characters and the audience and uses the 'wish wellingtons' to wish for the ice creams. The pattern of the episode is now well-established. Story events are generally immediate problems, which create objectives for the characters; the resolution of the problems progress the story towards the resolution of the super objective.

6

THE SAND CASTLE TURNS INTO A GIANT SAND CASTLE.
WILLIAM BEGINS TO CLIMB
3 1662.5

WILLIAM SCRAMBLES UP THE CASTLE ...
2 1712.5

... BUT IT'S TOO CRUMBLY!!
2 1.762.5

WILLIAM HAS LANDED IN A PILE OF SAND.
HE MUST THINK OF ANOTHER IDEA.
3 1837.5

WILLIAM MAKES A WISH.
1 1862.5

C.U. BOOTS.
2 1912.5

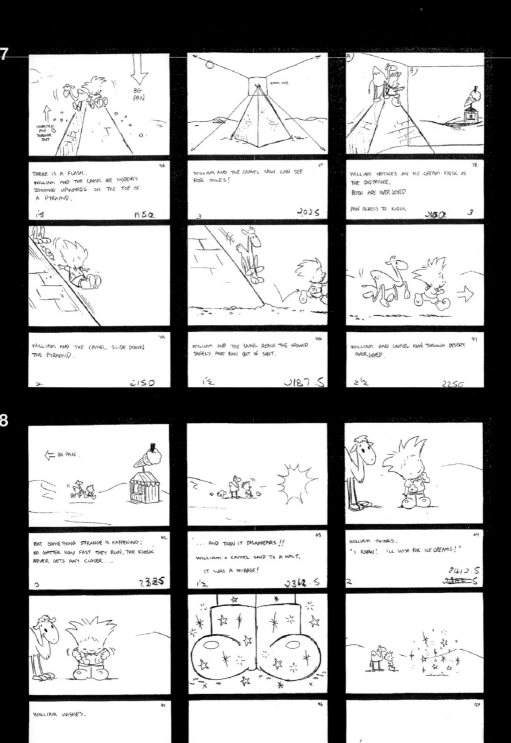

Storyboarding – Narrative as Problem Solving

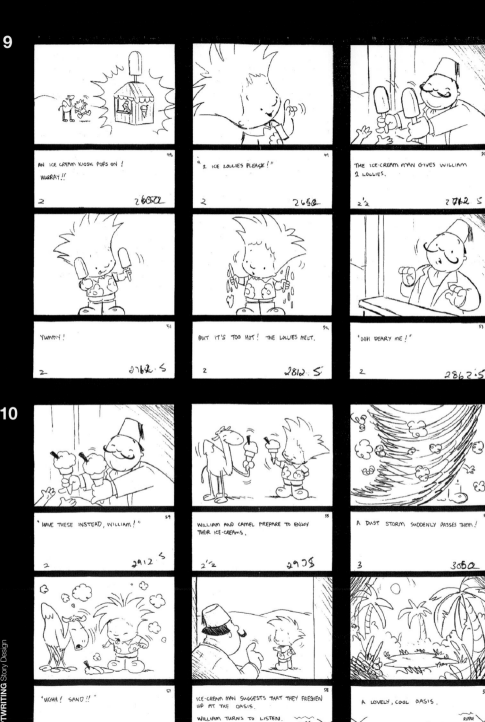

STORYBOARD NINE

Ice creams are granted but they immediately melt in the hot sun. This kind of storytelling device is important because it makes reference to already cited visual elements, which then take on specific narrative purpose. It may be obvious that a desert environment is characterised by hot sunshine, but the sun now prompts a story event. This aspect of storytelling is an important tool because it demonstrates that the writer is in command of all the story elements; even if they are not used immediately, they can be deployed later. It also shows that the writer is aware of the economy and specificity of the story, and no aspects are extraneous or arbitrary. The ice cream has now been denied twice, and the camel is no closer to finding its parents. In a more complex, adult-oriented story, this kind of moment may indicate that resolution is impossible, or requires the doubling of effort on the central protagonist's part.

STORYBOARD TEN

The ice cream vendor gives William two ice creams, but they are enveloped by a sandstorm. Here, sand is not merely present as a desert landscape, but used as an agent to prompt a story event. Crucially, this is not an unlikely occurrence in the desert and enables the possibility of an action sequence. William and the camel are covered in sand, again denied their ice creams. The vendor suggests that they try and find the oasis. A stereotypical element of the desert environment is used at a practical level to resolve the next problem.

STORYBOARD ELEVEN

Reaching the oasis is now allied to the super objective – the camel recalls that his parents live near the oasis. The ice cream vendor disappears and William and the camel walk into the distance; a long shot is used to recall the isolation of the desert and its particular rigours. William tires and considers how he might more quickly reach the oasis.

11

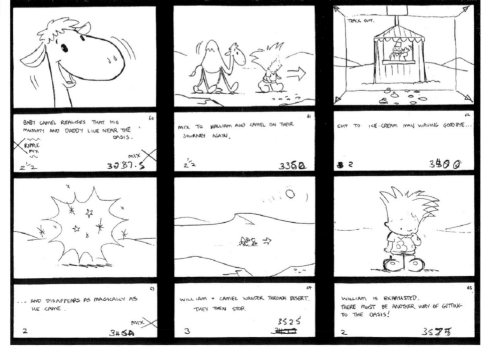

Storyboarding – Narrative as Problem Solving

STORYBOARD TWELVE

The writer must engage with the possible thought processes of a child at all times when writing children's series and play out simple ideas with clarity and precision. William's desire not to walk prompts him to think about other modes of transport – one relevant to him. William wishes for a bike and, of course, does not realise its ineffectiveness in the sand. He finds himself buried in the dunes, wishing for a helicopter. The writer must always use the shortfalls, ineptitudes and lack of knowledge in a character, as well as their qualities, abilities and distinctive characteristics.

STORYBOARD THIRTEEN

Though a helicopter duly arrives, William has once again not anticipated that it will cause a further problem – another sandstorm. Exasperated, William asks, 'How do people travel in the desert?', only to confront the irony of the camel telling him that they use camels – the ships of the desert. This narrative uses a verbal pun to drive the next aspect of the story. William wishes for a ship to 'sail' across the desert, and the pair are propelled towards the oasis.

STORYBOARD FOURTEEN

The super objective of the story is resolved when the camel is reunited with its parents. William begins to remove his boots – a convention that signals the adventure is near its completion and he will return to his home.

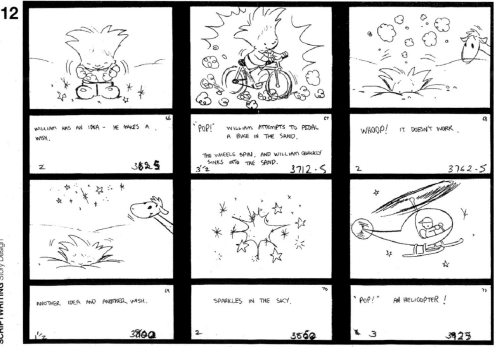

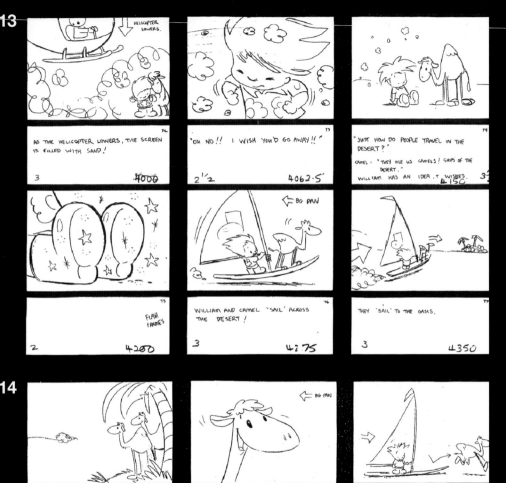

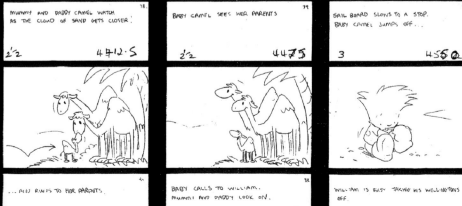

Storyboarding – Narrative as Problem Solving

15

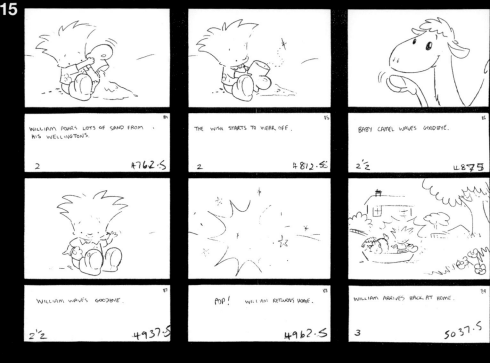

WILLIAM POURS LOTS OF SAND FROM HIS WELLINGTONS.

2 4762·5

THE WISH STARTS TO WEAR OFF.

2 4812·5

BABY CAMEL WAVES GOODBYE.

2'2 4875

WILLIAM WAVES GOODBYE.

2'2 4937·5

POP! WILLIAM RETURNS HOME.

 4962·5

WILLIAM ARRIVES BACK AT HOME.

3 5037·5

STORYBOARD FIFTEEN

William waves goodbye to the camel and
arrives back home to the sandpit. The domestic
environment always 'bookends' William's
adventures and is an important point of resolution

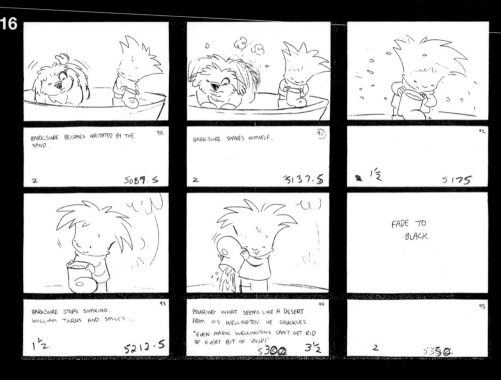

16

BARKSURE BECOMES IRRITATED BY THE SAND. 90.

2 5089.5

BARKSURE SHAKES HIMSELF. 91.

2 5137.5

92.

1½ 5175

BARKSURE STOPS SHAKING.
WILLIAM TURNS AND SMILES... 93.

1½ 5212.5

POURING WHAT SEEMS LIKE A DESERT
FROM HIS WELLINGTON HE CHUCKLES.
"EVEN MAGIC WELLINGTONS CAN'T GET RID
OF EVERY BIT OF SAND!" 94.

5300 3½

FADE TO
BLACK

95.

2 5350

STORYBOARD SIXTEEN
William is re-united with Barksure and he empties
his boots of sand, domesticating the narrative and
providing an amusing denouement.

Title: The Future of Gaming

Animator: Johnny Hardstaff

10:08:2000

THE FOLLOWING CASE STUDIES
ARE INCLUDED TO LOOK AT CERTAIN
ASPECTS OF WRITING FOR ANIMATION.
EACH ONE IS ESSENTIALLY AN
AUTEURIST APPROACH, BUT
EACH IS ALSO CHARACTERISED
BY SOME TECHNIQUES AND IDEAS
THAT ARE USEFUL FROM A MORE
GENERIC POINT OF VIEW. IN THIS
SECTION, SOME ATTENTION IS
GIVEN TO WRITING SUBJECTIVE
DOCUMENTARY, EMOTIVE
NARRATIVE, CONCEPTUAL AND
EXPERIMENTAL PIECES, COMEDY,
CHARACTER-DRIVEN WORK,
AND MATERIAL ESSENTIALLY
BASED ON SOUND.

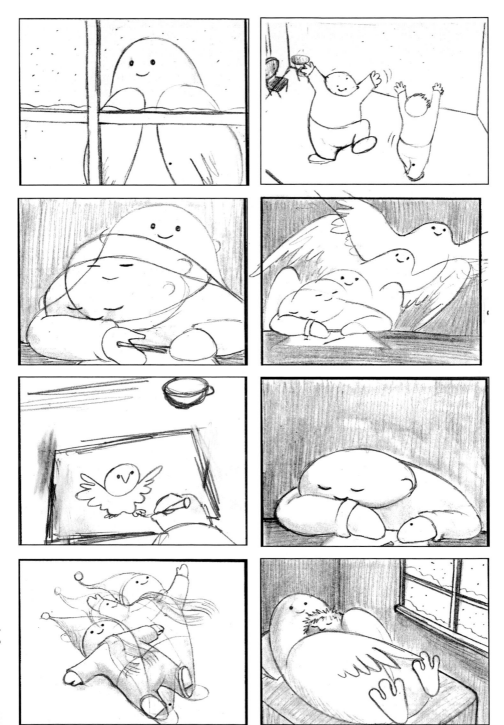

ONE OF THE HARDEST ASPECTS OF WRITING IS TO CREATE WORK THAT CAN ELICIT AN EMOTIONAL RESPONSE.

This is not the same as the kind of sentimentality found in many Disney features, which relies on a predictable response from an audience. It is the kind of emotion that emerges from a genuine empathetic connection with an audience. Once more, animation is particularly equipped to play out narratives that solicit these emotions because of its capacity to illustrate and enhance interior states, and to express feeling that is beyond the realms of words to properly capture. Interestingly, this particular aspect of animation has found one of its most pertinent places in the re-definition of traditional documentary. In what has traditionally been a genre aligned with actuality, objectivity and thesis, animation has used its specific qualities in embracing alternative, subjective realities and unorthodox histories to create highly emotive narratives, which find a common and universal response in many audiences. Viewers recognise when they have been privileged to engage with a different model of documentary, which is not about received knowledge, but perceived experience.

JOHN AND MICHAEL (2004)

Shira Avni's film *John and Michael* is an example of how a writer can exercise a responsiveness to personal subject matter, finding the most appropriate ways to engage with particular concerns. The film is loosely based on Avni's memories of close friends, John and Michael, two adults with Down's Syndrome, who she met at a Summer Camp in Ontario, Canada. Both were fun-loving figures who lived life to the full, and very much enjoyed each other's companionship.

Hearing of John's sudden death, Avni became preoccupied with thoughts about how Michael was coping with the loss. One day, hearing some sad music by a band called Ida, Avni found herself in tears, which prompted her to draw some sketches of her fond recollections of John and Michael. Having created an improvised storyboard in her sketchbook, she decided to make an animated film about the couple and contacted Ida for permission to use their music, which they duly granted. Avni felt that the film's real impact would be captured in the way the story of the two men was told. It was crucial to find a way in which the viewer would be moved by the story in exactly the same way as Avni.

Avni decided to have Brian, who also has Down's Syndrome, to read the script. She hoped he would have empathy with the subject and intuitively emote its feeling and purpose. In the end, Avni decided

Title: John and Michael

Animator: Shira Avni

These storyboard images seek to indicate the nature of the movement to follow, and suggest the ethereal, dreamlike, spiritual quality of the material addressed in the film.

SaRAH + ToNY + BiLLY + JoHN + MiCt

SCRIPTWRITING Writing Emotionally: Shira Avni

Brian would tell the story more spontaneously by responding to the storyboard she created.

Avni was careful to create a mood encompassing joy and grief simultaneously – a wonderful memory of something that is inspiring in its recollection, but painful in its loss. The visual aesthetic used brown modelling clay lit from beneath to create the effect of a stained-glass window, and the sense of an ephemeral but sacred memory. All the elements were interpreted in a visual styling that prompted memories of the playfulness of the main characters. The written script was essentially adapted by an empathetic storyteller attuned to visual narrative, whose vocal performance was augmented by the intensity of suggestion in the written lyric and music. All the elements were interpreted in a visual styling that prompted the playfulness of the main characters. Although this film might be regarded as being about disability, it is actually about humanity in its most positive light, demonstrating the importance of love, friendship, kindness and good humour.

AUDIENCE RESPONSE

Here are some pertinent responses from some students of a sociology of disability course at a university in Ontario, Canada:

'The film was very enlightening…I had no idea that people with disabilities, especially Down's Syndrome, were capable of being as physically and emotionally developed as they were in the film. Physically, the film showed that the two characters Michael and John were capable of shaving, cooking breakfast and functioning as 'normal' people would within society…When Michael grieves the loss of John it shows that he understands what it means to lose someone…'

'It was really amazing to see the impact that an animation film could have on me. At first it was hard to believe that a movie made from clay could bring so many deep emotions and real life feelings to the surface…having the disabled gentleman reading the script…brought the whole story to life because we were able to associate with what a person with the same type of disability could understand and retell…'

FOUR MODES OF ANIMATED DOCUMENTARY

Imitative: Borrowing from, revising or re-positioning established codes and conventions of newsreel, travelogue, 'fly-on-the-wall', vérité etc.

Subjective: Using individual voices or perspectives in order to evidence alternative social and cultural 'histories'.

Fantastical: Revising or re-positioning known social and historical subjects or events in a newly fabricated context to suggest a different ideological interpretation or model of critique.

Postmodern: Social and cultural narratives with no proven authenticity, actuality or authority from orthodox evidential sources, which may nevertheless offer up a relevant 'truth'.

Title: John and Michael

Animator: Shira Avni

The photographs of John and Michael become an important record of their relationship, especially when, like the film itself, they prompt the act of recollection and the comfort of memory in the face of grief.

john and michael

THE SCRIPT

This is the original script that I wrote before meeting Brian, the wonderful narrator of John and Michael. The script was written from the point of view of someone who is more literally inside the group home with John and Michael. You can see where Brian used the written lines he remembered and where he was giving his own interpretation of what he understood from the storyboard. Aside from the fact that Brian was shy about his reading ability, there are things in the script that I never thought about as something difficult for people with Down's Syndrome – i.e. the four- and five-syllable words 'enormously' and 'particularly' – were impossible for him to say! Also, the sentence structure is needlessly complex. I learned a lot from the recording session!

Shira Avni

John was very enormously big
And Michael was particularly small.
They lived together in a group home
And were the best of friends.

They liked to do all kinds of things
together and made each other
very happy.

In the mornings John would wake
up at dawn.
He'd sneak out of bed
And brush his teeth
And cook a big breakfast for everyone.
Afterwards they would clean up together
And everyone would go off to work.

Sometimes
On the warmest summer evenings
I'd see them dancing in the quiet hall
Or out on the grass
And it was as though they heard the same
Joyful music.
And then they'd collapse
And giggle at the ceiling
Or the stars.

But one day
In his thirty-second year
John's heart gave out
And he died.

And I wonder
If Michael sees him sometimes
And if he still dances
And laughs at the stars knowing
John would never truly leave him
Behind…

john and michael

THE NARRATION

People with Down's Syndrome are usually delayed in motor and language development and often have mild speech difficulty as adults. This means that the listener has to pay careful attention to what they are saying and ask to have to repeat if need be. The narrator of this film has Down's Syndrome himself and may not be understood fully on first hearing. The visual aspect of the film tells the story pretty well by itself and an attentive listener will understand the gist of what Brian is saying, and feel the emotions behind it. The text of his narration is included here.

TEXT:

Shira: So, um, tell me what the story's about.
Brian: OK, um…The story's
about…uh…Michael.
John was very very big
And Michael was
Very very small
They lived in a group home
They grew up together
And they are very good friends.
I just feel great about those two because
They are very, very special persons.

(Prompted by the question, Do you have a best friend?)
Actually, um, I do have, I do have a best friend who goes to
the same school as mine…and we used to – um – hang out…
And actually, um, we were always teasing and playing
And all that kind of stuff, so…
I just have a great time with my relationship to him.

He sneaks out of the bed
He get up and brush his teeth
He went to sleep, snoring
He got up and make a big breakfast
Have a cup of tea
And he go after and he
Close the door and go outside to go to work.

And big John say, "Shhhhh!"
After that he dances
And collapse on the floor and giggles
at the ceiling
And the stars.

This is funny, ok?
Hee hee hee…
But one day…
In his thirty-second year
John's heart gave out
And he died.

Michael was crying and upset
And he said something, um…
Did he have a nightmare, or he didn't?

He was on the bed thinking
Thinking about him
And see how do he feel.
He was feeling about John…and…
John came back and give him a hug
'Cause that's what he did.

[Song: 'Don't Get Sad']
Brian: I love the sad part
Shira: Tell me why you like the sad part.
Brian: I dunno – I just…like the sad part.

END

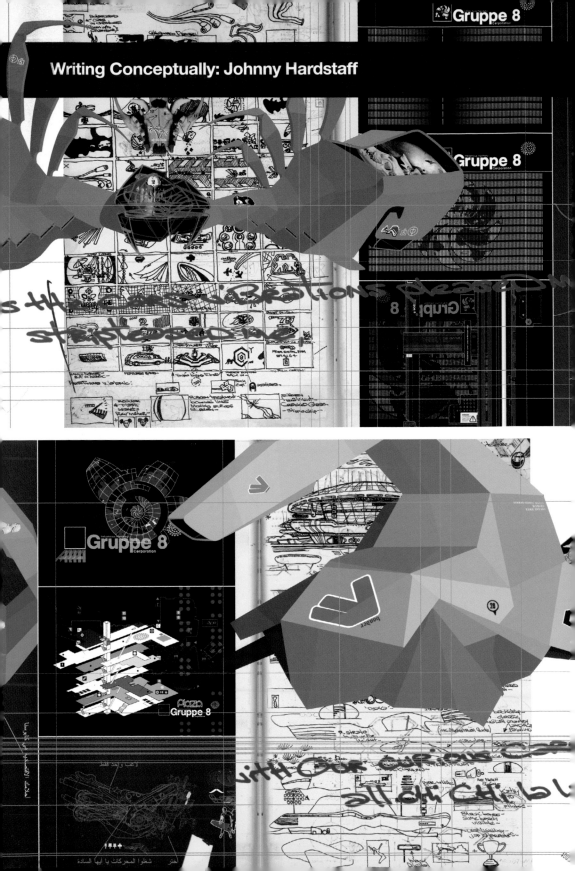

WRITING CONCEPTUALLY IS ABOUT THE METHODS EMPLOYED TO FULLY CAPTURE, EXPLOIT AND EXPRESS AN INTRINSICALLY PERSONAL AND CHALLENGING VISION.

It is crucial to look at the ways in which a writer working in this personal, sometimes 'metaphysical' style might approach using animation. This is as much about alternative ways of thinking as the structural methodologies of creating new work.

FUTURE OF GAMING TREATMENT
Cultural Studies:
Mid-term examination:
Marks awarded will make up 30% of your final grade.
Kill, Win, Drive, Explore, Fly, Fight, Escape, Control.

Everyday news.
Kill, Win, Drive, Explore, Fly, Fight, Escape, Control.
Electronic Entertainment.

Kill, Win, Drive, Explore, Fly, Fight, Escape, Control
Acceptable current affairs content, documenting
human nature?

Kill, Win, Drive, Explore, Fly, Fight, Escape, Control.
Unacceptable, barbaric and anti-social electronic
entertainment?'

Discuss the future of gaming in no more than 450 words.

(Please arrive at least 15 minutes early and assemble
outside the gymnasium. Bring a sharp 2B pencil.
Extra paper will be available.)

(Your invigilator today will be Mr Hardstaff)

Title: Future of Gaming Storyboards
Animator: Johnny Hardstaff
The intersection of Hardstaff's sketchbooks, developmental imagery
and poetic/polemic commentary in the development of his film.

In this revisionist version of a treatment (a mock examination paper), Johnny Hardstaff alludes to the ways in which the contemporary media and entertainment industries are elided in their interpretation and representation of news and current affairs. The sense of spectacle has overtaken any notion of truth and ultimately de-sensitised the creators and mediators of news outputs, along with its audience. Significantly, news, current affairs and entertainment have become indistinguishable and interchangeable, and this is the focus for the true examination of culture. Such a treatment is vibrant, informed, challenging, and radical; it suggests that the final work will have these qualities.

VISUALISATION
From the writer's perspective, it is important to recognise that the premise for this work is in visualisation. However, it is not the script or preparatory drawings that are being visualised – it is consciousness. These images are merely those developed by the artist for the artist, and as an expression of the artist. They are then constructed as an animated graphic design form to express the flux of ideas and visual principles, which in turn work as provocative stimuli for the viewer. There are many examples of this in contemporary advertising, where agencies seek out new looks and styles to delineate the distinctiveness of their brands and products. While Hardstaff's work fits into this category, it should be stressed that this is much more challenging in its signature personal outlook. Hardstaff believes that:

'Animation is a more adaptable and expressive medium than most. There is a capacity to say literally anything that is beyond most art forms. Where I see its particular strength is in its merging with the graphic visual language systems that people have been taught by industry to understand. In effect, graphic animation is best

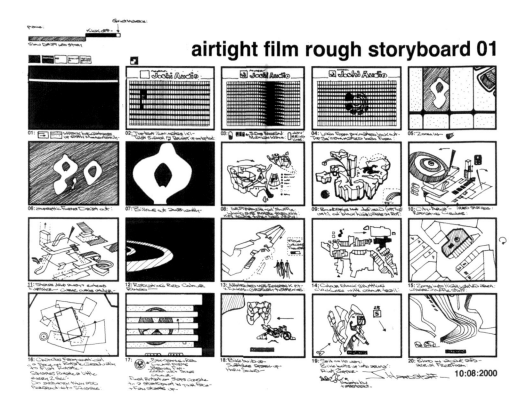

placed to represent and communicate within the virtual society that we largely exist within.

'What really appeals is the way that the blending of live action and graphic design actually offers a more accurate reflection of the culture that we live in than cinema can ever hope to generate.'

VOICE

Hardstaff's flouting of convention and his configuration of our lived experience as a much more fluid and unpredictable set of terms and conditions than the mere material and concrete informs his film-making practice. It led to the creation of *Future of Gaming* – a work that Sony disowned because of the radical nature of its narrative and imagery. Ultimately, and ironically, it was much admired by its intended core audience, and became a highly regarded and influential 'art' film, which re-defined the parameters of animation as a form. Although Hardstaff admires several key animators, he focuses on preserving his own singular voice. For the writer wishing to work in this spirit, it is very important to note that imitation and

repetition are not part of the processes of expression in this kind of work. He adds:

'All of my projects start their life within my sketchbooks. It is very often just a small thumbnail sketch that will spark an entire film, or the contradiction formed by two very different images that occur next to each other on a page in my sketchbook that will generate the initial idea or impetus to make a film. If I find myself drawing something over and over, then it is usually the start of something bigger. The idea develops and mutates in a very natural way within my sketchbooks, and in many ways forms itself, and then each has an equally individual way of coming into being.

'In a sense, I make innate connections between icons and images and words, and I deliver this in a less than traditional manner that makes sense to me, and in doing so, I hope that it will make sense to others. This is how I storyboard. It is an organic process. It changes and mutates and hopefully I gradually improve upon it all the way along until it is finished. It's not a traditional way of working perhaps, but then maybe that's why

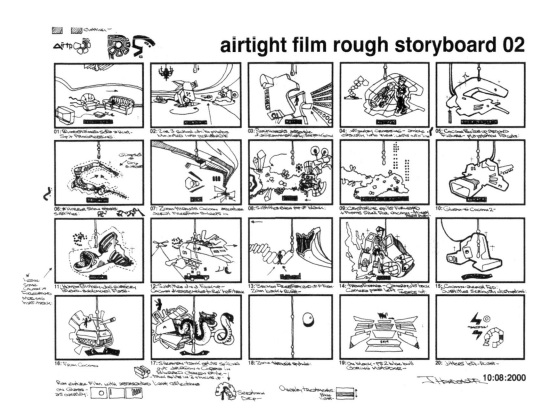

airtight film rough storyboard 02

it is effective for me. In short, it simply mirrors my own mental process. I rely on my own logic system to deliver what I want to say in what strikes me as the most suitable manner. The danger of working alone is that you have to trust your voice. You have to trust your ideas. You have to be single-minded if what you are going to make is to be in some way different to everything else out there, and therefore in some way worthwhile.'

Hardstaff's partly polemical stance offers an important perspective for writers and devisers in the sense that finding a method by which to record and accommodate a specific vision is informed by resisting other inappropriate ways of working. Finding an original voice is wholly about knowing what current trends and conventions are, and in some way rejecting them, while at the same time developing a visual language that can best express a conscious, emotional and intellectually provocative point of view. It accords with the notion of primal animation cited earlier, but also embraces other generic aspects of

Title: Future of Gaming Storyboards
Animator: Johnny Hardstaff

Hardstaff's improvised sketches and visual motifs played out in his sketchbooks begin to find more concrete expression in his projected storyboards, but it should be noted that these images are informed more by Hardstaff's sense of graphic design than 'cinema'. Hardstaff's 'animation' largely comes within the mise en scène, rather than through more metamorphic or montage strategies.

animation. *Future of Gaming* is a symbolic embodiment of an artist's consciousness and a literal expression of a personal perspective on the world. The animation writer in this case mediates internal engagement with emotional and psychological quandary into an external statement of personal and political import.

Writing Conceptually: Johnny Hardstaff

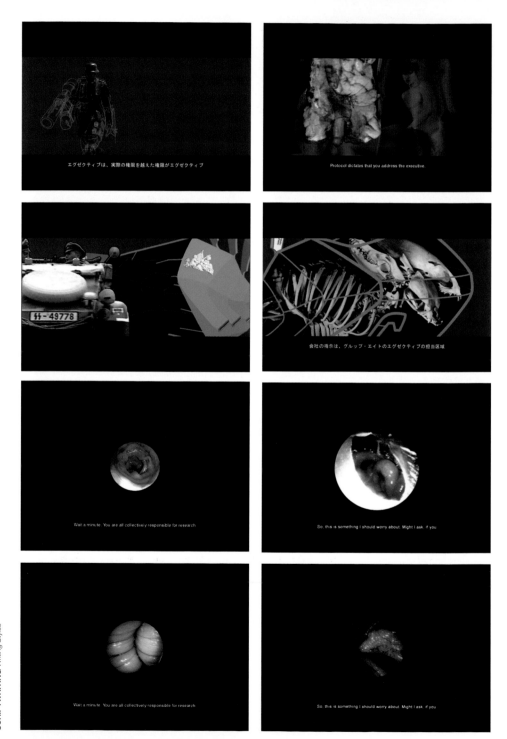

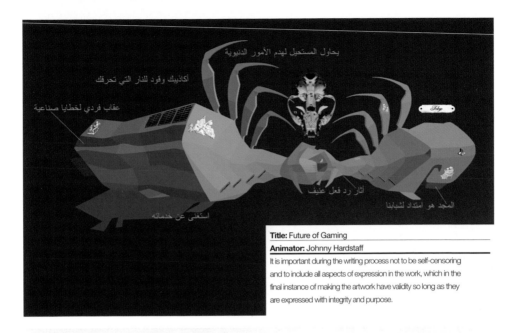

بحاول المستحيل لهدم الأمور الدنيوية

أكاذيبك وقود للنار التي تحرقك

عقاب فردي لخطايا صناعية

Tulip

استغنى عن خدماته

أثار رد فعل عنيف

المجد هو امتداد لشبابنا

Title: Future of Gaming

Animator: Johnny Hardstaff

It is important during the writing process not to be self-censoring and to include all aspects of expression in the work, which in the final instance of making the artwork have validity so long as they are expressed with integrity and purpose.

DEVELOPING AN INDEPENDENT VOICE

Be ambitious.

Be daring.

Seek inspiration from the forgotten past and your imagined futures, not from the contemporary and modern day.

Be afraid to say nothing, but don't be afraid to say anything.

Be brave.

Be utterly different. If you've seen it, avoid it. If it reminds you of something, don't do it. Expose yourself to everything outside of the interests of your field. Seek your inspirations beyond all others.

Be innovative and dangerous.

Be political.

Whatever people are currently doing, do the opposite. There is no simpler direction to original and innovative work than that.

Experiment.

Be contrary and difficult; accept no rules.

If there is an accepted way of doing something, do not accept it.

Challenge and test your medium.

Make it do things it has never done before.

Avoid convention.

Rather than ape cinema, music video or whatever, confront it. Challenge it. Ultimately, your role is to expand the parameters of now and to initiate some form of progress. You should be redefining tomorrow, not looking at the language of today.

Above all else, you must say something pertinent, something with emotional resonance.

If it's mindless, it's absolutely inexcusable.

Work differently.

Writing Character: Adam Elliot

THE ANIMATION FIELD OFTEN ATTRACTS WRITERS AND FILM-MAKERS WHO SEE AN OPPORTUNITY TO EXPRESS THEMSELVES IN A DIFFERENT WAY, OFFERING MORE MARGINALISED PERSPECTIVES AND OUTLOOKS.

Academy award-winning director, Adam Elliot, falls into this category. While his work might represent a pronounced and detailed engagement with the less well-regarded or misunderstood members of society, his major skill is in delineating complex notions of character, as it may be best represented in the animated form.

Elliot's key recognition that human kind treads a fine line between tragedy and comedy, bathos and pathos, success and failure, has meant that his approach has always been characterised by using the seemingly intrinsic 'innocence' of the animated film to foreground singularly adult concerns.

HARVIE KRUMPET (2003)
Harvie Krumpet is Elliot's most well-known and most admired work. Elliot believes that 'storytelling is equipment for living' and his writing style is based on the following broad principles:

The compilation of a list of interesting events to go in a provisional narrative.

A creative outlook which requires that such events need to reveal idiosyncratic or quirky aspects of human experience.

The rejection of plot in favour of the construction of vignettes of personal experience as accumulating story events.

Title: Harvie Krumpet

Animator: Adam Elliot

Harvie Krumpet, Elliot's Oscar-winning film, tells the story of the life of Harvie, which highlights issues of difference because he has Tourette's Syndrome. It also touches on the relativity and arbitrariness of existence, set against the illusion of fact, habit, routine and order. Harvie's mother teaches him facts when he is young, as if they are the guarantee of stability and continuity. As his life unfolds as a catalogue of bad luck, illness and ephemeral comforts, notions of objectivity, predictability and relief disappear. Interestingly, the film remains amusing despite its bleakness because it recognises that the only way to deal with alienation and ambivalence in life is to laugh at them. Animation is often absurdist – foregrounding the truth while delivering it through acceptance and good humour.

SCRIPTWRITING Writing Character: Adam Elliot

The importance of concentrating on character details, which ultimately become the subtle but key links between character, and inform relationships.

The imperative to recognise that almost all kinds of experience can be viewed simultaneously as both serious and amusing, depending upon perspective, outlook and 'the moment'.

The need to concentrate on minimal gestures when animating characters and to reduce excessive aesthetic tendencies. This approach has a direct effect on the way scenes and sequences are written.

The objective of being honest in the work rather than seeking perfection.

Elliot's approach was developed by often feeling disappointed when watching animation, recognising that it was technically good, but informed by a poor story. His intention was to engage with 'real people' through close observation in order to delineate archetypal traits and empathetic characteristics that would be identifiable to his audience. This was achieved by keeping detailed notebooks, thinking about tendencies in biography and autobiography, and the constant imperative to think about the accumulation of experience rather than a contrived story structure.

Elliot stresses that it is important not to exploit character, but to achieve empathy through integrity and respect. *Harvie Krumpet* was essentially an amalgamation of people, but all his experiences were believable and universal.

Underpinning this further is Elliot's preoccupation with 'the outsider' – this sense of 'difference' while defining his characters is actually empathetic for viewers because it is often how everyone actually feels about their personal and social status. Elliot recognised that people's sense of alienation from others was a common aspect of human experience and was often reconciled through humour. He encourages prospective writers to live fully, taking in all elements of those around them without judgement; to cultivate awareness through research and investment in the arts in order to avoid cliché; and to engage viewers in the 'truth' of a good story.

THINKING ABOUT CHARACTER

Characters are defined by story events.

Character is revealed by the choices and decisions made.

Characters have observable external qualities and traits, and perceivable internal motivations and objectives.

Character development should be revealed through the narrative structure in a 'character arc'.

A single character often determines the point of view of a narrative.

Characters – whether they are likeable or despicable – should be in some way empathetic.

Characters can win the sympathy of, or identify with, the viewer by being good-natured, unjustly victimised, curious, familiar, powerful etc. Crucially, they must be clearly motivated towards a desired goal.

Title: Harvie Krumpet

Animator: Adam Elliot

Harvie Krumpet is a fine example of character writing because he is conceived truthfully. His disability is viewed as part of his 'toolbox' for living, challenging audiences to accept, enjoy, empathise, and engage with the 'tragi-comic' circumstances it provokes.

INTERNATIONAL POST PRODUCTION SCRIPT PAL DIGITAL BETACAM 25FPS			HARVIE KRUMPET 2	
SCENE	START END	TOTAL SEC.FR	SPOT No.	DIALOGUE
01:02:13:00	FADE OUT.			
01:02:14:00	FADE UP.			
01:01:14:00	WS in a tiny alpine cabin under a full winter moon, the lights are on and a baby is crying.			
	01:02:14:200 3:15 01:02:18:10		8	[Super] Poland 1922
01:02:18:20	MS Closer to the cabin as the baby cries.			
01:02:21:08	CU Baby Harvie is crying in the arms of his mother, Liliana. Then he stops.			
	01:02:24:000 7:00 01:02:31:00		9	NARRATOR [V/O] Harvie was born into the world upside down, back to front, and was christened Harvek Milos Krumpetzki
01:02:31:11	WS Baby Harvie's father, Maciek, is standing by the bed.			
01:02:33:12	CUT TO CU MACIEK			
	01:02:32:100 2:08 01:02:34:15		10	His father's name was Maciek.
	Maciek accepts baby from mother, and holds him in the air			
	01:02:34:200 5:15 01:02:40:10		11	a lumberjack with hands as big as shovels and hair that smelt of pine needles.
01:02:40:11	MS Liliana, in bed. 01:02:41:100 2:08 01:02:43:15		12	His mother's name was Liliana.
01:02:44:02	CU Liliana.			
01:02:47:01	CUT TO MS Liliana, working in a mine.			

Copyright (c) 2003
The AUSTRALIAN FILM COMMISSION, SPECIAL BROADCASTING SERVICE CORPORATION,
FILM VICTORIA and MELODRAMA PICTURES

INTERNATIONAL POST PRODUCTION SCRIPT PAL DIGITAL BETACAM 25FPS			HARVIE KRUMPET 4	
SCENE	START END	TOTAL SEC.FR	SPOT No.	DIALOGUE
01:03:22:10	CUT TO CU Harvie. He's twitching.			
	01:03:20:20 05:15 01:03:26:10		21	But soon his parents began to notice .. peculiarities ..
01:03:29:18	CUT TO CU his index finger touches an apple			
	01:03:27:00 04:10 01:03:31:10		22	NARRATOR [V/O] He began to have odd twitches and liked to touch things with his index finger ..
	01:03:32:00 01:09 01:03:33:09		23	.. for no reason at all
01:03:33:10	WS Maciek is in the corner with Harvie, who's standing on a stool.			
	01:03:35:05 03:20 01:03:39:00		24	When he met someone, he had to touch them on the nose.
	Harvie touches Maciek on the nose.			
	01:03:39:20 02:15 01:03:42:10		25	The doctors said he had Tourette Syndrome ..
	01:03:42:20 03:10 01:03:46:05		26	a brain disorder that meant he couldn't control his impulses
	01:03:46:20 02:15 01:03:49:10		27	It was like trying to control a sneeze.
	Harvie touches his own nose.			
	01:03:50:00 02:20 01:03:52:20		28	There was no cure or explanation.
01:03:54:06	CU at school, Harvie's drinking his milk through a straw.			
	01:03:54:18 02:20 01:03:57:10		29	At school, Harvie was called a thick.

Copyright (c) 2003
The AUSTRALIAN FILM COMMISSION, SPECIAL BROADCASTING SERVICE CORPORATION,
FILM VICTORIA and MELODRAMA PICTURES

CHARACTER CONFLICTS

PERSONAL PREOCCUPATIONS
Struggles with inner-turmoil, self-consciousness, desires, needs and fantasies.

SOCIAL PREOCCUPATIONS
Engaging with other people in families, romantic relationships, friendships, workplace and social acquaintances.

CULTURAL PREOCCUPATIONS
Dealing with the impact of society and its affecting infrastructures for example, the legal system, social institutions, the media etc.

ELEMENTAL PREOCCUPATIONS
Working with natural forces and the physical and material aspects of the environment.

CONSTRUCTING CHARACTER

Characters can be established in a number of ways, but the following perspectives require consideration:

Addressing the character's background and any key formative contextual information.

Creating dominant psychological, emotional and physical traits.

Determining the 'inner' state of the character, and the core objectives and motivations that define the character's purpose.

Considering how a character would behave in a specific scenario or respond to a particular place.

Determining the character's position on a range of topics and activities.

Thinking about how a character works and uses objects in specific environments.

SCRIPTWRITING Writing Character: Adam Elliot

WHILE IT IS TRUE TO SAY THAT MANY COMEDY WRITERS HAVE AN INTUITIVE GIFT FOR RECOGNISING A GAG OR A COMIC SITUATION, THERE ARE A NUMBER OF APPROACHES THE WRITER CAN ADOPT AS A SET OF TOOLS FOR WRITING COMEDY MATERIAL.

It is important to remember that comedy is not so much a genre as a way of looking at the world. It has a very particular relationship to its audience because it requires a specific response for its acceptance and success – recognition in the form of joyful laughter. The key preoccupation of the comedy writer is not the structure of a joke or gag, but the mechanism that prompts the laugh.

Philosophy professor Ted Cohen has made some helpful observations that are useful to the writer. He notes that 'all jokes are conditional' – the audience will need to have particular knowledge to understand the joke, and that this knowledge is in some way already embedded in their sensibility, to be recalled by the common bond of the comic observation. He calls this a 'hermetic' joke – one that prompts an intimacy between the joke teller/writer and the audience. If someone doesn't 'get' the joke, the relationship breaks down; or worse, the joke may cause indifference or offence.

Title: Johnny Bravo

Animator: Van Partible

Van Partible successfully creates a comic character by focusing upon consistent core traits and qualities, and finding contexts in which they are continually exposed and undermined.

The second conditional aspect of a joke is the context in which it is told. This requires a particular sensitivity in the writing because it is clear that there is no subject that is taboo in joke-making – its delivery is subject to pertinence and timing. Many writers fear they will offend their audience by pushing at a taboo too much in order to find an original observation or repressed commonality, but this is often resolved by placing perhaps less acceptable or challenging views into the mouths of created characters. Further, deliberately critical and sometimes abusive jokes – in reality, the common stock of much comedy – can be played out in ways that either work as cathartic expressions of negative feelings or compound the tensions and difficulties between different social and cultural groups. Many commentators concur that joke-making itself is a way in which humankind can embrace taboos.

JOHNNY BRAVO (1997)

Many comic characters are effectively based on obvious traits or highly stereotypical elements. These become short cuts to heighten the efficiency of the gag structures. All comic effects are achieved through a particular sense of timing; speed and directness are the essence of much cartoon and animation humour. For the most part, the comic character is dramatised through some presiding and repeated preoccupations and behaviour. The following extract from Van Partible's bible for *Johnny Bravo* readily articulates this:

He's got the body of Adonis and the brains the size of an electron. His primary agenda is getting 'chicks', while keeping his hair looking good. Johnny is the poster boy for the 'lovable idiots of the world'. He has the testosterone of a high school football team, an ego the size of the Western hemisphere and an idiotic pick up line for every woman in the world.

See, that's one of Johnny's key concerns in life. He's out to get babes. Sure, he's got a warm heart at the center of it all, it's just that he's in a perpetually adolescent, hormone-driven phase, which causes him to ignore good judgement most of the time. It all stems from his insecurity and constant need for attention, of course, but he'd never let you know that. Hey, he doesn't even know that. It's a very base type of macho honour. His actions, his behavior, his dress etc. can almost always somehow be traced back to that one – for him – unattainable goal: the female.

Anything else that's 'cool' or could otherwise further his noble goal of impressing the womenfolk is alright in Johnny's book. This, of course, includes cars.

Johnny's charm stems from his childlike enthusiasm and innocence. He's also very naive. Johnny may have the body of a grown-up, but his mind is definitely pre-teen. But Johnny is never, ever mean-spirited about these things and when he gets caught – and he always gets caught – he's always sorry. He never gets rewarded for doing the wrong thing...after all, that wouldn't be right.

This character piece is, of course, based on Johnny's core traits, but the key part of this bible is that they are problematised, implicitly played out and contextualised; it is this that makes it not merely a helpful case study for a comic character, but for any character per se. Johnny's outlook, emotional parameters, qualities, shortfalls and attitudes to others are readily detailed in the character bible. It delineates his character and suggests possible jokes and storylines. The revelation of the central protagonist through the problems and difficulties he has to overcome is the main premise of most narratives, comic or otherwise.

This is exemplified in 'It's Valentine's Day, Johnny Bravo', where Johnny pursues a date for Valentine's Day, which also happens to be his birthday. The episode has a simple structure, but these structural dimensions become the platform for the construction of gags:

1. *Johnny's extended personal preparation for his birthday/ Valentine's Day.*
2. *Johnny rejects his mother's offer to set him up for a blind date.*
3. *Johnny rejects 'neighbourhood girl' Suzy's Valentine affections.*
4. *Johnny goes to the library to meet 'chicks' and is rejected by all of them.*
5. *Johnny tries to meet 'foreign girls' and attempts to attract girls by having a cute dog. He fails.*
6. *Johnny meets his blind date 'Heather Asplund' and is kissed by her.*
7. *Johnny has a mid-kiss dream featuring Donny Osmond.*
8. *Johnny and Heather enjoy their mutual physical vanity and fall for each other on a great date.*
9. *Heather is actually an undercover CIA agent who hypnotises Johnny, so he will forget her.*
10. *Mama throws Johnny a surprise birthday party. He receives a gift from a secret admirer – a stuffed animal, actually won by Johnny for Heather on their now forgotten date.*
11. *Johnny hits on a Pizza delivery girl in true Johnny-will-never-learn style denouement.*

REPETITION

Repetition and escalation are crucial to this kind of comedy. Having already been slapped and rejected in numerous ways by a number of women, he must then endure the following musical montage:

1. *Johnny tries to pick up a woman and gets beaten up.*
2. *Johnny tries to pick up another woman and gets beaten up in another fashion.*
3. *Johnny tries to pick up another woman and gets stun gunned.*
4. *Johnny tries to pick up another woman at a swimming pool and gets eaten by a shark.*
5. *Johnny tries to pick up another woman and gets trampled by a herd of buffalo.*
6. *Johnny tries to pick up another woman and gets thrown out of an airplane.*
7. *Johnny tries to pick up a skydiver as he's falling from the airplane. The skydiver pulls her parachute as Johnny falls crashing into the ground.*

Like Chuck Jones's *Roadrunner* cartoons, there is effectively a minimalist structure, which is mined in the maximum amount of ways, appealing through the familiarity of its repeated motifs. It is often said that 'comedy is a man in trouble', and Johnny readily exemplifies this seemingly universal rule.

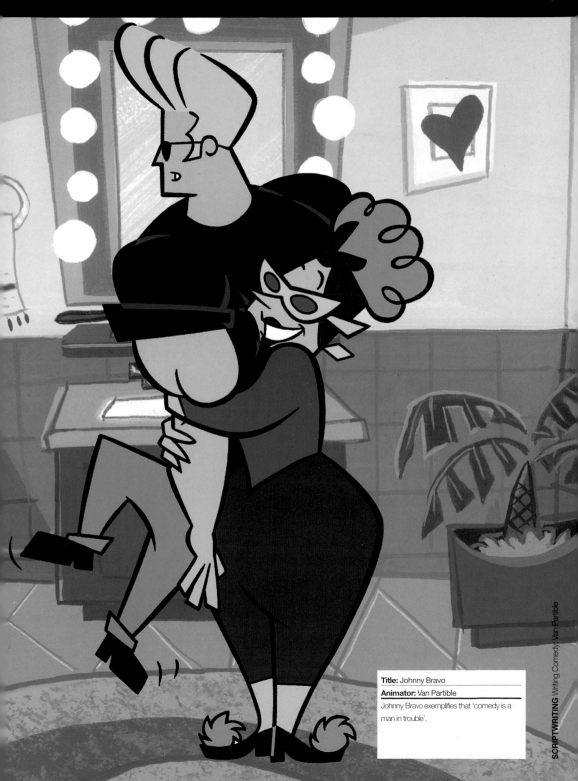

Title: Johnny Bravo

Animator: Van Partible

Johnny Bravo exemplifies that 'comedy is a man in trouble'.

Writing Comedy: Van Partible

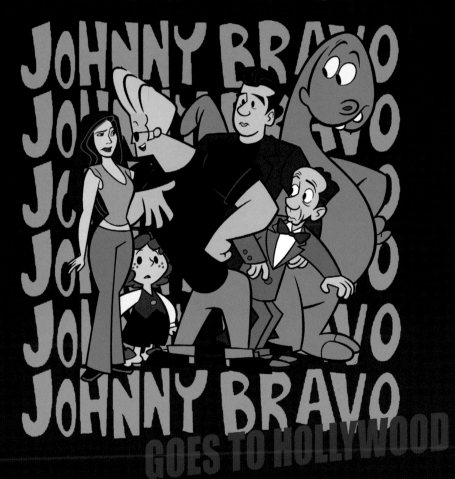

ALEC BALDWIN JESSICA BIEL DON KNOTTS
TIA CARRERE KEVIN MCDONALD MARK HAMILL
and HAL DOUGLAS as Some Talking Sky Man

JOHNNY BRAVO
JOHNNY BRAVO
JO
J
J
JOHNNY BRAVO
JOHNNY BRAVO
GOES TO HOLLYWOOD

A CARTOON NETWORK PRODUCTION "JOHNNY BRAVO GOES TO HOLLYWOOD"
WITH THE VOICE TALENTS OF JEFF BENNETT MAE WHITMAN BRENDA VACCARO GREY DELISLE
JESS HARNELL TOM KENNY ROGER ROSE AND FRANK WELKER AS JABBERJAW
ART DIRECTOR DAN HASKETT MUSIC COMPOSED BY LOU FAGENSON ANIMATION DIRECTION ROBERT ALVAREZ
STORYBOARDED BY DAN HASKETT VAUGHN TADA WRITTEN BY VAN PARTIBLE CRAIG LEWIS
EXECUTIVE IN CHARGE OF PRODUCTION FOR CARTOON NETWORK ANDREA LOPEZ SUPERVISING PRODUCER BRIAN MILLER
LINE PRODUCER DIANA RITCHEY-BERMAN CREATED AND PRODUCED BY VAN PARTIBLE

CARTOON
NETWORK
STUDIOS

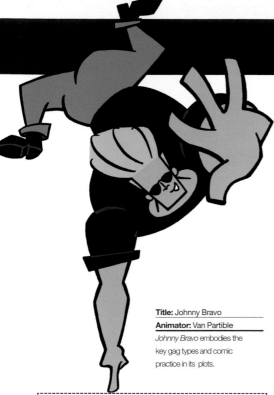

Title: Johnny Bravo

Animator: Van Partible

Johnny Bravo embodies the key gag types and comic practice in its plots.

SEVEN KEY GAG TYPES

Over-statement: Exaggerating linguistic statements or physical actions to further reveal the absurdities of language or bodily ineptitudes.

Reversal: Reversing the anticipated outcomes of a comic scenario to create an unexpected or surprise conclusion.

Impropriety: Challenging moral, social and ethical codes of 'polite' expression, conduct and behaviour by directly and literally playing out the taboo, particularly in relation to bodily functions, extreme views etc.

Innuendo: Employing expression that has a double meaning and is potentially taboo-breaking in its suggestiveness.

Substitution: This is similar to the innuendo gag, but is essentially a physical, gestural or graphic visualisation of double meaning.

Repetition: By constantly repeating phrases, actions and motifs beyond their logical usage and place, these elements take on the currency of anticipated points of comic expression.

Under-statement: The opposite of exaggeration, but potentially equally effective in pointing out a comic or ironic observation. Sometimes this can work by stating the literal truth about a situation.

THREE THEORIES OF COMEDY:

Superiority: After Hobbes, this theory says we need joke-making in all forms to feel superior to others around us whom we don't particularly know or understand.

Relief: After Freud, this theory says we need laughter to release bottled-up energies that might otherwise have negative or undermining psychological effects, which signal pleasure in their expression.

Incongruity: After Kant and Bergson, this theory suggests that we laugh at the 'incongruousness' or mis-matching of what we expect to occur in a particular scenario and what actually occurs. Joke constructions deliberately create these incongruities in devices such as puns, double meanings and 'illogicalities' made logical by the way they are placed in a particular environment.

TYPES OF COMIC PRACTICE:

Accidental/Physical: Often known as 'slapstick', this represents a physical routine or comic 'business', and usually involves things going wrong, the loss of physical control and autonomy, and the concomitant loss of dignity or status.

Discontinuity: Orthodox routines and practices – the conditions underpinning habit and expected outcomes – disrupted by illogical or surreal events, that merely serve to point up the absurdity of their difference, and point up the chaos lurking within the predictability of human existence.

Object-response: The belief that objects, artefacts and machines have a life of their own, and are inevitably disruptive, almost inevitably challenging humankind's need to master them. Things not working properly or breaking down, preventing proper communication or the efficient conduct of necessary work are central to much comedy.

Object-embrace: If it is the case that objects can rise up and undermine humankind, then it is just as much the case that humankind can 'fight back'. This normally occurs in three ways – where the object is destroyed, where the object is used against others, and where the object is re-deployed and assimilated in a new and positive way by an inventive owner or user.

Self-consciousness: The use of psychological, emotional and physical flaws in the human sensibility as the subject and object of gags.

TERKEL IN TROUBLE (2004)

Director Kresten Andersen embraced the influences of *The Muppet Show*, *The Simpsons*, and most particularly *South Park*, to create a radical version of the children's story, abandoning Disney-style sentimentality and moral trauma, and reflecting some of the indifference, cruelty and abandon of children's relationships with each other. Andersen and his colleagues added generic elements from the horror genre to create a more threatening atmosphere and a greater sense of anticipation. At its most extreme, the film features a child suicide as a result of bullying; it does not baulk at dialogue that commonly includes children swearing, parental abuse, and a general disdain for authority and ritual. In some senses, the 'excess' here is merely telling another truth – one that does inform some children in some situations and is all the funnier for its exposé.

Comic characters are for the most part types who embody repeated motifs in their behaviour, attitude and physical dysfunction. The key character in *Terkel in Trouble* is Uncle Stewart. His defining characteristics include a beard, waistcoat, wooden shoes and a red nose.

The core aspects of his character – the drinking, the anger, the generational (in)difference – are all played out against type: Uncle Stewart works on telephone helplines for children. Here is an extract that exemplifies the ways humour emerges from this incongruity:

Uncle Stewart: *Children's helpline, Stewart speaking.*

Terkel: *Hi Stewart, it's Terkel.*

Uncle Stewart: *Well, hello Terkel. Tell you what, I'm working right now…*

Terkel: *I know but…*

Uncle Stewart: *Well, you'll have to call me back some other time. I have to be ready for the kids and their problems.*

Terkel: *But I've got problems too.*

Uncle Stewart: *Do you?*

Terkel: *Yeah, that's why I'm calling.*

Uncle Stewart: *Fair enough.*

Title: Terkel in Trouble

Animator: Kresten Andersen

Uncle Stewart is a typical comic character in embodying traits that violate social and cultural conventions. Many of the pleasures for the audience are based on the enjoyment of his breaking the rules and operating outside the acceptable limits of everyday human conduct and expectation. When comedy is not grounded in common recognition, it is often based on fantasy violation of taboos and laws.

Uncle Stewart: Tell us about it, mate!

Terkel: It's because I get bullied at school.

Uncle Stewart: Yes... but what's the problem?

Terkel: They call me an animal torturer, a copycat and...

Uncle Stewart: I have to say, that's not very creative is it? What about shit-kicking swine?

Terkel: But Stewart...

Every aspect of the expected behaviour from a professional carer is violated by Uncle Stewart – he doesn't listen to Terkel's problem, and suggests more foul-mouthed insults. All, of course, done as if he still believes he is helpful and supportive. This is the comedy of excess and exaggeration, where the core taboo of being uncaring and brutal towards children is broken, but with considerable ironic effect.

VIOLENCE IN COMEDY

Writing comedy in animation is in some ways enabled by its intrinsic artifice. Violence has always been regarded as comic fare in animation, because no one is actually hurt no matter how excessive the brutality. Indeed, the sheer emphasis on physical motion and visual information in animation facilitates many slapstick and sight gags informed by the incongruity of actions and events. Similarly, the lack of realism in the characters is often an advantage when creating an extreme gag, because in its creation and reception, the amusement may require a 'momentary anaesthesia of the heart' (Bergson, 2005).

In other words, to enjoy the gag, it is important that no real sense of humanity or care is present at the moment of enjoyment, otherwise the joke might be compromised by concern or objection. The comedy writer needs conviction in this respect, as matters of taste should not undermine the desire to create a comic situation or outcome.

Characters either need to say something funny, do something funny, or be something funny, and the writer has to choose what this is on the basis of experience, observation and the structural skills listed and advised previously. On the surface, Uncle Stewart is a boorish, unacceptably rough, anti-social character, but these characteristics are the very essence of his comic role. The comedy writer must trust their own comic view of the world and look for the common absurdities, cruelties, silliness and follies that bind us all.

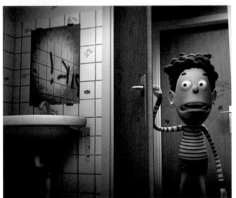

Title: Terkel in Trouble

Animator: Kresten Andersen

Terkel in Trouble is a comedy of excess and exaggeration –
one in which core taboos and expectations are broken with
considerable ironic effect.

UZI GEFFENBLAD OF ZIGZAG ANIMATION DEFINES CHARACTER PRINCIPALLY THROUGH SOUND IN HIS FILM *AMONG THE THORNS.*

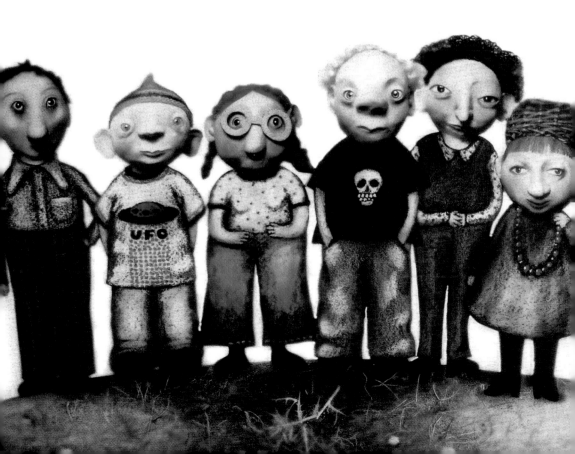

AMONG THE THORNS (2005)

While a number of films – most notably a story like *Peter and the Wolf* – use music as a symbolic motif to introduce and partially define the protagonists, Geffenblad is keen to use sound to explore a character's complexity. He believes that every character holds a secret and finding out the secrets of the characters is the real story of every film. The success of building a character is based on critical observation, but as Geffenblad also notes:

'It is important to remember that a character is never a mirror of someone or a true portrait. It's only a model to look at. If sound is to be a significant contributor to the narrative, then the relationship between the characters is actually more important than each character by itself.

'Design is also crucial. The designer has to understand the character and how to catch all aspects of it. It's important that the first impression in the film is right. A good character makes the spectator want to know more about it. Telling the story with sound gives both the audience and the film-maker a larger space for imagination and interpretation.

'Thinking of sound is part of writing a manuscript. It even affects the composition of a picture. You can use sounds to raise a question in the spectator's mind and then solve it with the picture/action some seconds later. And sometimes silence is the strongest sound you can use.'

Sound in animation can be the preoccupation of the sound technician, the editor, the animator and the director, but it is important that the writer considers what sound can achieve at the script stage. Sound could greatly determine the choices of imagery, the exact nature of what has to be animated, and what combination of dialogue, music and sound effects will be required. Geffenblad believes that the chief function of sound, however, is to make the spectator believe in what they see.

The more creative writer will avoid too much dialogue and over-excessive sound effects and music; these have sometimes been the over-amplified staple of television cartoons. The choices the writer makes in the initial scripts might provoke significant changes in the production process itself.

Geffenblad offers another remark that is pertinent to the writer seeking to take into account the relationship between sound and image. He notes that 'sound effects are faster than visual effects'. When writing descriptors in scenes, it may be that the writer must consider the difference between the 'functional' sound that merely accompanies action and the 'conceptual' sound that prompts its suggested meaning. Being aware of this difference ensures that the visualisation is always pertinent in the ways it supports the soundtrack or offers a counterpoint to it. This relationship is often one of the most powerful factors in achieving work of remarkable originality and effect.

Title: Among the Thorns

Animator: ZigZag Animation

Sound is a crucial component of communication both for the characters in *Among the Thorns* and for the audience. It signifies mood, atmosphere, attitude and emotion, and prompts the timing and authentic action of certain sequences. The film is set in a summer music camp, where a little boy's desire to play music helps to resolve some of the issues among his father, the orchestra conductor, a horn player, and the orchestra.

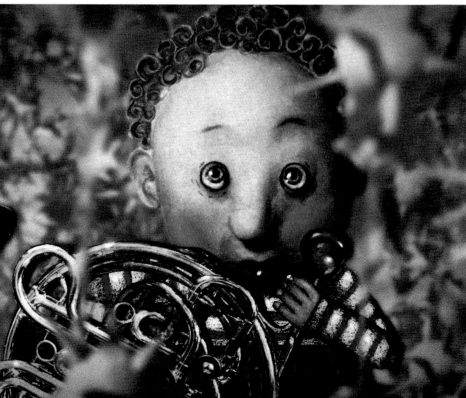

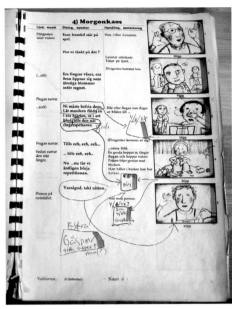

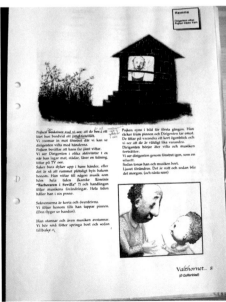

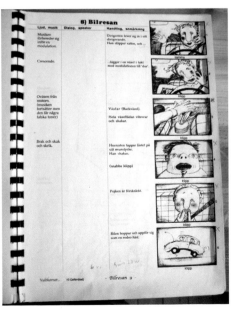

Title: Among the Thorns

Animator: ZigZag Animation

Geffenblad's original conception of the narrative in
storyboard form, and some original sketches of the
conductor's hand gestures – illustrating how music
functions pertinently to the animated motion.

JOAN ASHWORTH, PROFESSOR AND HEAD OF ANIMATION AT THE ROYAL COLLEGE OF ART, UK, IS AN ESTABLISHED 3D STOP-MOTION ANIMATOR, WHOSE FILM *HOW MERMAIDS BREED* REPRESENTS A SIGNIFICANT STEP FORWARD IN HER ARTISTIC ENDEAVOURS.

P.O.V.

HOW MERMAIDS BREED (2003)

The film represents an example of 'writing experimentally' both in the aesthetic and thematic approaches. Inspired by the traditions of Chinese foot-binding and Hans Christian Andersen's famed tale of *The Little Mermaid*, Ashworth wished to explore the overall theme of the physical and material oppression of women,
and to create a narrative that changed some of the mythical and cultural assumptions of these representations. Ashworth says:

'I explored these ideas for some time, but found that the narrative became too complicated. Eventually, with script editing help from my producer Martin Greaves, I stripped the story down to a mermaid in search of semen to fertilise her eggs.

'I liked the idea of her not being prepared to change into human form to procreate. Because of this reluctance to transform, she risks her race dying out.'

The role of the script editor can be very important – it aids an objective reader to focus on the core principles and outcomes of the story. The development of a story can be very problematic, and any pragmatic approach that can be undertaken to help in any way should be fully considered. Ashworth fully utilised her skills as a traditional 3D animator; she was prepared to use the technology available to facilitate her writing process more effectively. She didn't want to draw a storyboard. Instead, she made some figures and a set from white plasticine, and shot still photographs with a macro lens.

Title: How Mermaids Breed

Animator: Joan Ashworth

One of Ashworth's original sketches for her film, showing a man rowing from two perspectives, capturing the seamless, 'flowing' aesthetic, which she wished to create in the computer-generated depiction of clay, stone and sea forms.

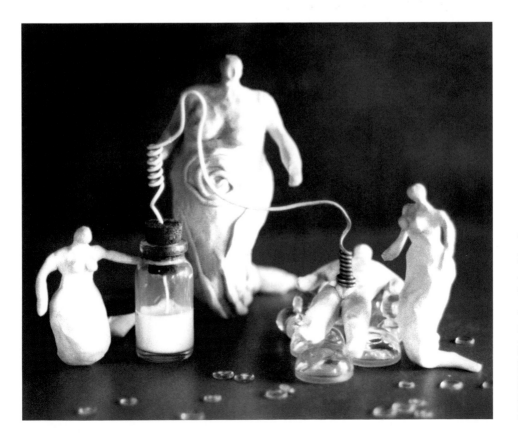

This strategy is useful for a number of reasons. It re-invents the storyboard, demonstrating that it need not be drawn, but could be composed of other visualisation tools such as digital photographs. The 3D images can work as a more effective environment to block characters and events within a virtual environment, rather than one bound by the frame. Significantly, the immediacy with which the images can be produced, and the 3D figures and set modified, mean that there can be a greater degree of experimentation and pre-visualisation for the computer environment at an earlier stage.

While the 3D storyboarding helped facilitate the cinematic, design-led and technical aspects of narrative development, the symbolic and thematic aspects of the script were addressed in what Ashworth calls a 'mindmap', helping her to bring the fragmentary aspects of her research into a more coherent focus, so it would inform the possibilities for dramatisation.

This worked alongside Ashworth's typically method-led investment in her work, seeking out pertinent experiences relevant to the project:

'Alongside the script and design development I prepared myself for animating the characters I had invented by imagining their motivations. I swam to imagine their movements in water and viewed wildlife films to examine how difficult it is for mammals to move on land.'

These invaluable techniques illustrate how the act of writing and devising can be indivisible from the practical and pragmatic process of creating animation itself.

Title: How Mermaids Breed

Animator: Joan Ashworth

These images represent some basic 3D 'storyboarding' in which plasticine figures are constructed, composed and blocked in order that photographs can be taken to determine possibilities for storytelling, performance, camera-moves and scene development. Above right is Ashworth's 'mindmap' for her film.

BIRDS
SYMBOLS OF ESCAPE
TRANSCENCE

BOAT
MAN
ORPHIC MINSTREL

...TIVE BIRDS

...n of Apollo + Calliope
...o his skill on the lyre

FERTILITY TIDES

voyages
love
eroticism
waiting
transformation
eating fruit

Fertile nature

In contact with fertile ground

SHELLS
...Breathe sea...
Sound of sea
•When she dies the Mermaid
come through the
mirror to take
her - she b...
one of
them.

PROTECTOR
OF EGGS

MIRROR
DEFORMING MIRROR
OF THE MIND

COLOURS OF ALCHEMY
• REDDISH GOLDEN BROWN
• BLACK
• WHITE.

...hands controllin...
edge of the tide.

Seat in water
a connection with the unconscious

MERMAIDS
FERTILITY
SEXUALITY
...NEED SPERM TO FERTILISE EGGS

lay eggs

WITCH
OWL
+ve BEARER OF WISDOM + CLAIRVOYANCE
-ve SADNESS • SOLITARY • RETREAT • DARKNESS
NIGHT • COLD • DEATH

MIDWIFE
FIXER
INSEMINATOR
SCIENTIST
SPERM COLLECTOR

SCRIPTWRITING Writing Experimentally: Joan Ashworth

Title: Astronaut

Animator: National Space Centre UK

THIS FINAL SECTION LOOKS AT HOW ANIMATION CAN BE DEPLOYED IN NON-TRADITIONAL BROADCASTS AND EXHIBITION CONTEXTS, AND HOW THE WRITER NEEDS TO ADAPT THE LANGUAGE OF ANIMATION FOR THE DIVERSE NEEDS AND REQUIREMENTS OF EACH MODEL. ALTHOUGH THIS HAS SOME CORRESPONDENCE TO THE APPROACHES PREVIOUSLY ADDRESSED AND DEFINED, SPECIFIC ISSUES ARISE IN THE WRITING FOR PARTICULAR PURPOSES AND ENVIRONMENTS – THE FOLLOWING WILL LOOK AT THESE IN MORE DETAIL.

ANIMATION HAS OFTEN BEEN USED IN THEATRICAL AND PERFORMANCE CONTEXTS, SOMETIMES AS PART OF A MAJOR PRODUCTION OR IN MORE EXPERIMENTAL WAYS.

Monkey! was a research project between Sharon White and Dominic Hill. This project primarily aimed to establish a working practice model between animators and stage directors, but also to achieve a seamless blend of animation and live performance in a three-dimensional space that played with theories of suspension of belief but ultimately delivered a well-told, magical story to the audience. As White recalls:

'To begin with, finding a theme of a play that would be suited to animation was a challenge. Arguably, any topic could be tackled and should be suited to animation, but for this project to be worthwhile, I wanted it to be something that could ONLY be done with animation, something that would be physically impossible to do on stage otherwise.

'I went away with the script (*Monkey* by Colin Teevan, based on the Chinese legend of the Monkey King) and started making some rough sketches and storyboards for the parts that I thought would lend themselves to projected animation. I started with the design process and researching visual styles that would suit the project. To be in keeping with the Chinese theme, I did some research into Chinese shadow puppets and came up with the idea of using silhouette cut-out animation.'

STORYBOARDING
'The first major challenge occurred right at the beginning when trying to design a storyboard for the stage, without the use of camera angles. The challenge was that the entire stage space was going to be visible throughout the duration of the play, and like a set design, it had to be seen by all of the members of the audience, from all of their individual sight lines. Traditional camera angles such as close-ups would have to be avoided, as any animated characters or effects would have to stay the same size in relation to the actors. This would mean that animated characters (like actors) would have to rely far more on body language rather than facial expression. Because of this, the storyboard could not be made without knowing where on stage the screen or screens would be; what shape and size it would be; what texture or surface it would be projected on to; and where the animation would be projected in relation to the actors. This basically meant that the stage would have to be designed first, and then the animation would have to fit into the stage design.

'The next challenge was starting to animate without a soundtrack. Normally, the soundtrack is recorded and broken down so that the animated movements are timed out very accurately and synchronised to the sounds. Without knowing how long actors would take to deliver their lines during the live performance, finding the correct timing for my animation was impossible. A solution would be to have the actors rehearse, and then record their speech as though it was for an animated film, so that the animator could work to this timing.

'A general observation from this project is that it is important for the writer to be involved in all aspects of the play, from the stage design to the rehearsals, to get a feel of the overall atmosphere of the play, and also to be able to observe the actors in character so that the set, the acting and the animation will all work well together.'

Title: Monkey!
Animator: Sharon White and Dominic Hill

Working in non-traditional spaces helps the writer draw upon animation techniques and graphic design well-established in the animated form, but less familiar in other contexts and models of use.

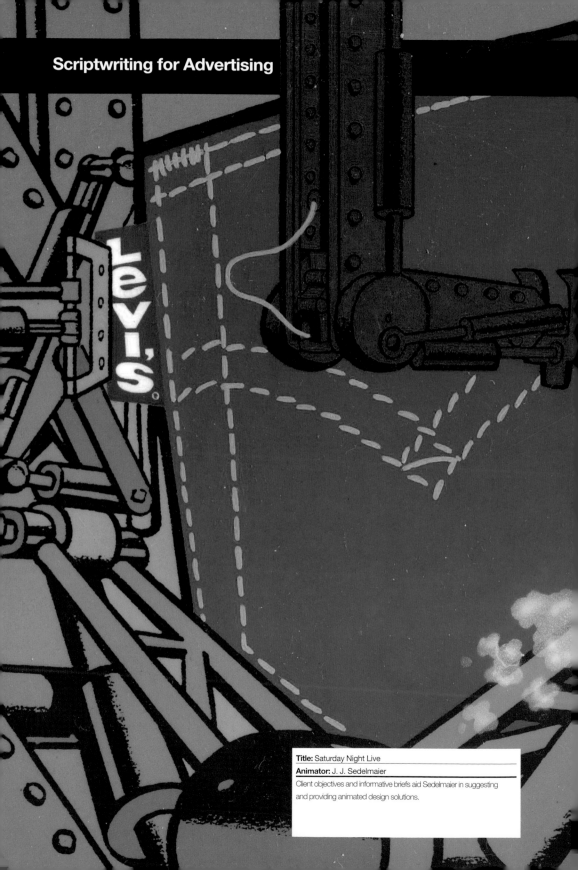

Title: Saturday Night Live

Animator: J. J. Sedelmaier

Client objectives and informative briefs aid Sedelmaier in suggesting and providing animated design solutions.

J.J. SEDELMAIER IS ONE OF THE MOST SUCCESSFUL COMMERCIAL AND SOMETIMES RADICAL ANIMATORS WORKING IN THE UNITED STATES.

He finds animation a particularly distinctive medium for writing because: 'You have complete control over every aspect of the project – graphic design, sound, pacing – everything! You also have ample opportunity to get your individual point of view across with timing and staging'. The particularity of the animated vocabulary is crucial in establishing a specific approach for a sponsor or advertiser, and Sedelmaier is especially sensitive to the uses and applications that are therefore available to him:

'Every project is different – most of my work is in the TV commercial realm, which not only involves the animation aspect but also the selling of your own idea – how you're going to approach it. Enthusiasm and humour help me raise the comfort level for my clients. I have to completely understand what my clients' objectives are to responsibly suggest an approach. I let them saturate me with information so I can get to know the problem as well as they already do, then I can suggest a design solution.'

Even when circumstances seem pressurised and improvised, Sedelmaier trusts the uniqueness of animation itself to provide the answer and stresses that: 'The craft affords you a wonderful foundation for fantasy and un-reality, so I use it for what it's best at and don't cheat (or insult) the viewer by not living up to its potential.'

OVHD

TO HATCH

ASTRONAUT IS AN IMMERSIVE HIGH DEFINITION 360-DEGREE FULL-DOME PLANETARIUM SHOW, WHICH FEATURES STRIKING ANIMATION DEPICTING THE EXPERIENCES OF A TEST ASTRONAUT AND THE UNIQUE RIGOURS OF SPACE FLIGHT.

As this book has sought to demonstrate, each context in which animation is used may determine particular approaches to the writing and devising process. Writing for a planetarium show requires a full understanding of the way a narrative is played out across a dome-shaped panorama, configured to fill up all the viewer's sightlines, including peripheral vision. The full dome image is some 35 times the size of a standard television frame, and each 25-minute show is made up of 45,000 images or frames.

This has resulted in adopting an approach where objects are brought in from the bottom of the dome, essentially disappearing into the far distance, or bringing objects in and out from foreground to background and vice versa, with the possibility of the change of an angle in the presentation of the object itself.

As a result, each person or object entering or exiting the environment is in effect a 'narrative trajectory'. The movement in and out of the panorama has to have a purpose and thus, an implied story. Lead animator Andy Gregory explains the process further:

'The creative team do some research and have some initial conversations with experts in the field. We have a 'brainstorming' session, and try to come up with about 40 shots from which we build up a story sequence. We evaluate each shot by its relevance to the subject and whether it succinctly and accessibly tells the story.

'Once we've made the selection of visuals and done further research, we create a shot list to establish a structure for the narrative and write a provisional voice-over script. We also have to be constantly thinking about the planetarium space and the audience to get a point of identification.'

Two core writing principles are considered here:

Creating a visual narrative/voice-over script for a 'trajectory' as a person/object enters and exits the space.

Creating a pertinent visual sequence/voice-over script to illustrate a complex aspect of science.

Title: Astronaut

Animator: National Space Centre UK

The planetarium dome presents particular challenges for the writer and animator as it is a 'frameless' space that necessitates the narration of trajectories of motion. Interestingly, the process of thinking about animating and projecting on to concave 'screen' spaces relates this model of work to the idea of 'the fourth dimension' and the sense of forces that provoke movement from a source through to a target position.

Scriptwriting for a Planetarium

SCRIPTING FOR A NARRATIVE TRAJECTORY

There is little voice-over. The script is deliberately minimal because the narrative is in the audience's experiential engagement. Too much scripted narration would constitute too much information and distraction. This is a clear example of where visual narrative is more important than textual narrative, but one must definitely complement the other.

The following is an extract from the Spacestation section:

(36) NARRATOR – 30 SECS

In the beginning of the space age astronauts spent relatively short periods of time in space. Missions were brief, typically lasting no more than a few days. The construction of space stations means much longer can now be spent living and working in space. But what do astronauts do once they are in space and how do they cope with day to day life in this unique environment?

We track through several modules dealing with the day to day activities of an astronaut living and working in space.

(pause)

(37) NARRATOR –14 SECS

Everyday tasks that we take for granted on earth become much more difficult. This is how water behaves in space. Imagine trying to take a shower or using the toilet when liquids just float away.

(38) NARRATOR –15 SECS

A major part of an astronaut's job is to perform scientific experiments and conduct research. microgravity provides the opportunity to study science in a way that is impossible on earth.

(pause)

(39) NARRATOR –12 SECS

Keeping fit is vital for an astronaut's health. They have to exercise for at least two and a half hours every day to minimise the long term effects of being in space.

(pause)

(40) NARRATOR –15 SECS

It is essential that regular maintenance and upgrades are performed to preserve the fragile environment of the space station. The smallest problem can very easily become a life threatening situation.

SCRIPTING FOR VISUALISING COMPLEX INFORMATION

The following is an example of penetration in animation where complex, unimaginable, interior states are visualised in an accessible and conceptually simplified way. This sequence shows the actual physical effects upon the astronaut's body as he enters space. It requires that extensive voice-over narration is constantly illustrated by dynamic and compelling visuals to prevent the more overtly scientific language becoming boring or alienating.

The visuals need to double the effect of the narration by immediately showing the element or effect being described and what it actually does. This animated action is essentially a story event and must be completely clear at its point of execution and when viewed, as there is no time to further ponder the issue or be distracted from the overall information-led narrative. The script required is more detailed and extensive, for example:

(17) NARRATOR - 25 SECS

An immediate result of this adaptation is a condition similar to sea sickness. Inside the inner ear there are thousands of little hairs and small crystals called otoliths. Their function is to constantly update the brain as to which way is up, but without gravity, there is no up or down. This confusion between what their eyes see and what their body feels results in almost two thirds of astronauts being ill. This space nausea can last up to three days until the astronauts get their space legs.

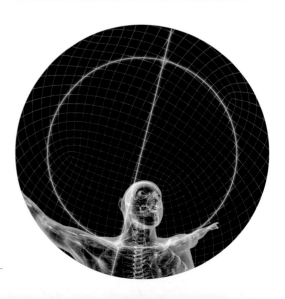

SCRIPTWRITING Animation in Alternative Contexts

THE NEXT SECTION WILL INCLUDE THE FOLLOWING FOR FURTHER STUDY AND INFORMATION:

GLOSSARY
SCRIPTWRITERS' ADVICE
CONCLUSION
REFERENCES AND BIBLIOGRAPHY
FILMOGRAPHY AND WEBOGRAPHY
ACKNOWLEDGEMENTS AND PICTURE CREDITS

Glossary

ACT
Usually part of the traditional 'three act structure' of a narrative and composed of a sequence of developmental scenes, which lead to story crises and climaxes.

ANTHROPOMORPHISM
The imposition of human traits and characteristics on animals, objects and the environment.

APPLICATION
The technical and pragmatic means by which to execute the animation process and secure intended outcomes.

BEAT
A beat is normally understood as an exchange between characters, which demonstrates action and reaction, and consequently advances the scene through dramatic conflict. A beat can also be understood as an implicit rhythm or pulse underpinning a sequence of related images, which signal different moods or emotional effects.

CONCEPTUALISATION
The underpinning theoretical, thematic or technical principle that guides the narrative and is ultimately revealed as the key purpose and outcome of the text.

CONDENSATION
The maximum degree of suggestion in the minimum of imagery.

FABRICATION
The physical and material creation of imaginary figures and spaces.

METAMORPHOSIS
The ability to facilitate the change from one form into another without edit.

OBJECTIVE
In each story event or scene, or in each of the characters/protagonists, there is normally a specific goal to be attained or fulfilled in the ultimate attainment of the 'super objective'.

PENETRATION
The visualisation of unimaginable psychological, physical or technical interiors.

PLOT
The specific choices of story events that advance narrative development.

PROMOTION
Animated films are often created for a particular audience (e.g. children, festivals, sponsors etc.) – and require that core images, often used in promotional materials, properly capture the nature and intention of the work.

SCENARIO
A projected or provisional story event, which plays out a particular narrative requirement (e.g. more exposition, more character development) and may become a possible scene.

SCENE
A story context or period of time informed by actions, which dramatise the execution of character and narrative objectives, the development of story/conceptual requirements in the attainment of eventual closure, and the realisation of the 'super objective'.

SCRIPT
The working 'blueprint' for the work; can appear in a variety of forms, from traditional descriptor/dialogue layouts, prose pieces, notes and sketches, storyboards, to photo-montages.

SEQUENCE
A sequence is a series of story events or scenes, which succeed each other in the creation of an act, or in the advance of an accumulating narrative.

SOUND ILLUSION
The completely artificial construction of a soundtrack to support the intrinsic silence of animated forms.

STORY EVENT
A particular narrative incident or action, which signals a change or development in the story and foregrounds a particular meaning or value. Usually, the story event is informed by dramatic conflict or a significant shift in emotional emphasis.

STRUCTURE
The traditional 'structure' of many narratives is in three acts – the first establishing the premise of the story and concluding with the first major turning point or problem in the narrative. The second act further develops character and story, further compounding the problem, but signalling its possible resolution. The third and final act achieves climax either through resolution, catastrophe or denouement in relation to the problem but reaches closure in some form. In principle, structure can be understood as the choice and succession of story events which establish, problematise, complicate and resolve narrative/character questions, issues and outcomes, while simultaneously provoking specific emotions and responses.

SUPER OBJECTIVE

The ultimate goal or object of desire of the character/narrative, which is normally revealed and attained at the closure of the story/text. This might be the key theme or statement of the piece.

SYMBOLIC ASSOCIATION

The use of abstract visual signs and their related meanings.

SYNOPSIS

A brief narrative overview of the final piece, which offers the core story indicators, stylistic approaches, or visual intentions as a presiding narrative to the piece, suggesting the main aspects of the content, and the key outcomes.

TECHNIQUE

Animation can be made in a range of techniques. The most prominent are drawn animation; cel animation; 3D stop-motion animation; computer generated animation, and animation based on experimental, fine art principles – including cut-out animation, painting or scratching directly on film, manipulating clay and objects etc.

TREATMENT

A fully developed version of the narrative piece, which includes phase, sequence, or scene breakdowns, and includes a full description of the narrative development. This may include advanced descriptions of characters, significant narrative objectives and motivations, specific visualisations of action and story events, and an over-arching 'critical' understanding of the work created, which informs all elements of the descriptors, possible inclusion of dialogue, and the thematic and stylistic outcomes.

VALUE

A story value is an expression of a sub-textual principle that signals a positive or negative aspect of character behaviour, story development, or symbolic or metaphorical shift of emphasis.

VISUALISATION

The process by which the style, design and imagery is decided upon in the creation of an animated film. This might include mood boards, sketches, storyboards, character designs, backgrounds and layouts, props and costumes, visual effects etc.

THIS SECTION IS COMPOSED OF MATERIAL BY SEVEN WRITERS WORKING IN THE ANIMATION INDUSTRY.

Each writer has considerable experience in the field, and has responded to a range of topics in a spirit of offering advice, support and insight about being an animation scriptwriter. The seven writers are: .

Danny Stack
Script adviser and editor on the AIR, Mesh and Animate! schemes in the UK, and co-creator of *Aliens FC*.

John Dilworth
Academy Award nominated for *Chicken from Outer Space* (1995), which later became *Courage the Cowardly Dog* for the Cartoon Network, and maker of such individual films as *The Dirdy Birdy* (1993) and *Life in Transition* (2005).

Bill Plympton
Leading independent auteur film-maker, with credits including *Plymptoons* (1990), *How to Make Love to a Woman* (1995), *Surprise Cinema* (1999), *Mutant Aliens* (2002) and *Hair High* (2005).

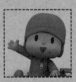

Ken Scarborough
Lead writer on major television animation series, *Curious George*, *Arthur*, *Doug* and *Pocoyo*.

John van Bruggen
Prolific writer on *Rolie Polie Olie* (1998), *Maggie and the Ferocious Beast* (2000), *Franklin* (2002-3), *Franny's Feet* (2003-4), *Gerald McBoing-Boing* (2004), *Miss Spider's Sunny Patch Friends* (2005), and creator of *Coolman!* (2004).

Chris Gifford
Co-creator of the educational pre-school series, *Dora the Explorer* and *Go, Diego, Go!*

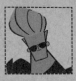

Van Partible
Creator of *Johnny Bravo*.

HOW DID YOU GET INTO
THE FIELD OF ANIMATION?

DANNY STACK: I was working in Channel 4's entertainment (comedy) department in the UK, and the animation department briefly came under our umbrella, which granted me access to the commissioning editors and the projects they were working on. I was always interested in animation as a medium so it was interesting to get a glimpse to see how things were done, at least from the commissioning side of things.

It was around this time that I gave up my full-time job at Channel 4 to pursue my dream of being a scriptwriter. This was 1999. I took on some freelance work to help me pay the bills while I focused on writing my scripts. Part of this freelance work was assessing the proposals that were sent to Channel 4's animation department. From this, I got more involved in animation but from the proposal/script stage – the actual animation process still eludes me!

However, as my experience grew, I quickly became aware that while animators were great at coming up with interesting visual ideas, their storytelling skills were somewhat under par or not quite up to scratch. I saw it as an ignored field for screenwriting so I decided to see if I could get involved in writing animation scripts as a way to help develop my career and assist animators to express their vision in a more satisfying and dramatic fashion.

JOHN DILWORTH: My interest in animation began fairly late. I was working through high school doing children's book illustration on spec, hoping to develop a career in cartooning and children's book illustration. I recall being dissatisfied with the images. I wanted to see them move. I decided to attend art school and learn animation. I began as a freshman at the School of Visual Arts in animation without a clue how it works. I remember looking at exposure sheets for the first time and sweating from anxiety. How will I ever understand this? Over time, with much patience and a large amount of self-encouragement, it comes. When I saw the very first pencil test of my animation, I nearly exploded with excitement. That was twenty years ago. I still feel the same way today.

KEN SCARBOROUGH: I got into animation much the same way an animated character gets into any fraught or perilous situation. It was only after I lit the rocket's fuse that I discovered it was tied to my own foot. In the early 90s I moved to New York to write for a quasi-sketch comedy series for HBO's Comedy Channel. When WGBH was starting the series *Arthur* I was hired to develop and headwrite that because they liked the style and tone of my pilot re-write for *Doug*. Since then I've developed and consulted on or written for a number of projects both in animation and live action.

BILL PLYMPTON: As an illustrator and cartoonist, I had a pile of funny ideas and project possibilities. The 'How To Kiss' concept was a page I did for *Rolling Stone* magazine of six different kisses, and it was a really huge success. 'Famous Last Sights' was basically the last things famous people saw before they died. Isadora Duncan saw a wafting scarf; Sylvia Plath saw a turkey inside an oven; Mama Cass saw a big turkey sandwich – it was really popular. I had lots of funny ideas, which could be made into animated films. It was just a question of drawing them. I immediately went to that file and made short films, one every two or three months. All those years pent-up, not being an animator, made me feel I was way behind schedule, that I had missed the boat and I needed to catch up. People have said that I am very prolific but it was those fifteen years not doing animation that made me want to get my ideas out there and find an audience.

JOHN VAN BRUGGEN: I got into writing for animation after several years of directing, mostly on *Saturday Morning* series. The storytelling aspect of film always appealed to me and I especially enjoyed going through scripts, analysing them and making notes for the story editor. I often took a pass at the scripts myself after the final draft to include alternate dialogue or 'extra business'. I started asking around about scriptwriting at the Nelvana studio. My plan was to fill any directing gaps with writing gigs. As luck would have it, the first season of *Rolie Polie Olie* was halfway through and the story editor, Pete Sauder, felt he could take on a 'greenhorn' writer without jeopardising his schedule.

I originally got into animation because I needed a job after graduating in Fine Arts from the Ontario College of Art in Toronto. My real animation education began years earlier, watching Saturday morning cartoons with my brother. The interest in animation was always there, even as I painted and drew at the college. When the opportunity arose (after graduation) to work

in the layout department of Nelvana in the late 80s – and take home an honest wage making cartoons – I jumped at the chance. I had no formal training in animation and learned 'on the job' from my supervisors and co-workers.

CHRIS GIFFORD: I got into animation when Helena Giersz agreed to create characters for *Dora the Explorer*. She is a wonderful animator, artist and creative problem solver. She convinced us that she could animate the pilot that we had been working on. Up to that point we were looking into a mix of 3D animation and puppets. Helena worked with animators in Poland and they produced the 15-minute pilot. When we got the series pick up we moved the operation to Nickelodeon's Burbank Studio.

VAN PARTIBLE: During my senior year of college at Loyola Marymount University, I created a two-minute animated piece about an over-the-hill ageing rock star. That film was brought to Hanna-Barbera in 1993 during a time when they were looking to produce seven-minute shorts. They liked it, we developed it, and eventually turned it into the series *Johnny Bravo*.

WHAT ATTRACTS YOU TO ANIMATION AS A LANGUAGE OF EXPRESSION – WHAT MAKES IT DIFFERENT FROM 'LIVE ACTION' OR OTHER ARTS ?

DANNY STACK: I'm not an animator and I don't consider myself an animation writer specifically. I like to think that I'm an all-around screenwriter who has an interest and talent in writing for animation. However, I am surprised that more screenwriters are not drawn to animation and its potential for exciting visual stories, whether it's discerning cutting-edge animation or the unashamed fun of a kids' cartoon/feature film. What is particularly exciting about animation is that you can literally let your imagination run riot. You're never restricted in terms of budget or location, and the laws of reality as we know it most certainly don't apply. This is incredibly appealing as a writer, especially a screenwriter, because of the rich imagery and wild fantasies that can be conjured up on a page of animation.

You can go anywhere. Do anything. Play with monsters, myths, aliens and even creatures of your own making! Outer space, inner space,

body, mind and beyond – they can all be visually explored through the art of animation. No other visual medium affords you this opportunity.

JOHN DILWORTH: Using animation as a form of expression allows me to behave irrationally without censure. And a large part of that behaviour is how it is expressed through the drawings. I get a tremendous amount of satisfaction out of watching a ridiculously designed character move. It simply is absurd. Funny design is only one element, how that funny design walks, for instance, can rupture a pancreas. Animation is unlike other art forms as it can encompass all the other art forms. The ability to manipulate those elements individually and without limitations, to create a new other thing that is in motion, for me, is the difference.

KEN SCARBOROUGH: I like that animation can take you anywhere: to outer space, or into someone's thoughts or just plain into their head to see the gears that operate the eyeballs and tongue. Characters can be mashed, stretched, blown up and die (and it's hilarious). Hare-brained contraptions can be built that are funny simply because they work (think of Gromit laying track) or don't (think of that poor coyote). There's so much you can 'buy' animated characters doing because their behaviour is so eloquent. Going from hate to love in an instant? Utterly believable. Big dog scared of tiny dog? Sure. A character experiencing the slightest tingling of distrust borne of the continual betrayal of his hopes? Happens all the time.

Besides the obvious, series animation tends to be much more writer-driven than even live action television. In movies and live action television, the director and actors work out the performances. In animation there are no actors to give a single, unified performance. There are the voices and then there are people who do the storyboards, the timing, etc. For all of it to come together and give a sense of a performance, they all need to be working from the same playbook, and in series animation that tends to be the script.

BILL PLYMPTON: I look at scenes and moments in films that I really like. I look at and listen to audiences to see how they respond and what they laugh at. I try and learn something from every film, even if it is a bad film; I like to know what fails, too. I am always looking for a different perspective, and if you are an animator telling a story, the secret is to look for a fresh

point of view. Sometimes it is the simplest thing that is the funniest, and oftentimes, it is because it is so personal, so intimate, so common, and people share the observation.

JOHN VAN BRUGGEN: I enjoy writing for animation in that it is a nice blend of film and the novel. That is, as an animation writer, you have to paint much more of a picture than a writer for live action. You need to describe the characters, what they look like, what they're doing, where they are and how that place looks. You also need to write what they say, and be specific about how they say it, from the tone of their voice, to an indication of timing. In live action, the actors, director, cinematographer, etc., work out most of those aspects of the film-making process.

Unlike a novelist, and especially if you work in television, you must tell your story in a finite amount of time, taking into account the show's length and 'act breaks'. Some might see these factors as limiting, but I enjoy the challenge of writing within these constraints.

CHRIS GIFFORD: Well certainly, the possibility for action sequences is pretty hard to beat. We can create epic scenes, which would just be un-produceable for us if we were shooting live action. Also I've enjoyed the ability to make changes based on research. The need to create an animatic has afforded us the ability to test before we've gone to animation and often we make major changes based on kids' reactions to the animatic viewing. We also have made certain changes after an episode has been animated. Of course this runs up the cost, but we have included a budget for creative re-takes.

VAN PARTIBLE: You can really manipulate a performance out of a cartoon character, whereas in live action, you're limited to the actor's talent.

WHAT ANIMATORS/ANIMATION/WRITERS DO YOU ADMIRE OR HAVE BEEN INFLUENTIAL?

DANNY STACK: Chris Shepherd is amazing. He's got such a distinctive voice. No one does it quite like Chris. His multi-award-winning short film *Dad's Dead* sends shivers down my spine every time I see it. And it's only seven minutes long! He's very inspiring because of his strong individual director's vision.

Samantha Moore's work is also unique because she's pioneered the 'animation docudrama' with her short films *Sweet Peas* and *Doubled Up*. She uses sound and music to delightful effect to complement and enhance the imagery of her subject matter. An exceptional and original talent in the UK.

Sam Morrison – my co-writer for animation/family projects. He's great. He's got such a natural ease and instinct for story, not to mention his subtle knack for characterisation and humour.

Tim Hope's got such a great style and packs a sly emotional resonance into his work. There's something so distinctive and thought-provoking about his imagery and delivery. It somehow goes beyond the mere visual representation of what's in front of you. There's a deeper and emotive core to everything he does. A breathtaking artist.

JOHN DILWORTH: I was raised watching Warner Bros and MGM cartoons. I admired the work of Bob Clampett, who would do things to a pig and a duck that I still think about and laugh at. Tex Avery taught me timing and how to use sound effects. Other influences include very early Mickey Mouse and Donald Duck, Fleischer's *Popeye*, the films of UPA, Jay Ward's *Rocky and Bullwinkle*, DePatie-Freleng's *Pink Panther*, Chuck Jones's *How the Grinch Stole Christmas* and *The Dover Boys*, the puppet films of Rankin Bass, the films of John Hubley, Bruno Bozzetto, Yuri Norstein, Nick Park and Paul Driessen. There are so many extraordinary human beings who have inspired me I cannot list them all in fairness.

KEN SCARBOROUGH: Frankly the animations I like are the same things that everyone likes. Because what I work with most of all is story and story structure, I think my work has been mostly influenced by movies, plays, books, fairy tales, etc. So I can't say that any particular animated piece has influenced me more than, say, the movies of Chaplin and Keaton and Lloyd, 30s screwball comedies, Preston Sturges films, the novels of Kurt Vonnegut, or all those TV perennials about a guy who has a job and a family (*The Andy Griffith Show*, *The Dick Van Dyke Show*, etc.).

BILL PLYMPTON: I have my influences that are European. I like that kind of humour – *Monty Python* and *The Goon Show* were really important. As far as animators go, I love

Svankmajer but for the most part the Eastern European humour is too dry and they take themselves a little too seriously. For me, it is mostly the British sense of humour – a dry wit mixed with surrealism, which I think is wonderful.

JOHN VAN BRUGGEN: Chuck Jones has always been a favourite, especially his Daffy Duck cartoons. 'Duck Amuck' really stands out as an influence. I enjoy exploring the idea of breaking the 'fourth wall' and opening up a dialogue between the animator and the animated. On the other hand, I admire the naturalism of Hiyao Miyazaki in such films as *My Neighbor Totoro* and *Kiki's Delivery Service*. I love his attention to detail and how his characters drive every story. If I have a mentor in the business, it would have to be Bob Ardiel, my story editor on *Franklin*. Bob has a great way of telling a story simply and a real knack for working with you to make your script stronger.

CHRIS GIFFORD: First of all, I would never consider myself an animator, I'm a children's TV producer and writer who has gotten the opportunity to work with wonderful animators and learn from them. Jeff DeGrandis, Henry Madden, Kuni Tomita as well as Helena and her husband Kris. All extremely talented and influential.

VAN PARTIBLE: I really admire the design stylings of Ed Benedict and Dan Haskett. I was lucky enough to work with both of them on *Johnny Bravo*. They were both gracious enough to pass on their knowledge and expertise, so I learned a great deal about the art behind animation.

HOW DO YOU WRITE/DEVISE/DEVELOP A PROJECT?

DANNY STACK: I'm all for beautiful and striking imagery but ultimately what I'm interested in as a writer is whether something is a good story, and to ensure that the images correlate or complement the ongoing narrative rather than distance itself from it. It's a fine balance, however.

JOHN DILWORTH: I develop ideas either through random sketches or cognitively, in my head. I may be inspired by something visual, like a film, cartoon or literature. I rely on my intuition a great deal. I have silent dialogues with myself, asking questions and listening to a sensation in my nervous system as a reply.

KEN SCARBOROUGH: I guess I feel like I develop different series and different episodes in different ways. Whenever I go about developing a new story I always have a slight feeling that I'm inventing a new form. But that sense of it being a puzzle is part of what keeps it fresh, I think. When I write an episode I just try to come up with a situation that has interesting things happening visually and emotionally (for characters and viewers) and which in the end has something to get across – that the story hasn't just been about winning or defeating the bad guy, but that the characters themselves have learned, grown or developed in some way as a result of their efforts.

When I develop a series, I'm looking to create a cast and a world that will give me the maximum number of opportunities for those kind of stories and in-built conflicts of values. You work to develop strong characters.

HOW DO YOU COME UP WITH STORIES?

BILL PLYMPTON: I am just looking for jokes. Sex and romance are a big obsession with everybody. I think that obsessions are a great source of humour. I really wanted to engage with sex and nudity. I've taken some criticism from women about being a misogynist, but that is unfair. I just don't think they have the same sense of humour and are not prepared to laugh at this view of sex. It is a puritanical response.

JOHN VAN BRUGGEN: Whether I'm developing a project to pitch or a new script premise, I always try to find some personal way into the characters and the story (or stories) being told about them. I'm at my happiest when I can bring some of my own life experiences to the table.

CHRIS GIFFORD: Both *Dora the Explorer* and *Diego* are curriculum based and so in many ways we are driven by the need to satisfy that curriculum. We strive to have a visual reference for everything our characters are talking about so little kids can make the connection, but we also try to narrate action sequences. For us it's not 'show don't tell'. It's 'show and tell'.

VAN PARTIBLE: I start with the character. The character has to feel real. Even if it's a

cactus plant, it has to be rooted in humanity so that the audience (and myself) can emotionally connect with them. Linda Simensky, the former head of programming and development at Cartoon Network, once gave me a formula that has stuck with me over the years: complex characters in simple situations work much better than simple characters in complex situations.

WHAT ARE THE PARTICULAR CHALLENGES/PROBLEMS OF YOUR WORKING PROCESS AND HOW DO YOU RESOLVE THEM?

JOHN DILWORTH: The challenge to this style of working process is maintaining a continuity of story style yet encouraging spontaneity among the writers. Unfortunately, I cannot offer much in relief here as I relied solely on my vision of the series and my intuition. Both these qualities are specific to me. Had another writer been supervising in my absence, I would have had to spend a lot of time with that writer reviewing the material and expressing why I felt something did not work or what I liked.

KEN SCARBOROUGH: Keeping things fresh. Keeping your own interest and enthusiasm up. Having something interesting to say – or at least an interesting way to say something familiar. The usual fights with producers. Standing up for things that are working and being willing to roll up the sleeves to fix things that aren't. The first order of problems are solved by imagining your way out – setting new tasks, taking things in different directions. The second kind of problems are solved with talk, talk and more talk.

BILL PLYMPTON: I do have limits. I don't do a lot of swear words. I don't do a lot of defecation jokes. I don't do any rape jokes. I am into bestiality. I think bestiality is very funny. All of that is in traditional cartoons – Bugs Bunny is always dressing up as a woman to attract Elmer Fudd. I don't do piss and shit jokes. I do vomit jokes, of course, but sex is the really fertile area for jokes. It is fun to laugh at death, sex, and violence. You have got to laugh to survive.

JOHN VAN BRUGGEN: Sitting in front of a computer and pecking at the keyboard isn't always the most ideal way of solving a story point or coming up with just the right piece of pithy dialogue. Whenever inspiration eludes me, the best thing I can do is to head outside for a nice, long walk. Inevitably, I have a solution for my 'problem' within the first few blocks. A change of perspective almost always works wonders!

Keeping running journals of story ideas helps me to ward off writer's block. I jot down every idea, no matter how dumb. I just write and use what I can; the rest remains in my notebook, on a shelf...there to help me in my hour of need. My journal collection becomes a sort of 'story morgue'. A plot or genre that doesn't suit one series (or character) might work just fine for another. Or some small detail in a 'long dead' idea could spin off into an entirely different direction and become a whole new, living and breathing story. In short: throw nothing away!

CHRIS GIFFORD: Well I can't draw at all but I'm pretty visual so my biggest challenge is to try to communicate what I'm seeing in my head. I've sent these awful looking stick figures to our animators, and they have been very kind and creative in interpreting them. Another challenge is convincing people that the changes we want to make are important. The success of both shows has validated our process a bit but showing videos of kids watching the animatic or animation and having the animators see why we want to make a change has been extremely important to their being invested in carrying it out. When you see those cute little kids turning away from your work, you want nothing more than to fix it and get them back.

VAN PARTIBLE: There's always a problem in repeating storylines, telling bad jokes, getting too bogged down in exposition, or creating characters or situations that are too 'inside' and do not relate to anybody outside your world. These are all constants. The only thing I can do is create something that gives me enjoyment and hope that my passion shows through and the audience is able to connect with that. If I try to second guess my audience, things get watered down or the ideas get muddied. You must realise that it's impossible to please everybody's tastes. It's all a risk. You have to be willing to put your neck on the line and accept the criticism. And believe me, there's a lot of criticism!

WHAT 'BEST ADVICE' OR 'TOP TIPS' WOULD YOU GIVE A STUDENT OR NEW PRACTITIONER SEEKING TO WRITE OR DEVISE AN ANIMATION SCRIPT?

DANNY STACK: For me, it's all about story. Everything comes from that or can be tailored to it. Lovely images and breathtaking vistas don't give me as much joy if they're not linked to an emotional narrative. That's my personal preference. Some animators are artists who can express their ideas through striking imagery and intelligent transitions, and that's great, but I prefer a story to be part of that imagery as it always adds another level to the piece.

If you're just starting out, decide which type of animator you are. Are you the animator who enjoys telling stories through interesting and quirky images or are you a more discerning and thought-provoking artist who likes to experiment and challenge the art form? There's certainly room for both but knowing which type you are, and feeling comfortable and confident with your choice, can make the difference between an indistinctive voice or a storytelling talent that demands people's attention.

JOHN DILWORTH: One thing to keep in mind when setting out to write an animation script is creating a well-rounded hero, with specific qualities that can be expressed easily to anyone.

KEN SCARBOROUGH: If you're an animator, it's important to have something to give the audience beyond good animation. Anything that's presentational, naturally, has an element of 'Hey, look at me!'. But people want and deserve to be rewarded for the time they spend watching, so there has to be something beyond that.

BILL PLYMPTON: When I was younger I didn't always have enough paper to draw on, so every time my mum came back from the butchers with burgers or steak wrapped in these big sheets of butcher paper, I would get it out of the garbage, smooth it out, and do drawings on it. It had blood splots all over the place, so I would draw war scenes and include them in the battles – maybe that is where I get my violence from! You've got to be single-minded and really want to do it.

JOHN VAN BRUGGEN: A good way to learn about writing is to watch as many television shows and movies as you can, both good and bad. If you like a show, think about why it worked, how it engaged you and why you rooted for its characters. If you didn't like a show, ask yourself why...and how you would fix or improve it. Read as much as you can. If you're writing for a children's show, read books for kids. Look at picture books for children so you can see how stories are visualised and how words support the pictures (and vice versa). If you keep getting your premises rejected for a show, try not to get discouraged. Keep at it and you'll find yourself another happy little niche!

CHRIS GIFFORD: Know your audience. Research your stories and spend most of your time re-writing before going to script. If you are not an animator check in with your animators before going to script on all the issues that they will face when they try to produce it for you.

VAN PARTIBLE: Travel. Even if it's in your own neighbourhood. Search for stories, observe humankind and its quirks. Really notice the things that make up character. Whether it's the way they move or the way they talk, there's a character somewhere in your life. But most of all, do a lot of searching within and find out your passions, your quirks, your tastes. Then you'll really begin to understand motivation and character. Finally, keep a journal and write about your life experiences. Even if nobody sees it, it will help you get in the habit of observing, questioning, pondering and eventually, creating.

Throughout this discussion, it has constantly been stressed that to be a writer, deviser or creator in animation is to combine the skills and knowledge that underpin traditional screenwriting with the understanding of animation as a particular language of expression, which may be executed through a variety of techniques.

Ultimately, the act of writing for animation is essentially about how writers define themselves in relation to animation.

At its simplest, a writer can write a screenplay, which bears remarkable similarity to works in live action, with more pronounced tendencies to the surreal and spectacular – demonstrating the work of an animation-savvy writer rather than a 'hands-on' animator. At the other end of the scale is the animator 'auteur' – the writer working completely alone or with a small team. In this case, the act of writing may still follow a traditional model, but may be approached by working out of sketchbooks, writing poetry or prose, or simply improvising or working with materials and artefacts.

Somewhere in between are the writers who contribute to studio or small company-led work, each contributing significantly to a collaborative effort, sometimes with a lead figure or director at the helm; sometimes with acknowledged collective authorship. Most people working in this more industrial model have to be prepared to commit their creative identity to the company or corporate brand, and to remain 'invisible' as part of a production team.

The independent animated film has been the most common context in which genuine auteurs have emerged, but it should be noted too, that in recent years, distinctive 'voices' have also characterised a great deal of television work, particularly in the field of animated cartoons. In both instances, much of this distinctiveness has come out of the effectiveness of the writing and the freshness and modernity of the visualisation.

While the impact of computer-generated animation may have dominated debates about the status, definition and continuity of the animated film, this has essentially been a 'red herring', because animation is properly defined by its vocabulary, and not its technologies. That vocabulary is still defined by the specificity of the writing, devising and creativity discussed in this book.

KEY POINTS IN WRITING FOR ANIMATION

Animation has a distinctive language which at one extreme, can create a mimetic representation of the material world, while at the other, operate in completely abstract terms.

Animation has some specific aspects of its vocabulary that essentially define its difference from live action: metamorphosis, condensation, anthropomorphism, fabrication, penetration, symbolic association and the non-diegetic illusionism of sound.

Animation is effectively defined through its production processes, having to engage with 'technology' etc. towards creative visualisation.

Animation is chiefly characterised by its own generic 'deep structures': formal, deconstructive, paradigmatic, primal, political, abstract and re-narration.

In its more traditional storytelling vehicles, animation is still reliant on fully developed characters, engaging themes and topics, narrative development and dramatic conflict; these arise through the active questions, situational problems, core objectives, and creative solutions played out by the primary protagonists.

Good animated stories normally have a balance between substantive action and resonant meaning. In terms of scriptwriting this requires a balance between movement and exposition. Movement creates interest, while exposition expresses and explains what would logically take place in scenes.

Traditional animation narratives need to establish problems that require resolution. It is crucial to be aware of character imperatives and goals, the development of character relationships, and what the overall purpose is of a scene or sequence of scenes.

Description is always written in third person, present tense.

Visualisation remains a priority, and most animated films tell their stories effectively through images rather than through 'talking heads'. If dialogue is used it must be pertinent and necessary.

References and Bibliography

SCRIPTWRITING

ASA BERGER, A. (1997) The Art of Comedy Writing (New Brunswick: Transaction)

ASA BERGER, A. (1997) Narratives (Thousand Oaks & London: Sage)

BLUM, R. (2001) Television and Screenwriting (Boston & Oxford: Focal Press)

BRENNER, A. (1980) The TV Scriptwriter's Handbook (Cincinatti: Reader's Digest)

BYRNE, J. (1999) Writing Comedy (London: A&C Black)

COUSIN, M. (1975) Writing a Television Play (Boston: The Writers Inc.)

FRENSHAM, R.G. (1996) Teach Yourself Screenwriting (London: Hodder)

HARDING, T. E. (1972) Let's Write a Script (Adelaide: Hulton)

HORTON, A. (1998) Laughing Out Loud: Writing the Comedy-Centred Screenplay (Los Angeles: University of California Press)

HORTON, A. (1998) Writing a Character-Centred Screenplay (Los Angeles: University of California Press)

KELSEY, G. (1990) Writing for Television (London: A&C Black)

MCKEE, R. (1999) Story (London: Methuen)

PARKER, P. (1999) The Art and Science of Screenwriting (Exeter: Intellect Books)

ROCHE, J. (1999) Comedy Writing (London & Chicago: Hodder & Stoughton)

SMITH, N. (1989) The Essential A-Z of Creative Writing (London: Cassell)

TOBIAS, R. (1995) Twenty Master Plots (London: Piatkus Books)

WOLFF, J. (1995) Successful Sitcom Writing (New York: St Martin's Press)

ANIMATION PRACTICE

BLAIR, P. (1995) Cartoon Animation (Laguna Hills, Ca: Walter Foster Publishing)

BECKERMAN, H. (2004) Animation: The Whole Story (New York: Allworth Press)

BIRN, J. (2000) Digital Lighting and Rendering (Berkeley, Ca: New Riders Press)

CORSARO, S. & PARROTT, C.J. (2004) Hollywood 2D Digital Animation (New York: Thompson Delmar Learning)

CULHANE, S. (1988) Animation: From Script to Screen (London: Columbus Books)

DEMERS, O. (2001) Digital Texturing and Painting (Berkeley, Ca: New Riders Press)

GARDNER, G. (2001) Gardner's Storyboard Sketchbook (Washington, New York & London: GGC Publishing)

GARDNER, G. (2002) Computer Graphics and Animation: History, Careers, Expert Advice (Washington, New York & London: GGC Publishing)

HART, C. (1997) How to Draw Animation (New York: Watson-Guptill Publications)

HOOKS, E. (2000) Acting for Animators, (Portsmouth, NH: Heinemann)

HORTON, A. (1998) Laughing Out Loud: Writing the Comedy-Centred Screenplay, (Los Angeles: University of California Press)

JOHNSON, O. & THOMAS, F. (1981) The Illusion of Life (New York: Abbeville Press)

KERLOW, I.V. (2003) The Art of 3D Computer Animation and Effects (New York: John Wiley & Sons)

KUPERBERG, M. (2001) Guide to Computer Animation (Boston & Oxford: Focal Press)

LAYBOURNE, K. (1998) The Animation Book (Three Rivers, Mi: Three Rivers Press)

LORD, P. & SIBLEY, B. (1999) Cracking Animation: The Aardman Book of 3D Animation (London: Thames & Hudson)

MCKEE, R. (1999) Story (London: Methuen)

MEGLIN, N. (2001) Humorous Illustration (New York: Watson-Guptill Publications)

MISSAL, S. (2004) Exploring Drawing For Animation (New York: Thomson Delmar Learning)

NEUWIRTH, A. (2003) Makin' Toons: Inside the Most Popular Animated TV Shows & Movies (New York: Allworth Press)

PATMORE, C. (2003) The Complete Animation Course (London: Thames & Hudson)

PILLING, J. (2001) 2D and Beyond (Hove & Crans Pres-Céligny: Rotovision)

RATNER, P. (2004) Mastering 3D Animation (New York: Allworth Press)

RATNER, P. (2003) 3D Human Modelling and Animation (New York: John Wiley & Sons)

ROBERTS, S. (2004) Character Animation in 3D (Boston & Oxford: Focal Press)

SCOTT, J. (2003) How to Write for Animation (Woodstock & New York: Overlook Press)

SEGAR, L. (1990), Creating Unforgettable Characters (New York: Henry Holt & Co)

SHAW, S. (2003) Stop-Motion: Crafts for Model Animation (Boston & Oxford: Focal Press)

SIMON, M. (2000) Storyboards (Boston & Oxford: Focal Press)

SIMON, M. (2003) Producing Independent 2D Character Animation (Boston & Oxford: Focal Press)

SUBOTNICK, S. (2003) Animation in the Home Digital Studio (Boston & Oxford: Focal Press)

TAYLOR, R. (1996) The Encyclopaedia of Animation Techniques (Boston & Oxford: Focal Press)

TUMMINELLO, W. (2003) Exploring Storyboarding (Boston & Oxford Focal Press)

WEBBER, M. (2000) Gardner's Guide to Animation Scriptwriting (Washington, New York & London: GGC Publishing)

WEBBER, M. (2002) Gardner's Guide to Feature Animation Writing (Washington, New York & London: GGC Publishing)

WELLS, P. (2006) Fundamentals of Animation (Lausanne: AVA)

WHITE, T. (1999) The Animator's Workbook (New York: Watson-Guptill Publications)

WHITAKER, H. & HALAS, J. Timing for Animation (Boston & Oxford: Focal Press)

WILLIAMS, R. (2001) The Animator's Survival Kit, (London & Boston: Faber & Faber)

WINDER, C. & DOWLATABADI, Z. (2001) Producing Animation (Boston & Oxford: Focal Press)

Filmography and Webography

As well as the films profiled in the text, the following films repay viewing for their particular distinctiveness in writing and/or devising:

ACHILLES (1995)

AND THEN I'LL STOP (1990)

ANIMAL FARM (1954)

AUSTRALIAN HISTORY (1970)

BALANCE (1989)

BIG SNIT, THE (1985)

BLACK DOG, THE (1987)

BODY BEAUTIFUL (1991)

BOY WHO SAW THE ICEBERG, THE (2000)

CAT CAME BACK, THE (1988)

CHICKEN RUN (2000)

CRAC! (1981)

CRIME AND PUNISHMENT (2000)

CROSSROADS (1991)

DEATH AND THE MOTHER (1988)

DIMENSIONS OF DIALOGUE (1982)

DREAMS AND DESIRES – FAMILY TIES (2006)

DUCK AMUCK (1953)

FATHER AND DAUGHTER (2000)

GERALD MCBOING BOING (1950)

GHOST IN THE SHELL (1995)

GREAT (1975)

HAND, THE (1965)

I MARRIED A STRANGE PERSON! (1997)

INCREDIBLES, THE (2004)

INTERVIEW (1979)

IRON GIANT, THE (1999)

KING-SIZE CANARY (1947)

LINEAGE (1979)

LMNO (1978)

LUXO JR. (1986)

MAN WHO PLANTED TREES, THE (1987)

MONSTER HOUSE (2006)

MY NEIGHBOUR TOTORO (1988)

OLD MAN AND THE SEA, THE (1999)

ONE FROGGY EVENING (1955)

PETER AND THE WOLF (2006)

PICNIC ON THE GRASS (1988)

POND LIFE (1998)

PRINCESS MONONOKE (1999)

RYAN (2004)

SECOND CLASS MAIL (1984)

SHREK (2001)

SON OF SATAN (2003)

STREET OF CROCODILES (1986)

STREET, THE (1976)

TALE OF TALES (1979)

TANGO (1982)

TOY STORY (1995)

TOY STORY 2 (1999)

25 WAYS TO GIVE UP SMOKING (1989)

TWO SISTERS (1990)

WHAT'S OPERA, DOC? (1957)

WEBOGRAPHY

www.writerswrite.com

A comprehensive resource for those interested in all aspects of writing and publishing. It has a literary emphasis, but has information on many genres of writing and markets for publishing work.

www.animation-writer.com

A website dedicated purely to animation writing resources, including links to writers and animation scripts.

www.screenwriting.info

Covers information concerning aspects of script construction, with tips and advice about developing a traditional screenplay.

www.screenwritersutopia.com

Screenwriters, critics and practitioners share viewpoints and expertise. A range of news and information about professional screenwriting is also available.

www.awn.com

Animation World Network – simply the key resource for the animation community worldwide, including articles, information and news.

www.toonhub.com

Contains information about a range of cartoons and animated films.

www.nfb.com

The comprehensive site of the National Film Board of Canada, which has a range of 'auteur' films exemplifying a variety of approaches to story development.

www.toonarific.com

Fan-based forum of information and discussion about cartoons – useful in identifying audience tastes and points of investment and interest.

www.toonhound.com

A site dedicated to British animation, comic strips and puppet shows, enabling for engaging with already established characters, stories etc.

www.animated-news.com

Contemporary animation news site on current series, work in development, animation opportunities.

www.cartoonbrew.com

News and commentary on the animation industry from CartoonResearch.com's Jerry Beck and AnimationBlast.com's Amid Amidi, both established authors on American cartoon history.

SCRIPTWRITING Filmography and Webography

Acknowledgements and Picture Credits

Renée Last, Brian Morris, Lucie Roberts, Lucy Bryan, Sanaz Nazemi, Eloyse Tan and all at AVA Publishing for patience, tolerance and continuing support.

Dan Moscrop and Marina Lopes at Them Design

Andy Chong and Ben Dolman for being splendid Animation Academicians.

Linda Simensky (PBS)

Bec McPhee (Australian Children's Television Foundation)

Lee Burton (Australian Children's Television Foundation)

Peter Lord (Aardman Animation)

Jim Campbell (Aardman Animation)

Kathryn Hart (Zinkia Entertainment)

Vivien Halas (Halas & Batchelor)

Samantha Moore (University of Wolverhampton)

Kasey Frasier (StretchFilms)

Kim Dent Wilder (Mainframe)

Melanie Coombs (Melodrama Pictures)

Chris Rose (BBC)

Tim Phillips (Australian Children's Television Foundation)

Jessica Cooper (David Higham Associates)

And most importantly, all the talented named artists and writers in the text.

P5, 28-29, 48, 50–53 Images courtesy of Australian Children's Television Foundation
P6 Creature Comforts Series 1 © Aardman Animation Ltd. 2003
P8-9, 96, 142, 145–147 Images courtesy of Van Partible
P5, 10, 98, 100, 102–107, 109–111 Images courtesy of Tiger Aspect
P13–15 Images courtesy of Ali Taylor
P17 Pocoyo TM © 2005, Zinkia Entertainment, S.L.
P18–19, 60 Image courtesy of Indestructible Productions
P4, 22 Images courtesy of Joan C. Gratz
P24 Images courtesy of Guido Manuli
P26, 79–81 Images courtesy of Halas & Batchelor Cartoons
P30–31, 58 Images courtesy of Delphine Renard
P32 Images courtesy of Realtime UK
P20, 34, 164-165 Images courtesy of J.J. Sedelmaier
P36, 82, 84 Images courtesy of Norman McLaren
P38 Image courtesy of Brian Larkins
P4, 40–41 Images courtesy of Richard Haynes and Mikolaj Watt
P4, 42–47 Images courtesy of Gil Alkabetz
P55 Image courtesy of Bill Plympton
P57 Images courtesy of Chris Shepherd
P2–3, 63, 124, 132, 134–137 Images courtesy of Johnny Hardstaff
P66 Images courtesy of Mainframe Entertainment
P68–69 Images courtesy of Virgil Widrich
P71 Creature Comforts Series 1 © Aardman Animation Ltd. 2003
P72–73 Creature Comforts Series 2 © Aardman Animations Ltd. 2005
P74–77 Images courtesy of Chris Shepherd
P85 Images courtesy of Anja Perl and Max Stolzenberg
P86, 89 Images courtesy of Robin Fuller
P91–93 Images courtesy of John Grace and An Vrombaut
P95 Images courtesy of David Anderson
P113–123 Images courtesy of Hibbert Ralph Studio
P126–131 Images courtesy of Shira Avni
P138–140 Images courtesy of Adam Elliot
P5, 148–151 Images courtesy of Kresten Andersen
P152–155 Images courtesy of Uzi Geffenblad
P156–159 Images courtesy of Joan Ashworth
P5, 160, 166,168 Images courtesy of National Space Centre, UK
P163 Images courtesy of Sharon White and Dominic Hill

All reasonable attempts have been made to clear permissions and trace and credit the copyright holders of the images reproduced in this book. However, if any have been inadvertently omitted, the publisher will endeavour to incorporate amendments in future editions.